Susan,
It was a memorable ride!
Afonso

Susan,
You capped the program off with a great story. Thank you fo' THE SUSAN.

Susan,
Best Wishes
Bob Dida

Susan,
Thanks for making
new found
Knowledge THANKS for making
Just haw fun and your
help dery possible!
Mark O'Brien

Susan,
Thank you for all,
of your time and effort
during the Capstone
Project. Tom

Susan,
Thanks Be your
everything! are great!
Mark B. W.

Susan,
This was a great
experience, more
enjoyable than I could
have imagined!
Jim DeGrazia

all the hard work in
Business Conception
Valerie Johns

Susan,
Thanks very
much for all
the work!
Dave Hogan

Thanks for the
great legal advice
to keep us out of
jail!!
Dan Morhot

Chère Susan,
merci pour tout l'aide,
le savoir et les bons
moments avec
les gens de B...

Susan –
Max Zionott Thank you for all of
the sage counsel.
Dave Pierce

Susan –
Thanks for
all the
great show!
Bryan Fernik

Susan –
I'll always remember
your classes – Ireland was a
great experience
Maule Muse

Susan
Thanks for
your dedication
to our class.

Susan –
Thanks to a
great editor &
teacher! All the
Best in the future –
MIKE CARRANO

It was a great experience,
Ceth Roman

Susan,
Thank you for all
of your help. I truly
enjoyed working with
you. Best of luck always,
Patrick

Susan –
I really enjoyed
your classes
and spending
RWU in Ireland
it you.
Nice wrap up
Cindy H

Susan–
I learned a bunch!
Thanks for a great
course + a great
time.
Renee Olson

Susan–
Thanks for
your advice and
your time is much
appreciated. I have
learned alot
for Angie

Susan, Thanks for the EMBA memories
Bryan
Thanks Susan,
Connect to
Save Telecom team!

Susan, Thank you!
I enjoyed a member of

Susan,
I will have to
differ to co-counsel.
Thanks George C.
Satoshi

Susan,
We start my next career
as a professional Singer.
"Oh Danny boy, oh say can you see"
It's been great to
Jeff Murphy

Susan,
Thanks for helping
me start my next career

IRELAND — THE INNER ISLAND

A JOURNEY THROUGH IRELAND'S INLAND WATERWAYS

KEVIN DWYER

The Collins Press

First published in 2000 by
The Collins Press,
West Link Park,
Doughcloyne,
Wilton, Cork.

© Kevin Dwyer 2000

British Library Cataloguing in Publication data.

A CIP catalogue record for this book is available from the British Library.

Printed in Spain

Cover design by Artmark

ISBN: 1-898256-91-8

Photographs printed by GMS Professional Imaging Ltd., Dublin.

PHOTOGRAPHS
Prints/enlargements of photographs can be purchased from:
Kevin Dwyer, Photographer, Factory Hill, Glanmire, Co. Cork, Ireland.
www.kevindwyer.ie

Facing page: Evening light on the bridge at Carrick-on-Shannon.

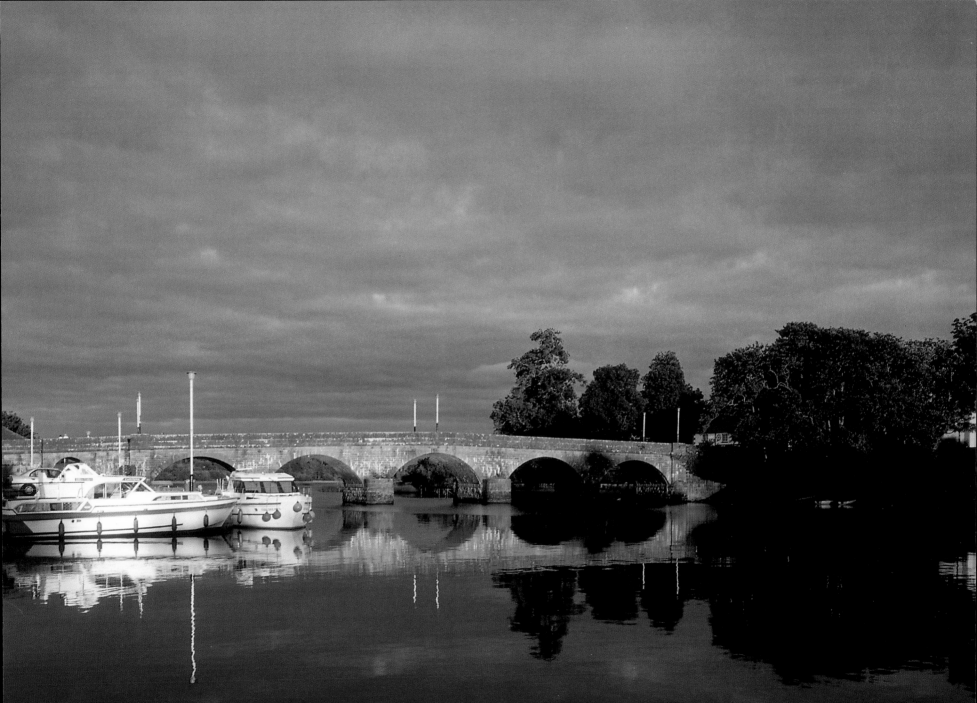

To Fie, Jayme, Samantha & Julie

They say my head is in the clouds,
it's also on the waters,
I dedicate this book to them,
My wife, my son and daughters.

Kevin Dwyer — January 2000

CONTENTS

'There is *nothing* — absolutely nothing — half so much worth doing as simply messing about in boats.'

Kenneth Grahame, *The Wind in the Willows,* 1908

INTRODUCTION

My friend The Viking returned with me to the Shannon. His lot had been there over 1,000 years before, carrying on with plunder, pillage, and other activities! We were there with the two ladies in our lives enjoying good food, drink and the incredible experience of an inland waterways holiday.

Born in Cork, like many others who live near the coastline, I was brought up to think that to go out in a boat meant going out to sea. I have done my fair share of sailing over the years and yes, I have endured the discomforts associated with that activity.

Four years ago, as my youngest daughter Julie approached the end of her school career, I realised that Easter would be our last school holiday. I suggested that to celebrate the occasion we should do something different and proposed a short weekend cruise on the River Shannon from Portumna to Athlone and back.

The crew consisted of Julie and two of her friends, my wife Fiona and myself. We drove from Cork, collected our cruiser and discovered an activity in Ireland which we had never thought about before.

My own introduction to the inland waterways was at a time when I was putting the finishing touches to my first book, *IRELAND Our Island Home,* an aerial tour around Ireland's coastline. I started taking photographs for *IRELAND The Inner Island* in June 1997 and my photographic work was complete by November 1999.

I have chartered boats from five companies on different parts of our waterways and flown over most of them. I have tried to capture a sense of being on the waterways and, at the same time through my aerial photography, to give you a feeling for and knowledge of what they are like.

With the pressures of modern day life we need holidays which take us as far away from stress as possible. For me, I never believed that it was possible to relax to the level that I have on an inland waterway holiday.

IRELAND The Inner Island will take you on a journey through Ireland's inland waterways. Their variety is shown to you in this book and they await for you to enjoy them.

KEVIN DWYER **Cork — January 2000**

The Lee Navigation

Quietly hidden halfway along the south coast of Ireland is an inland waterway encompassing Cork Harbour, one of the largest natural harbours in the world.

The Lee Navigation travels north, past Roches Point, for a distance of 20km up to the Port of Cork.

The navigation will best be remembered by those who travelled with the City of Cork Steam Packet company from Fishguard in south Wales to Cork and on the *MV Innisfallen*. The beauty of the approach to Cork city was always spoken about. Fort Camden high to the west and Fort Carlyle high to the east guarded the entrance to Cork harbour. Straight ahead there were the fortifications on Spike Island.

Today, sailing up the navigation and between the two forts, you are tempted to head west up the Owenabue River and home of the Royal Cork Yacht Club, established in 1720 and the oldest in the world.

The modern world catches your eye when, on the western shoreline, you see the industries in Ringaskiddy, the oil refinery at Whitegate and the natural-gas-fired power station at Aghada. It is of course possible to ignore all of these and head off in a north-easterly direction away from the main navigation and up to the tranquillity of East Ferry.

The main channel of the Lee Navigation, having followed a northerly direction into the harbour, has to head due west past the town of Cobh with the magnificent St Colman's Cathedral looking down over the harbour.

Beyond Passage West, the Lee navigation follows a north-westerly direction up Lough Mahon and past Little Island, finally crossing over the Jack Lynch Tunnel and up to the City of Cork.

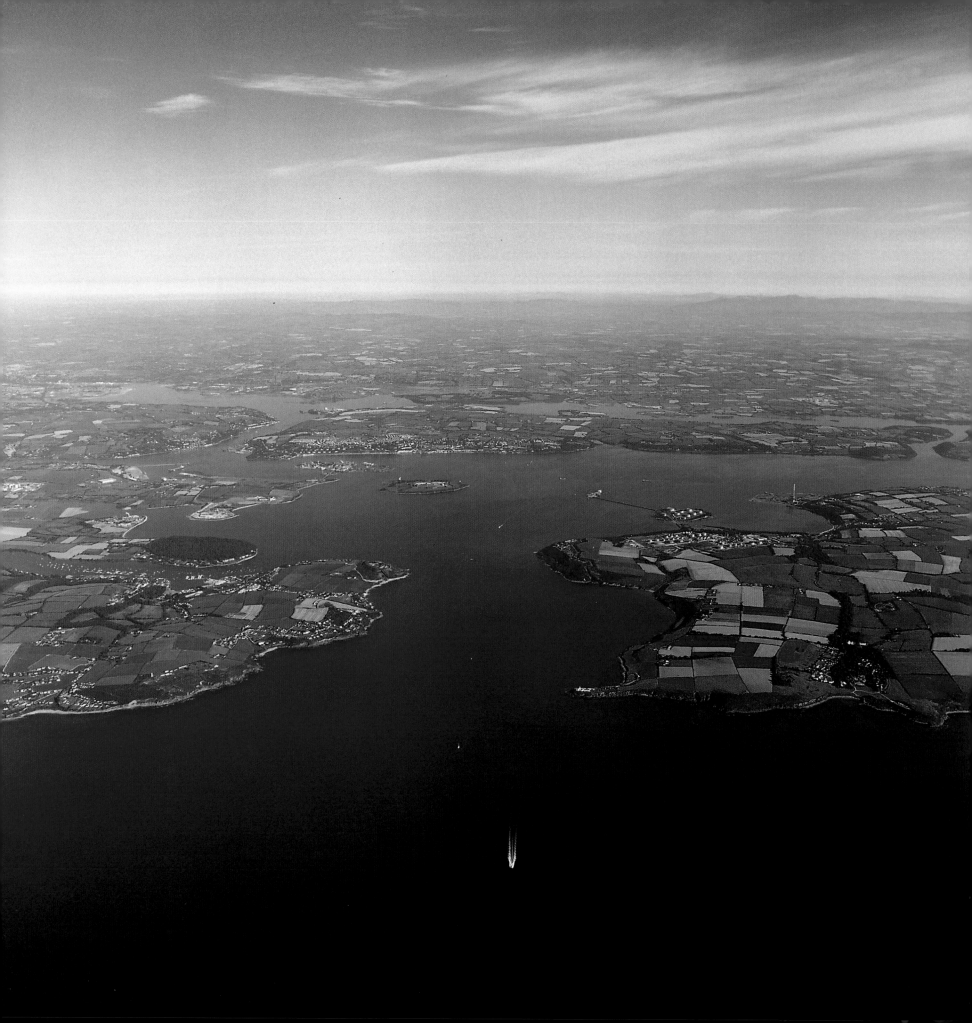

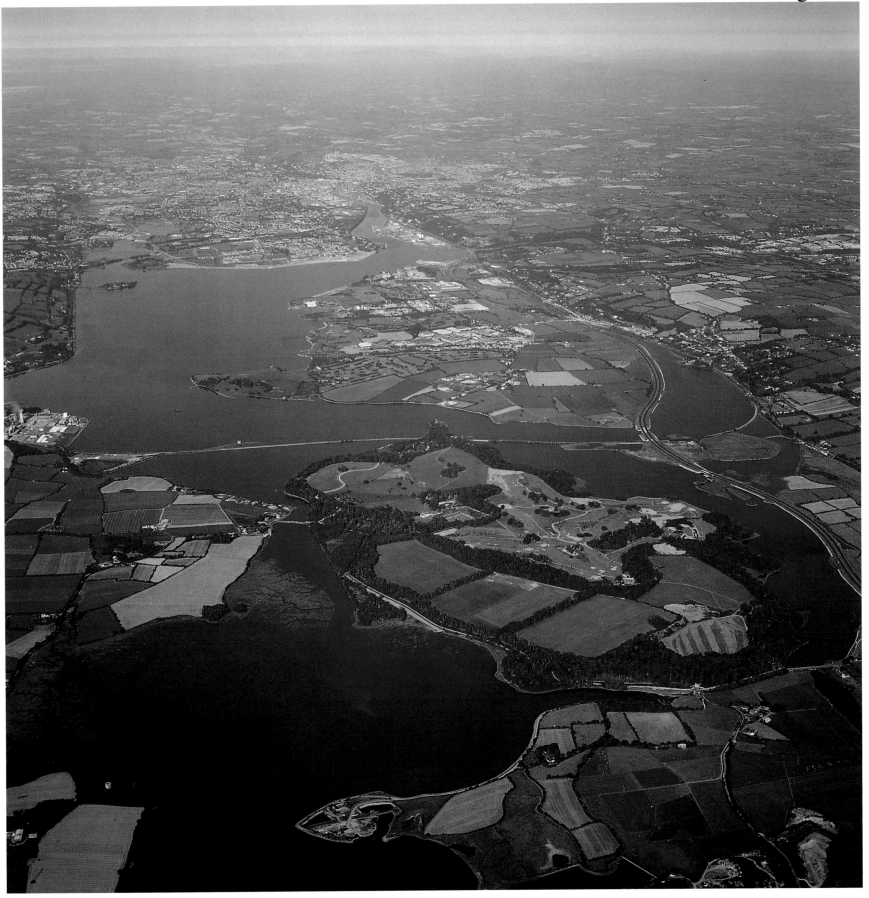

Facing page: Cork Harbour from 6,500 feet, with the Lee Navigation going in past Crosshaven, turning left between Spike Island and Cobh, then passing Haulbowline, Ringaskiddy and Monkstown on its way to Cork City. *Above:* The Navigation entering left, through Lough Mahon, with Little Island on the right and Fota Island in the foreground.

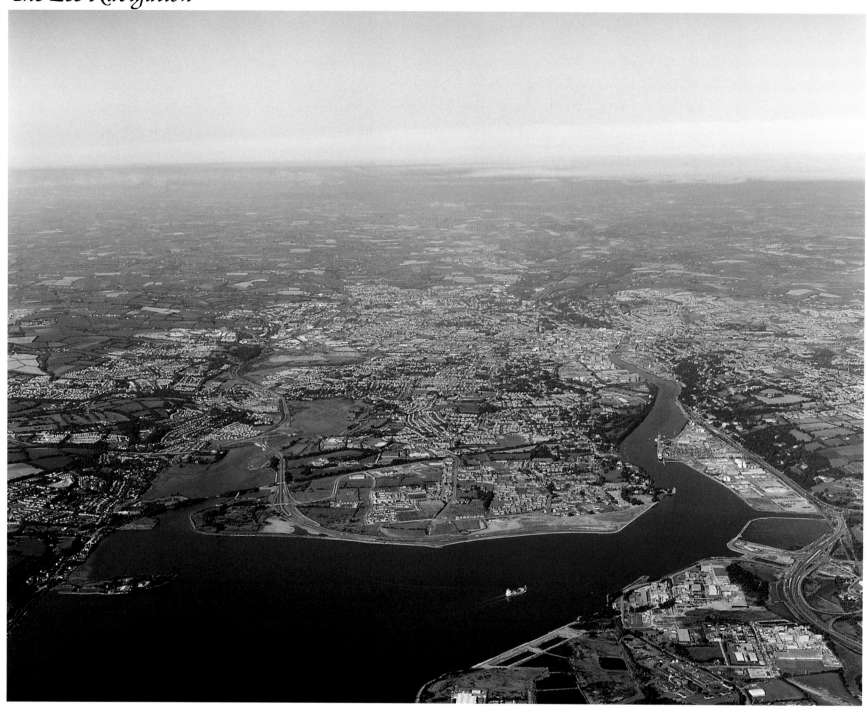

The River Lee passing to the right, over the Jack Lynch Tunnel, on its way to the Port of Cork. *Right:* A liner berthed at the Custom House Quay.

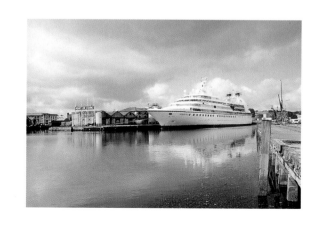

The Munster Blackwater Navigation

The River Blackwater is better known as an excellent salmon-fishing river rather than a navigation.

It is little known, but in the 1750s, at the planning stage for the Grand and Royal Canals, consideration was being given to create a navigation via the River Blackwater to connect coal pits near Kanturk in north County Cork to Youghal Port.

Entrance to the Munster Blackwater Navigation from the south coast of Ireland is past the town of Youghal, home for a while of Sir Francis Drake and location in the mid 1950s for part of the film *Moby Dick* starring Gregory Peck.

The Blackwater Navigation meanders north, past rather magnificent estates. Seventeen km inland, the Bride Navigation joins from the west with the main channel now heading north to the bridge at Cappoquin. Beyond the bridge and north of the riverbank, now in ruins, is Lismore Canal, which can be visited by road but sadly not by water.

At Cappoquin, the River Blackwater takes a 90º turn to the west and beyond the limits of its navigation passes Lismore, Ballyduff, Fermoy, Ballyhooley, Bridgestone Abbey, Killavullen and travels past Mallow 60km away.

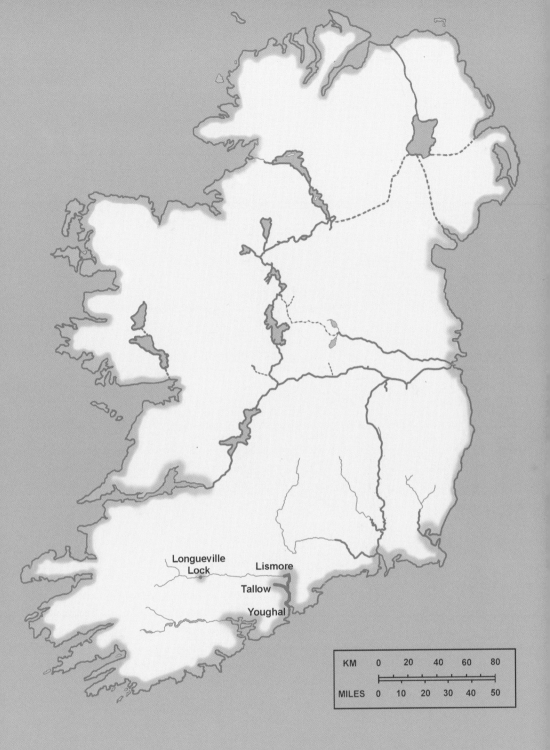

Today one travels towards Killarney out the Navigation Road and past Cork Racecourse Mallow. For a number of kilometres on the northern side of the road you can easily make out the growth on either side of what was the Mallow to Lombardstown Canal. Just beyond the turn for Ballyclough, you will see a railing on the right-hand side of the road. You can go over and examine Longueville Lock, constructed in 1759 on an eight-mile section of canal but never linked to Lismore and Youghal.

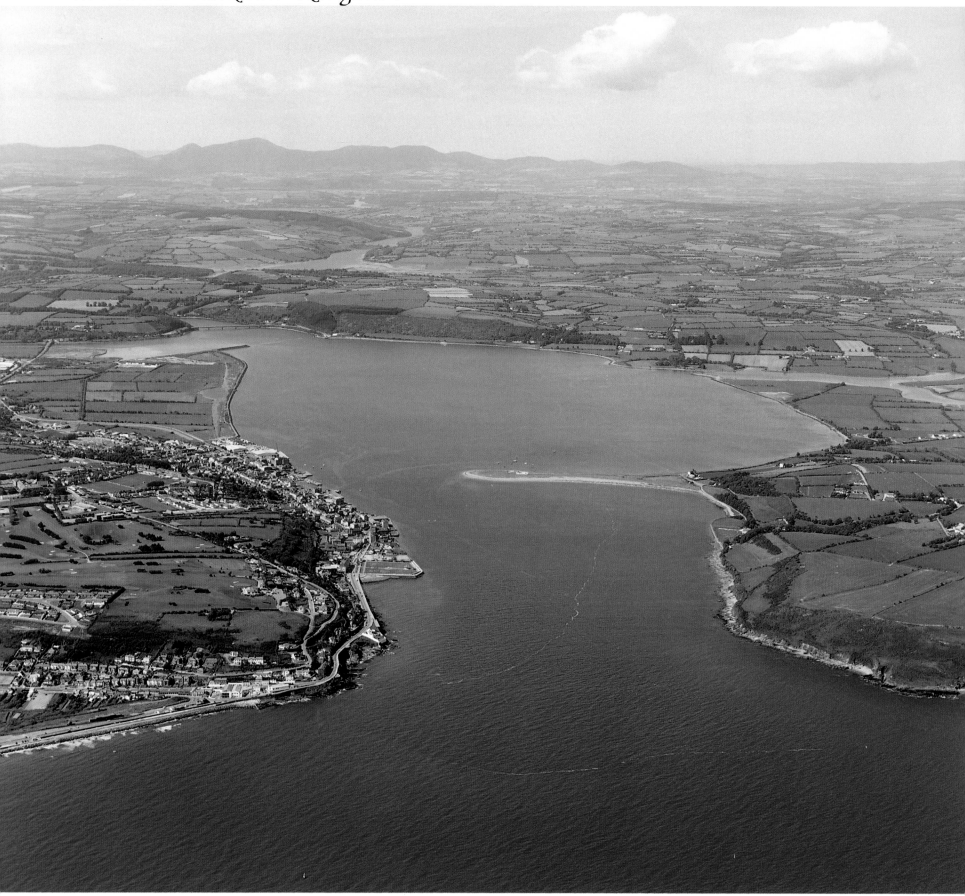

The town of Youghal in County Cork looking towards Waterford with the Munster
Blackwater Navigation travelling north towards the Knockmealdown Mountains.

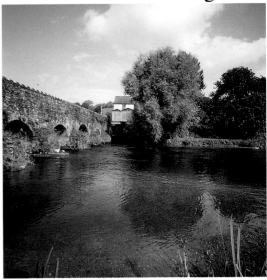

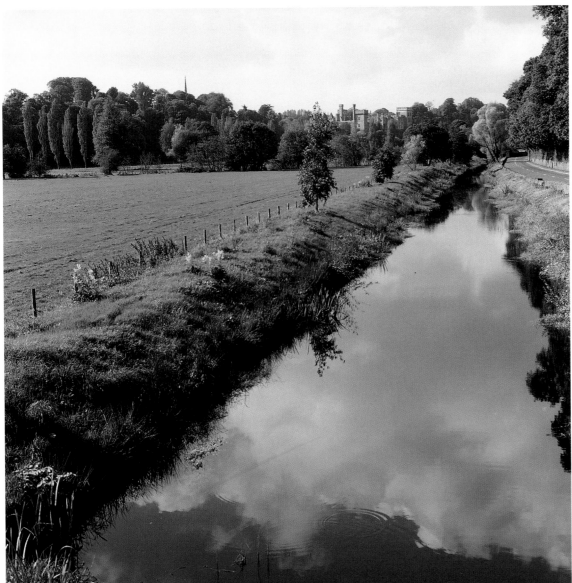

The Lismore Canal and Lismore Castle *(above)* with the end of the Bride Navigation at Tallow Bridge *(top right)* and Longueville Lock on the Lombardstown to Mallow Canal *(bottom right)*.

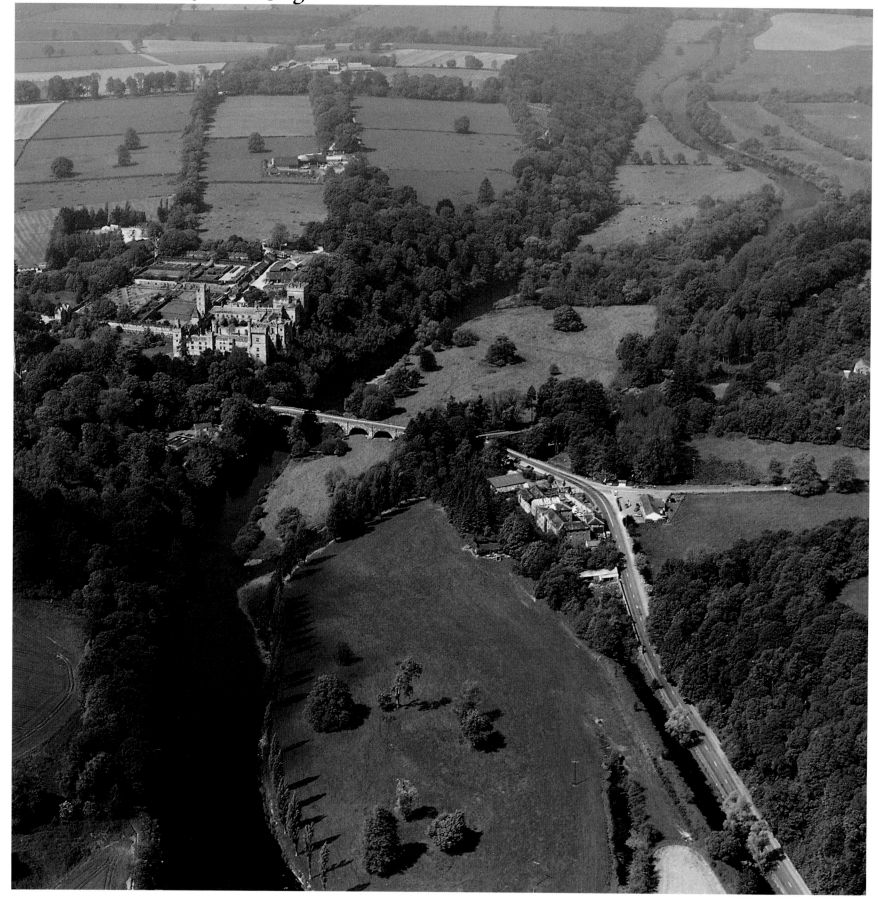

The River Blackwater passing Lismore Castle and Lismore Bridge
and, on the right, the Lismore Canal.

The Barrow Navigation

The Barrow is the most picturesque of Ireland's inland waterways. It travels from New Ross in County Wexford north through wooded valleys, past the Blackstairs and Wicklow mountains, up a gentle staircase of locks to the flat lands around Athy in County Kildare.

Entering from the south coast up the Barrow estuary, you arrive at Cheekpoint from where you can sail west up to the marina and facilities in Waterford city or onwards to Carrick-on-Suir.

Keeping to the main channel of the Barrow, you head north past the port and town of New Ross in County Wexford, just above which you again have an option to head west up the River Nore to Inistioge. From here the navigation to Kilkenny was never completed through lack of funding.

The Barrow Navigation, still tidal at this point, travels in a north-easterly direction towards St Mullins and the sea lock of the Barrow Navigation.

It is interesting to note that in 1537 an act of Parliament was passed referring to the River Barrow and other waters in the county of Kilkenny and stating that it was illegal to build a weir across the river to raise water levels for fishing or milling without putting a 'King's Gap' or flash lock into the weir to allow boats to pass.

The lower reaches of the Barrow Navigation from St Mullins to Graiguenamanagh and upwards towards Borris are very beautiful. Woodlands slope down the valley sides towards the edges of the river as the Blackstairs mountains look down on you from the east.

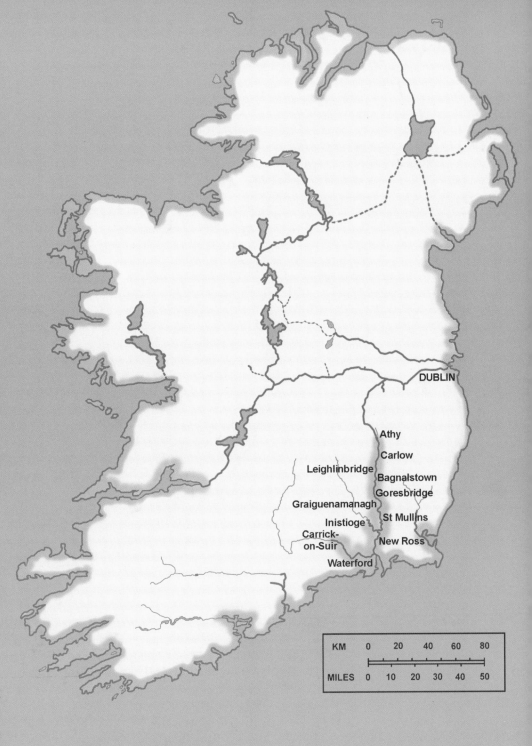

There are friendly lock-keepers who will assist you through many of the locks but as you progress along the river you will find that you have to do a little hard work yourself.

The Navigation passes Goresbridge and Bagnalstown. At Leighlinbridge you travel under the oldest bridge on the river dating back to 1320. Onwards and up past Milford you arrive at the town of Carlow. Here the land begins to flatten out and you come across the magnificent mill at Levistown which leads you into the longest cut of 3.2km on the navigation. Finally you arrive in the County Kildare town of Athy.

The Quay at Carrick-on-Suir, County Tipperary, and *(below)* the River Nore heading to the left and the Barrow Navigation heading up to the right.

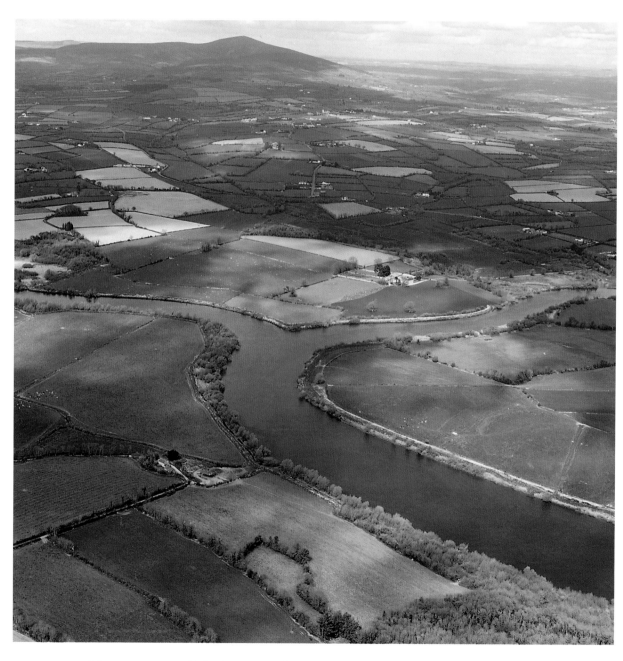

Facing page: Inistioge on the River Nore in County Kilkenny.

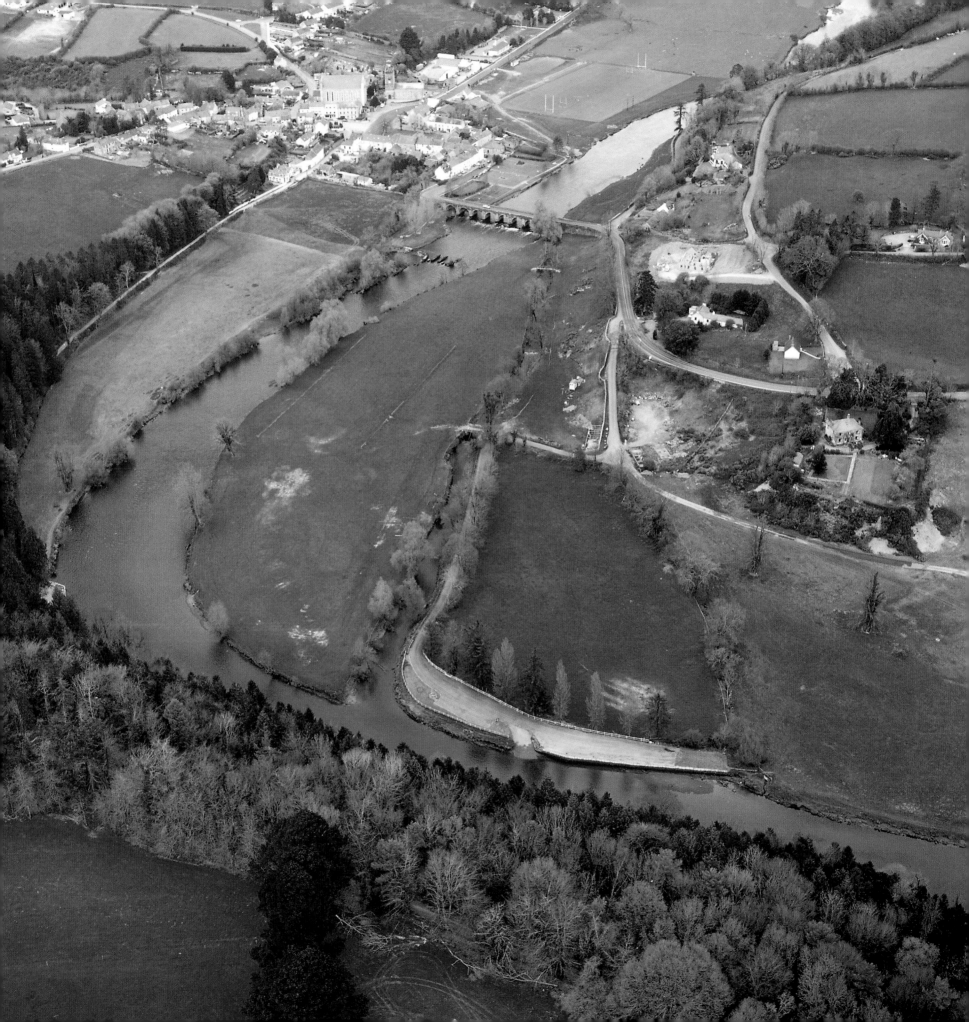

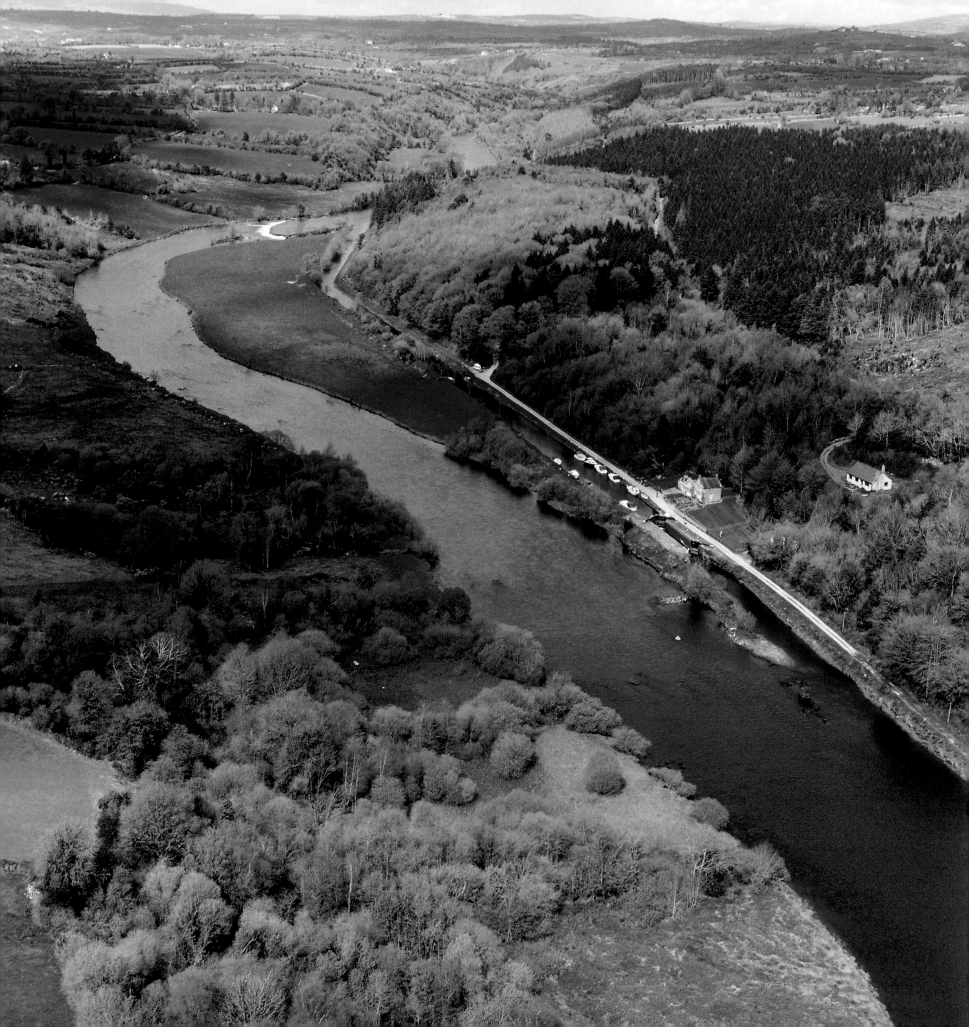

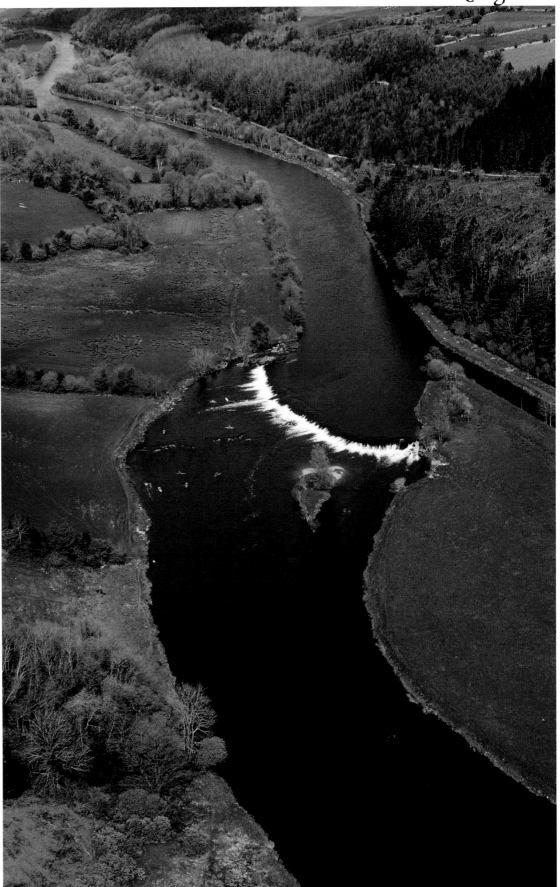

Facing page: The tidal lock at St Mullins and the start of the Barrow Navigation which stretches 64.7km to Athy.

Above: A narrowboat tied alongside the Barrow Way and *(right)* St Mullins Weir.

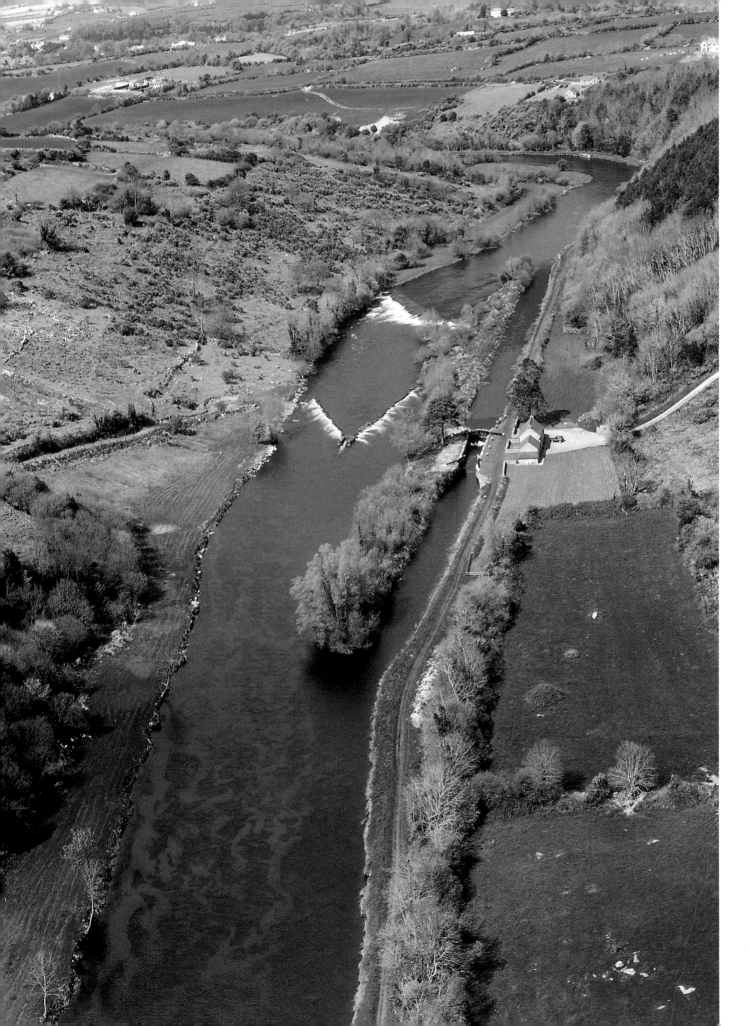

The Eel Weir next to Carricklead Lock.

Facing page:
The renovated lock-keeper's house.

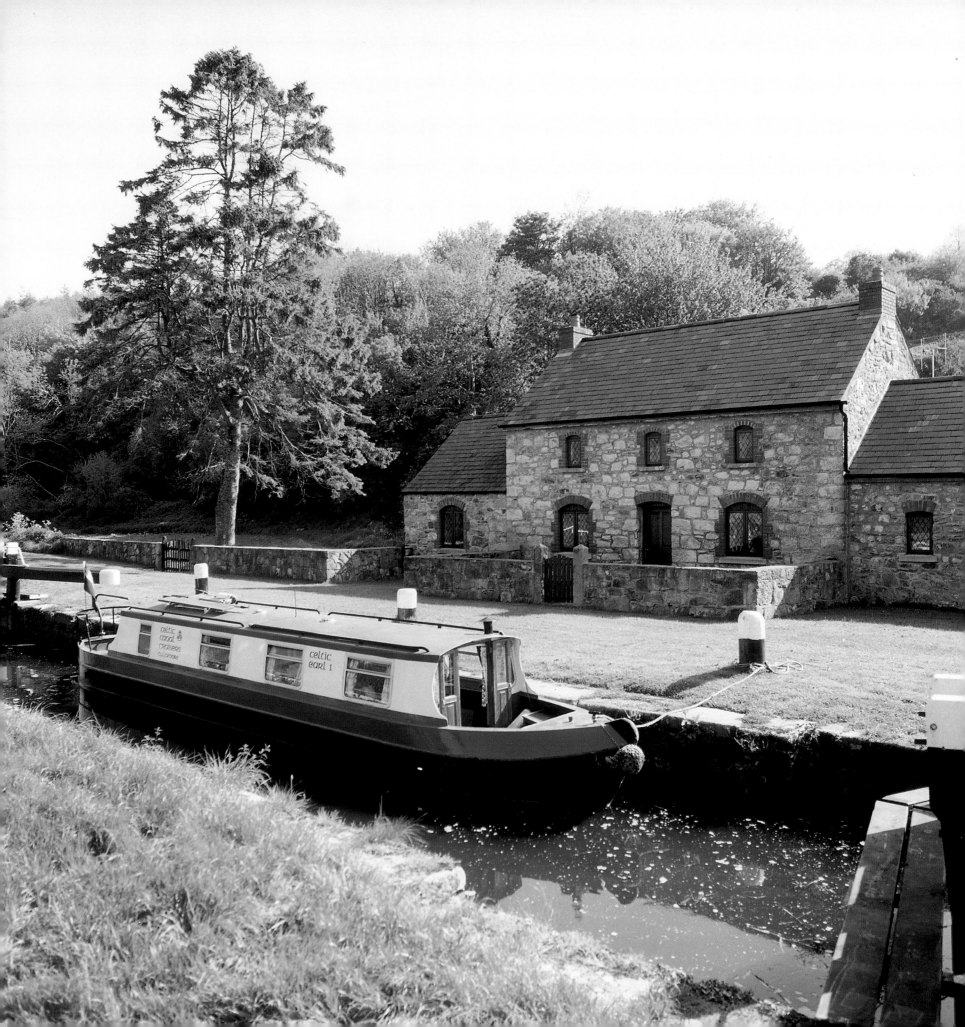

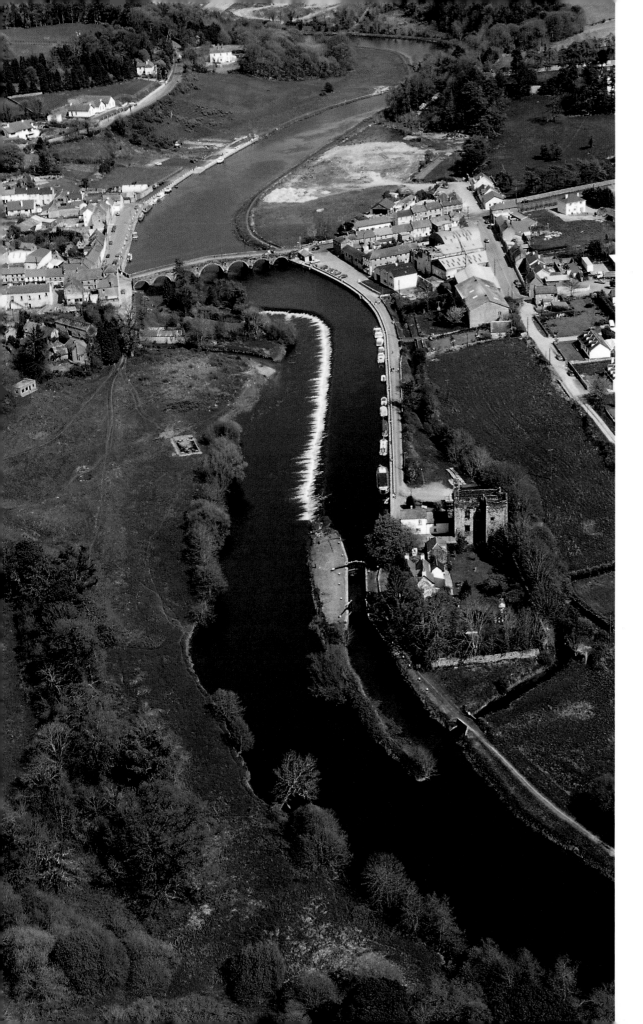

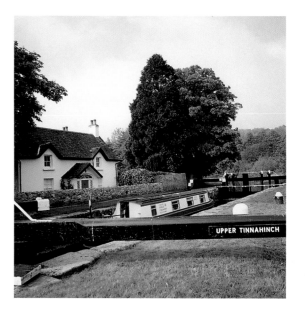

The long weir leading from Upper Tinnahinch Lock to Graiguenamanagh Bridge which was built in 1798, and *(above)* Upper Tinnahinch Lock.

Facing page: Looking over Graiguenamanagh Weir towards Brandon Hill.

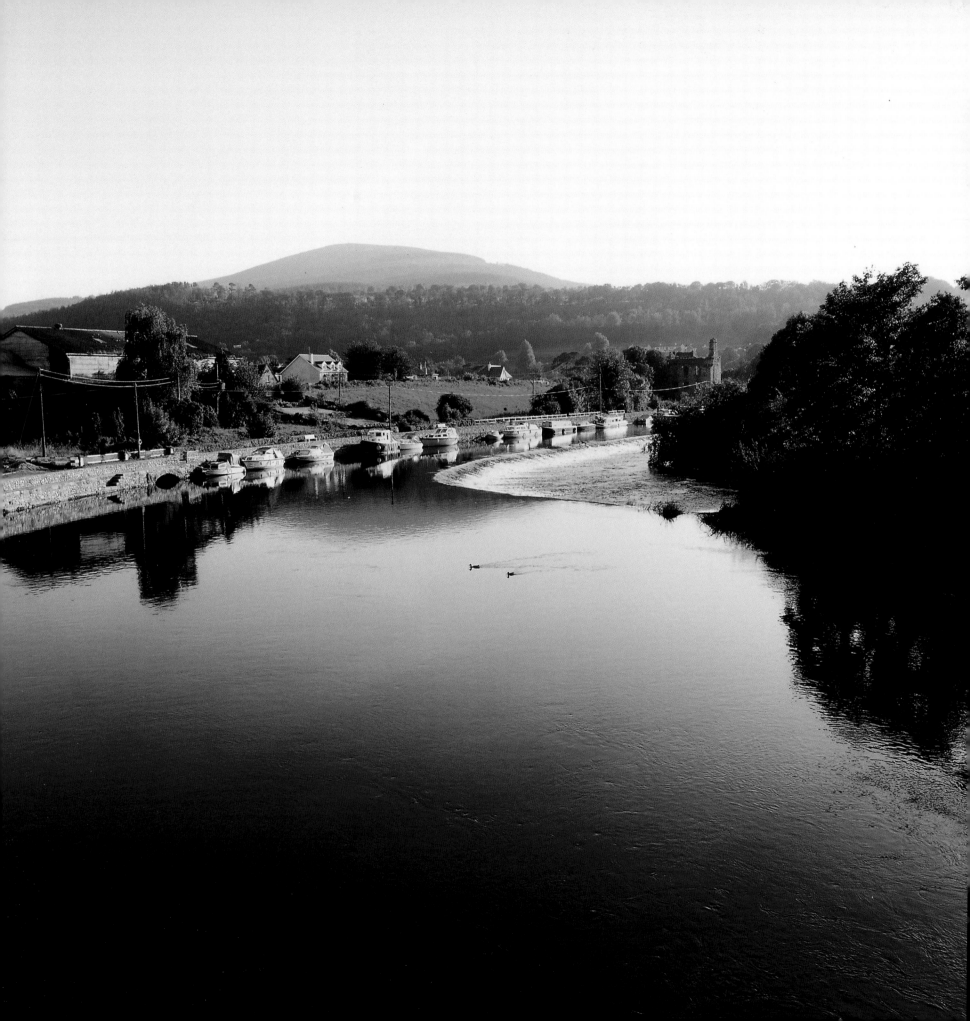

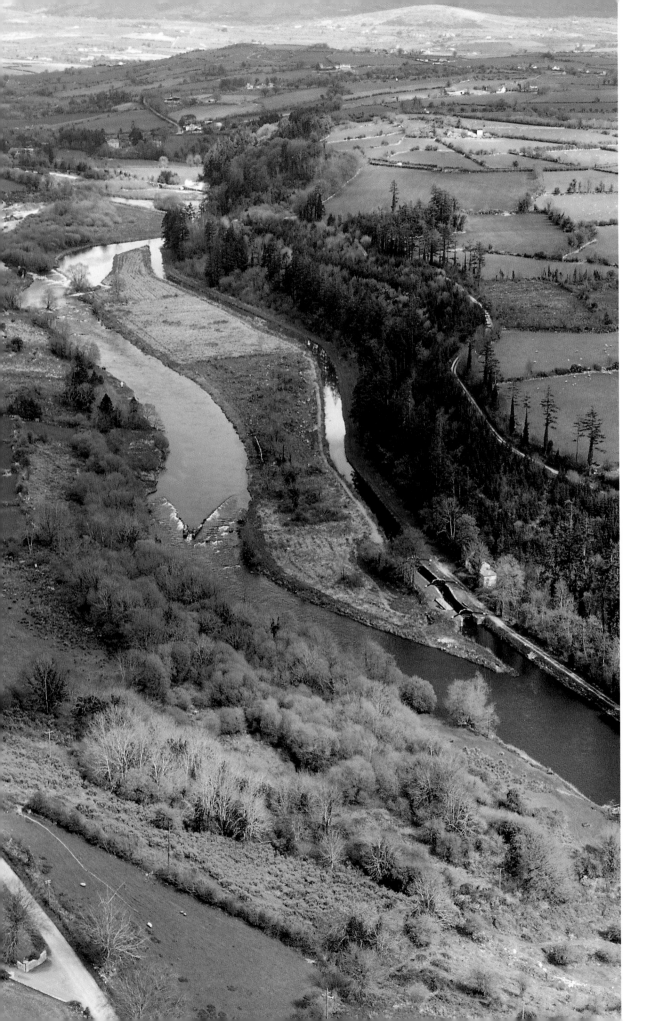

The double lock at Ballykeenan, 2.41km north of Graiguenamanagh and *(above)* three narrowboats at Ballykeenan.

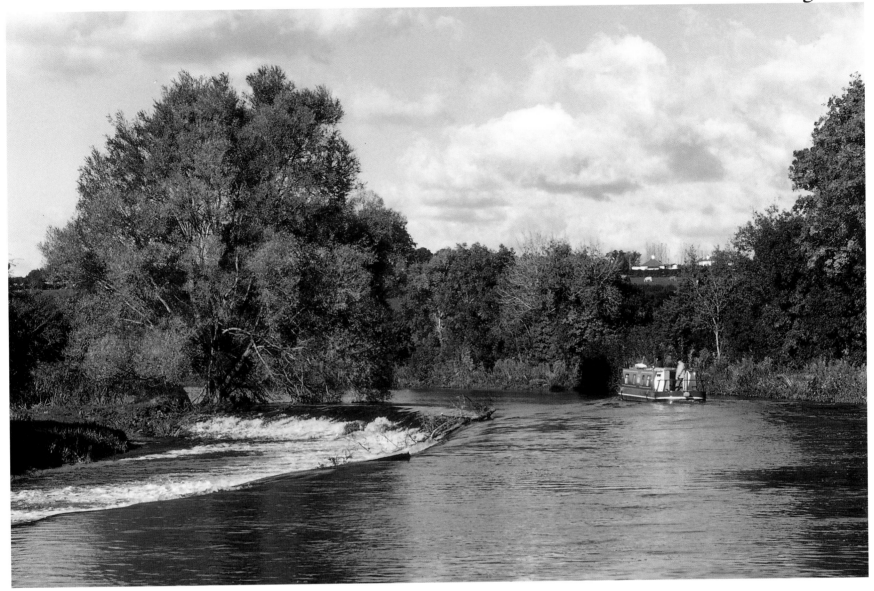

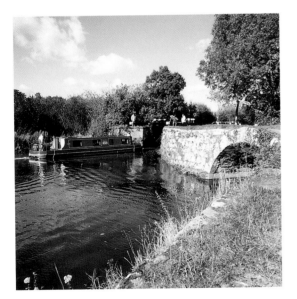
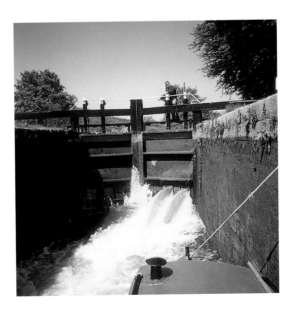
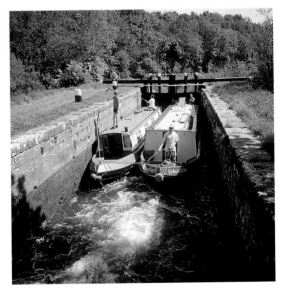

A narrowboat passing Clashganna Weir and *(below)* navigating a Barrow lock.

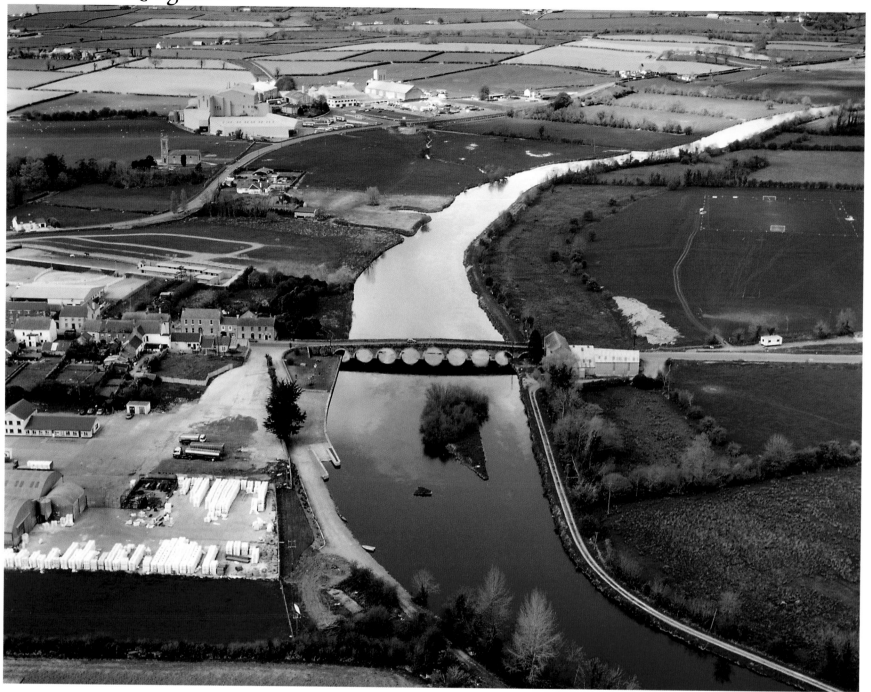

Goresbridge in County Kilkenny with an excellent quay wall and slip. The bridge leads over to County Carlow.

Facing page: The navigation channel marked on the railway bridge south of Bagnalstown. Keep the red marker to port (left-hand side) and black marker to starboard (right-hand side) going upriver.

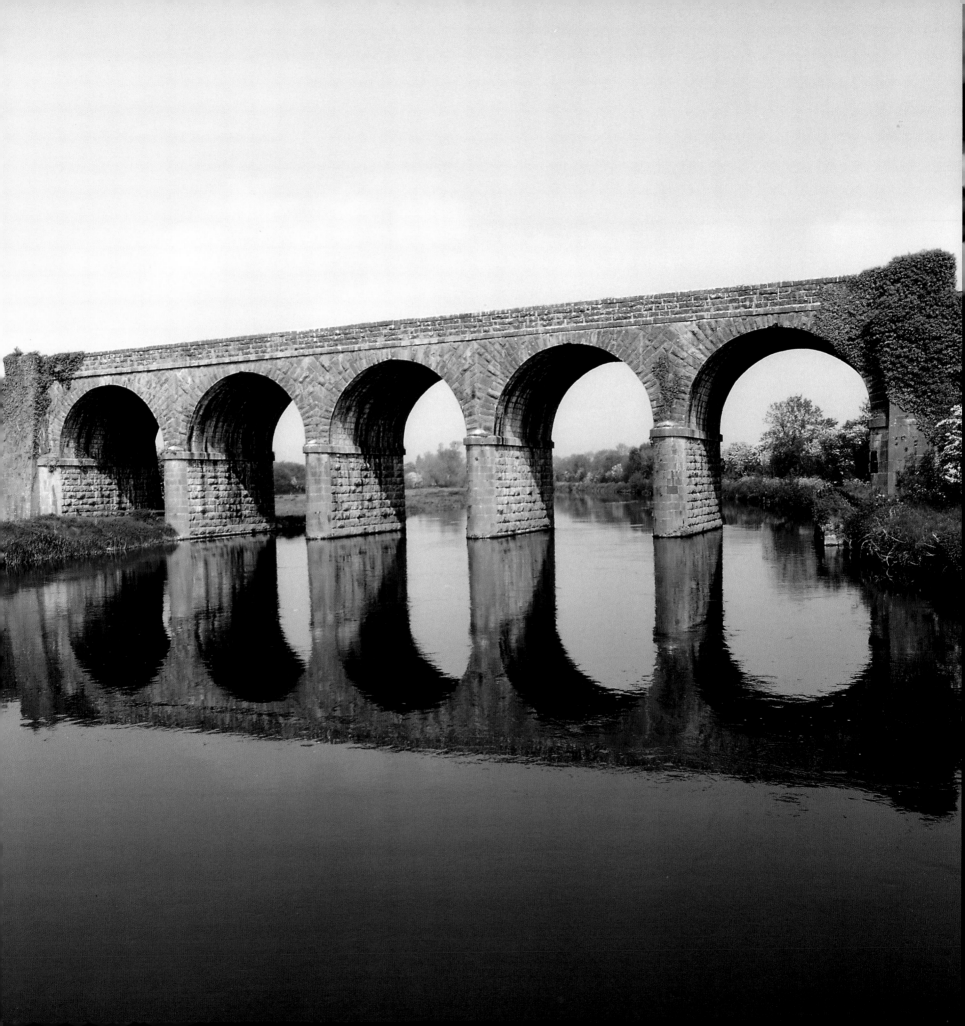

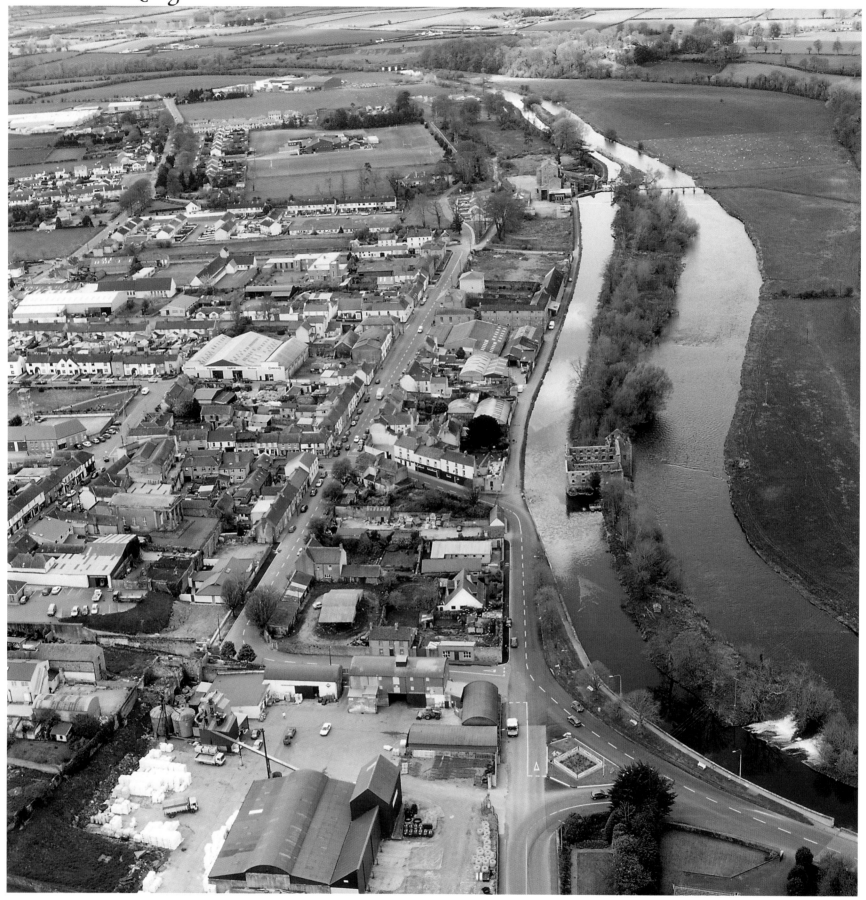

Looking south over Bagnalstown with the cut and river forming the edge of the town.
The distance to Athy is 33.9km.

Heading towards perfect reflections in Rathellin Cut between Bagnalstown and Leighlinbridge.

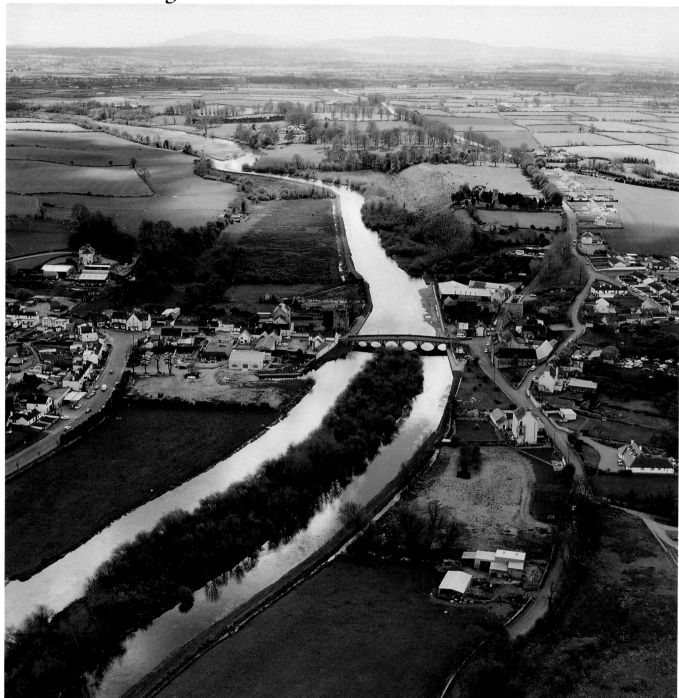

Looking south over Leighlinbridge, the oldest bridge on the river built in 1320 and widened in 1789, with an old milestone on the riverside. *Facing page:* The old and the new, Rathvindon Lock and Weir with the N9 Waterford to Dublin road passing over Cardinal Moran Bridge.

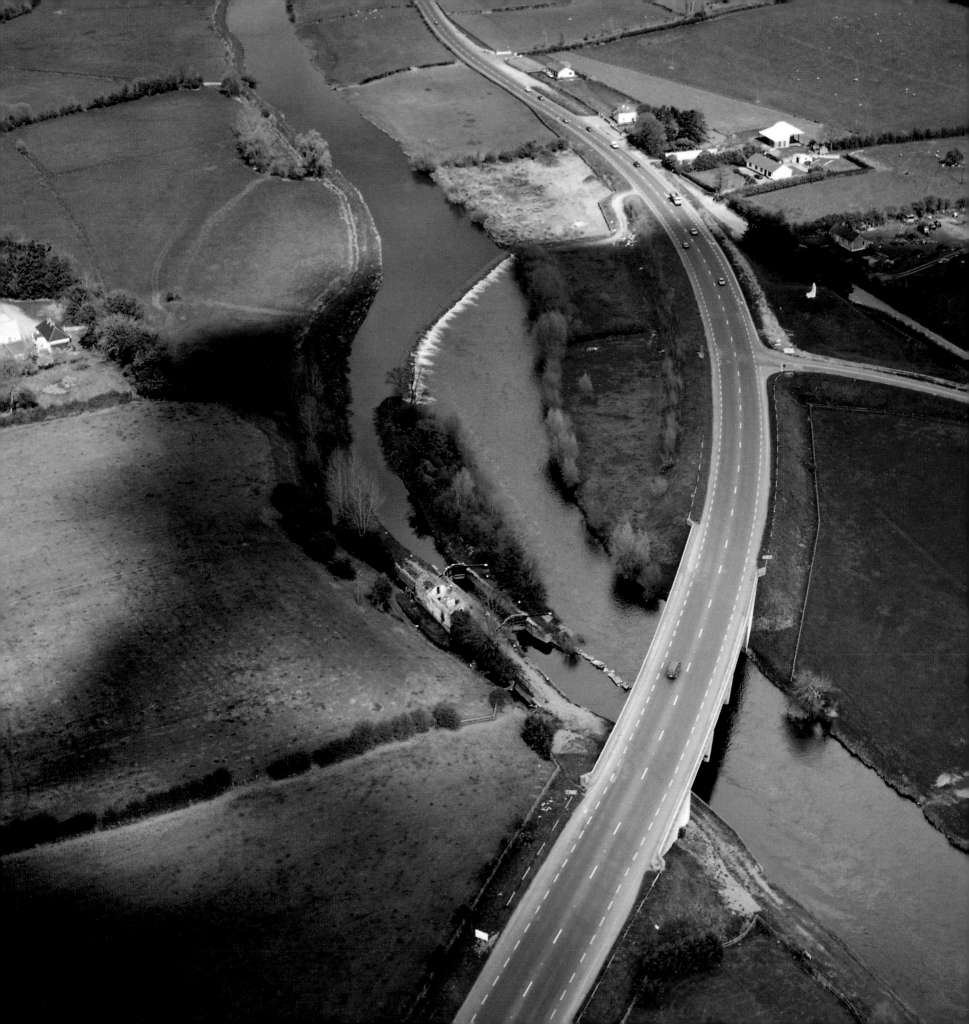

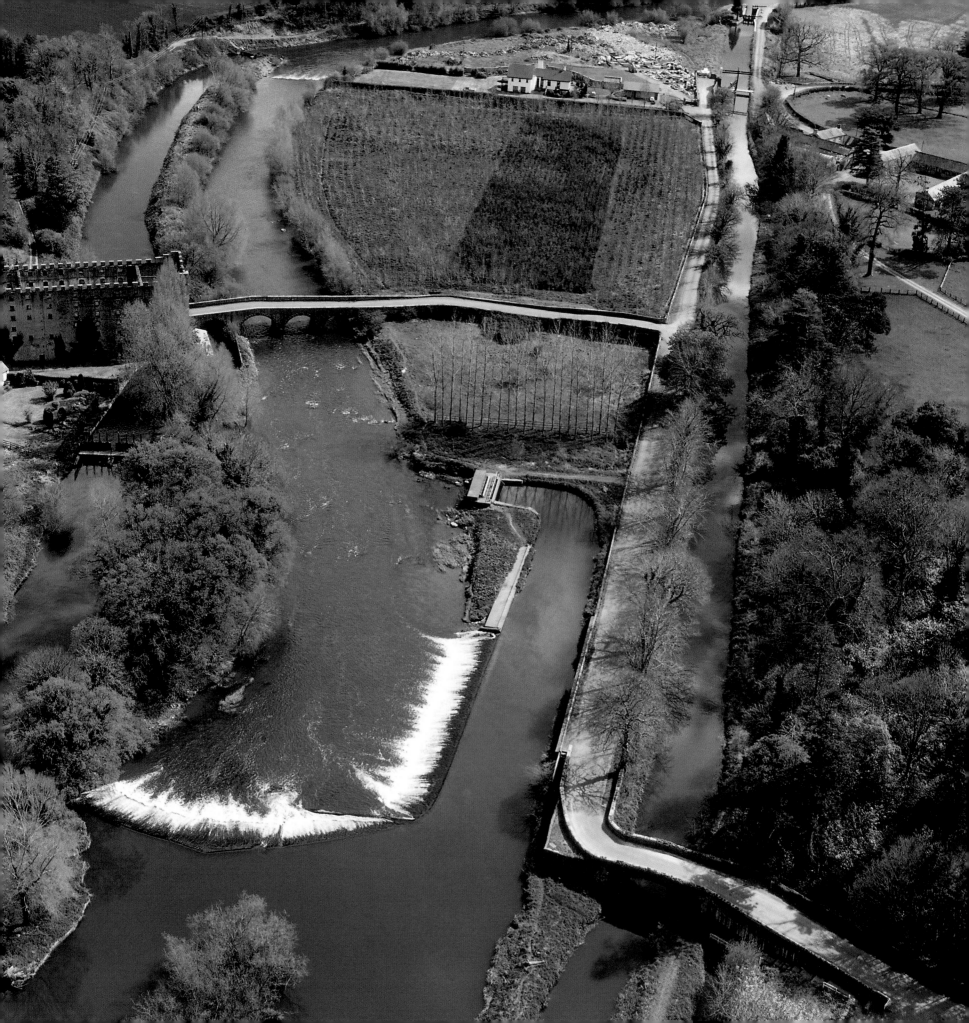

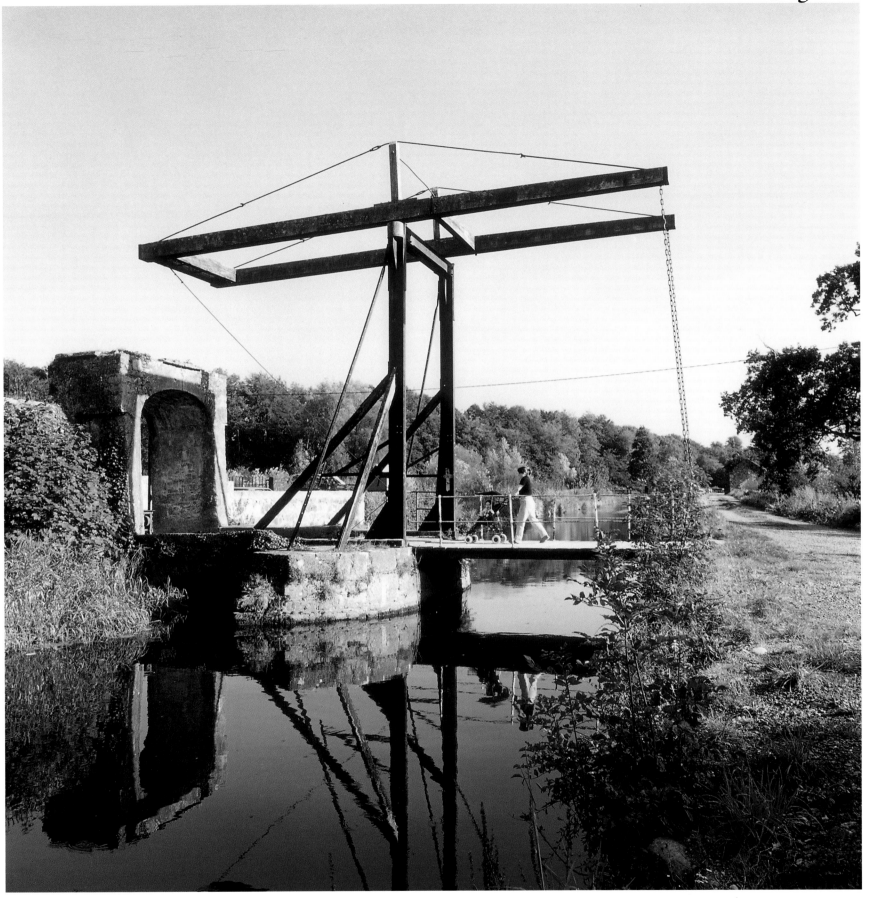

Facing page: The weir at Milford, County Carlow, leading to Strong Stream Mill.
The Barrow Navigation just above Milford Lock is on the right-hand side.
Above: The bascule bridge at Milford in September 1997.

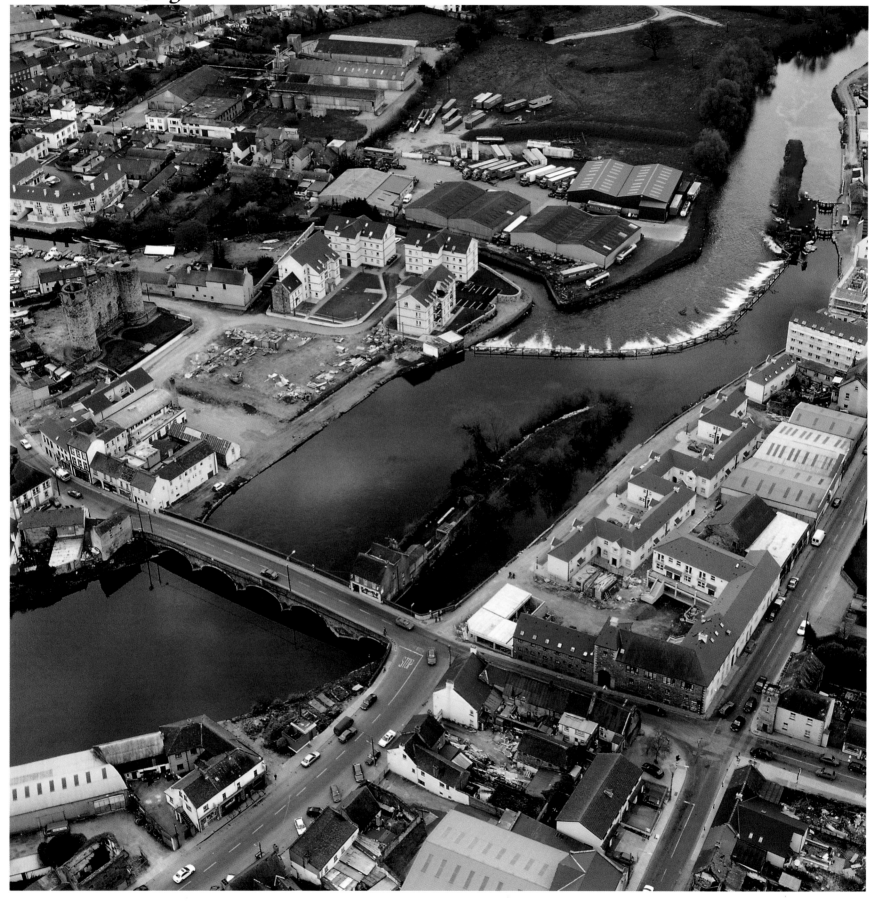

The castle façade overlooking the Barrow Navigation in Carlow town, where the bridge has a clearance of only 2.5m, the lowest on the Barrow Navigation. The distance to Athy is 18.7km.

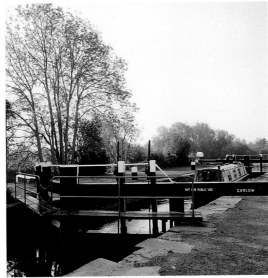

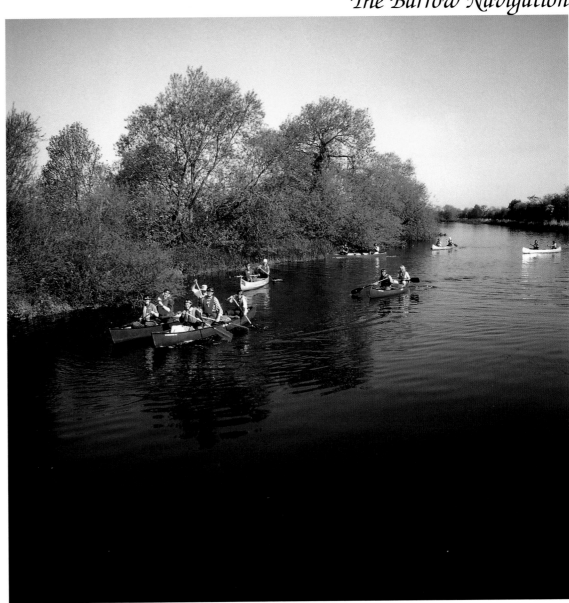

Carlow Lock in the early morning *(top left)* and *(bottom left)* tranquillity near Bestfield.

A group from Camphill Communities of Ireland on their annual trip in 1998, down the Barrow from Maganey in County Kildare to St Mullins in the southern tip of County Carlow.

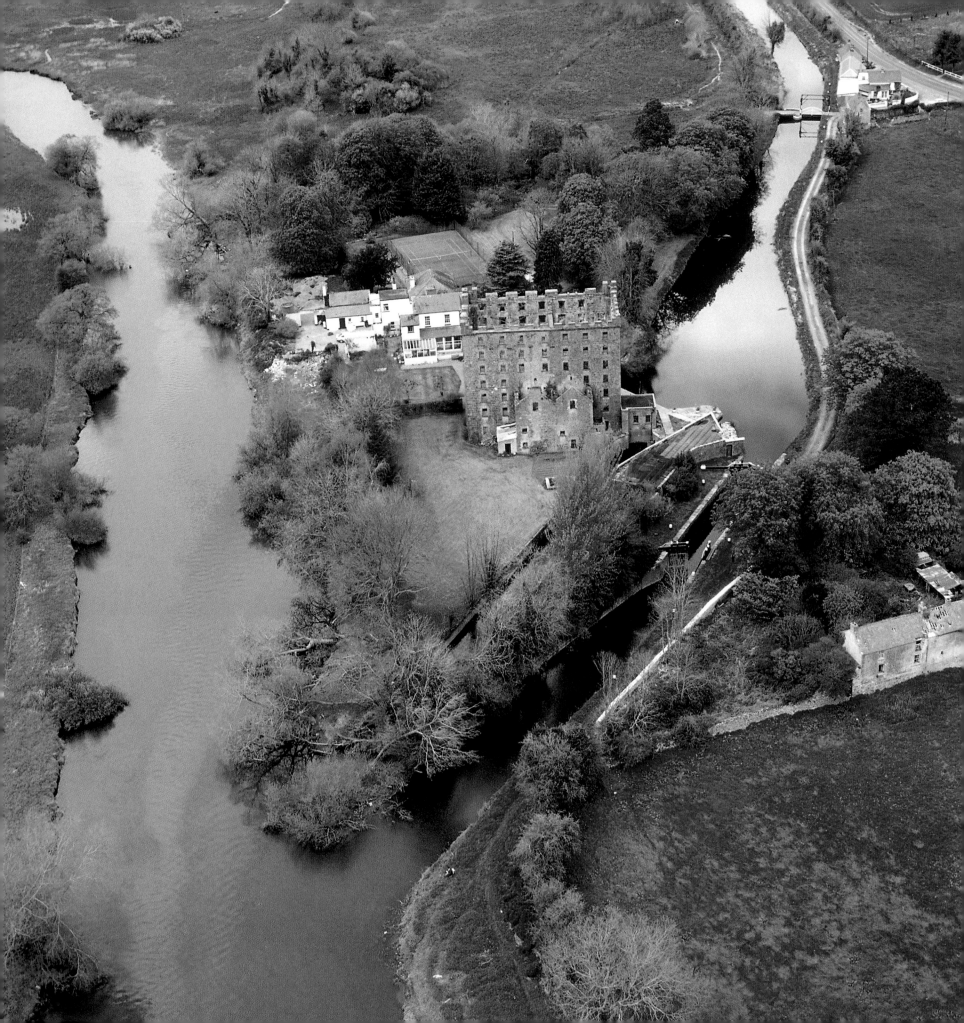

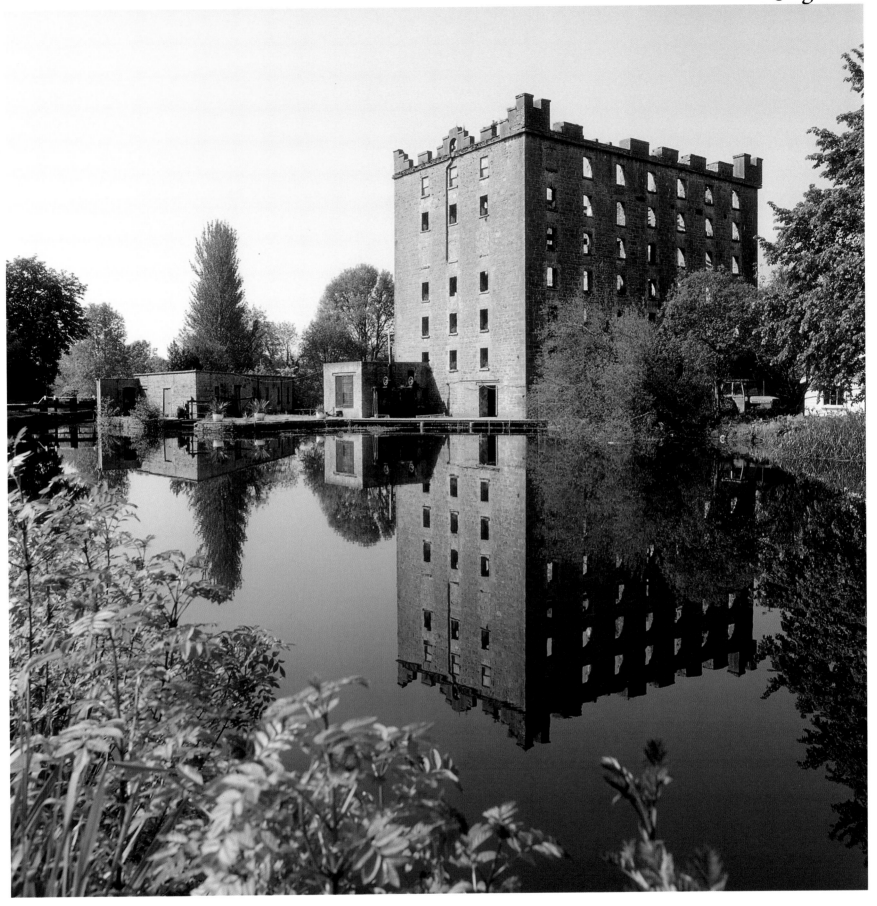

Facing page: Levistown Lock in County Kildare, leading towards Levistown Cut which is the longest on the navigation extending for 3.2km. The lifting bridge can be seen in the distance. *Above:* The ruins of Levistown Mill.

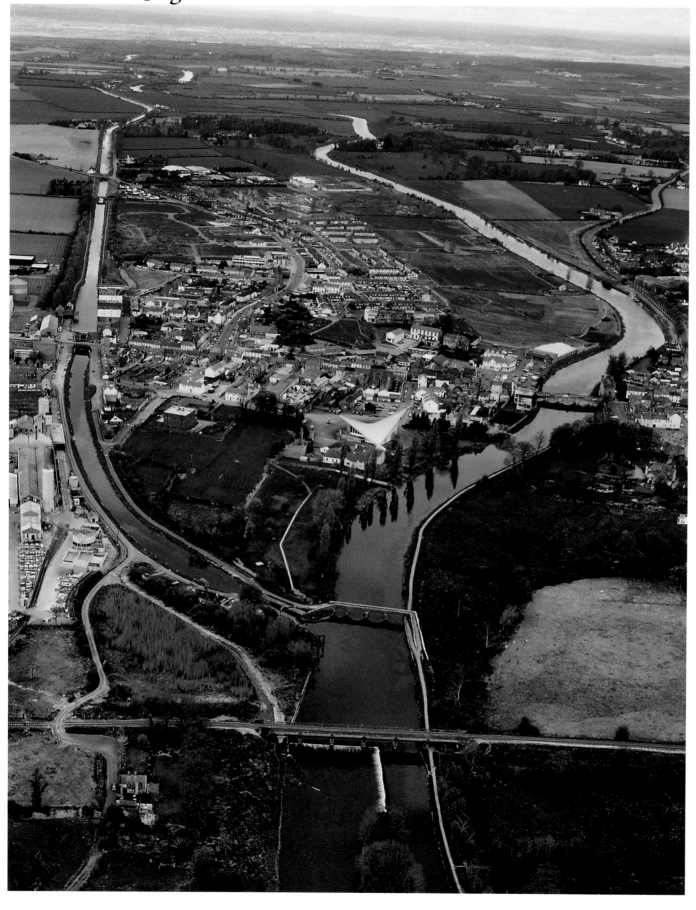

The River Barrow heading to the right under Horse Bridge and to the end of the navigation at Athy, County Kildare.

Facing page: The contrast between the modern Dominican Church in Athy, the town bridge (built in 1796 but with records of a bridge dating back to 1413) and White's Castle built in 1506.

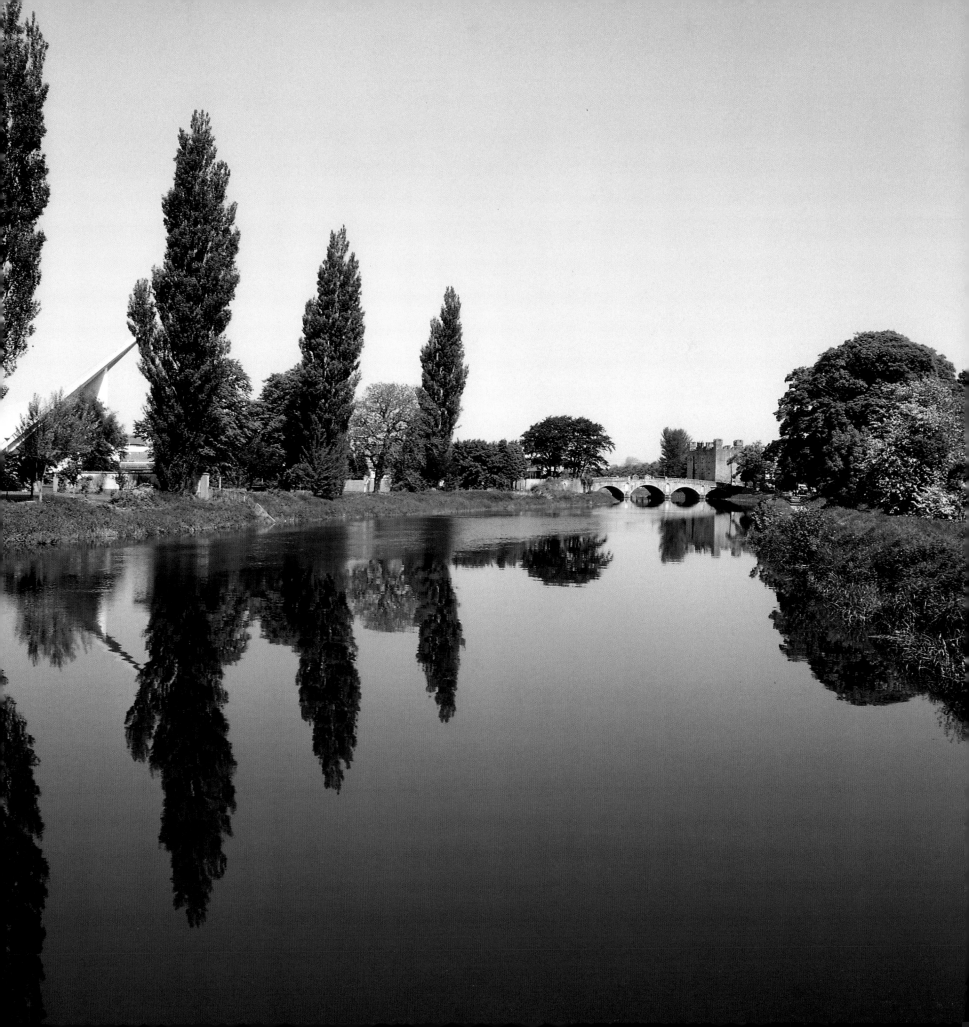

The Grand Canal

The Grand Canal was a very important artery for trade from Dublin west to the River Shannon. It consists of a number of different branches and lines which link it with towns along its route and also the adjoining waterways. Work commenced on the Grand Canal Scheme in 1756.

We enter this navigation from Athy at the southern end of the Barrow Line of the Grand Canal. This branch of the canal is 45.6km long and was completed in 1791.

Just beyond Athy and having travelled up through locks 28 to 26 you enter a 21-kilometre flat stretch of waterway. You approach Monasterevin where there is a beautiful aqueduct over the River Barrow. The final part of this navigation brings you past Rathangan to the Main Line of the Grand Canal at Lowtown.

The main source of water for the Grand Canal System is the Milltown Feeder which flows into it above Lock 19 and close to Lowtown. The Milltown Feeder is 13km in length and not very wide. Pluckerstown Bridge has a height clearance of only 1.8m.

Navigation up the feeder is only possible for smaller craft and some of the narrowboats. If you can make the journey it is well worth while. At Pollardstown Fen you experience the type of landscape and vegetation which was widespread in Ireland almost 5,000 years ago.

To continue our journey on the Grand Canal, we have to transport ourselves to Dublin on the east coast of Ireland where we enter through the sea locks from the River Liffey into the Ringsend Basin. From here the canal tracks in a curve along the Circular Line, joins the Main Line and heads west towards the Shannon.

You can take an excursion south to Naas down the Naas Branch. You travel past the head of the Barrow Line at Lowtown, 10.9km later.

Descending beyond Lock 20 you enter a 29.8km flat stretch of the Grand Canal. This will lead you past the Edenderry Branch to the north and onwards to the town of Tullamore. This is the homeland of the Royal and Ancient Bog of Allen Yacht Club.

The end of the Main Line is at Shannon Harbour where, 131km from Dublin, the Grand Canal descends through locks 35 and 36 to the River Shannon.

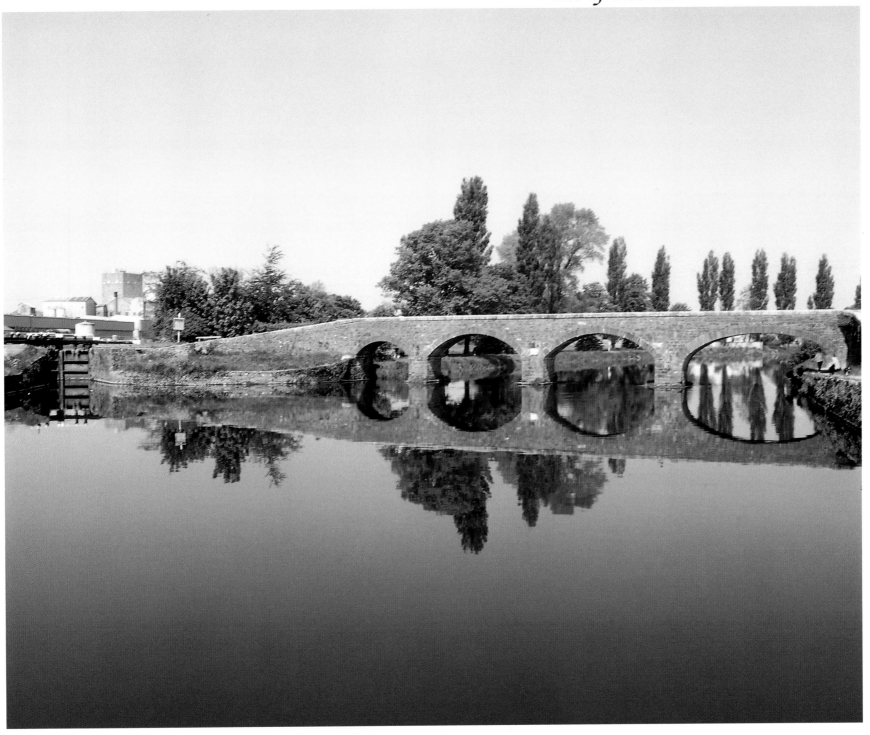

The entrance to the Barrow Line at Lock 28 in Athy with a distance of 45.6km to the Main Line of the Grand Canal at Lowtown. Horse Bridge over the River Barrow reflects across the picture.

Vicarstown, County Laois, on a 21-kilometre flat stretch of
the Barrow Line between Locks 26 and 25.

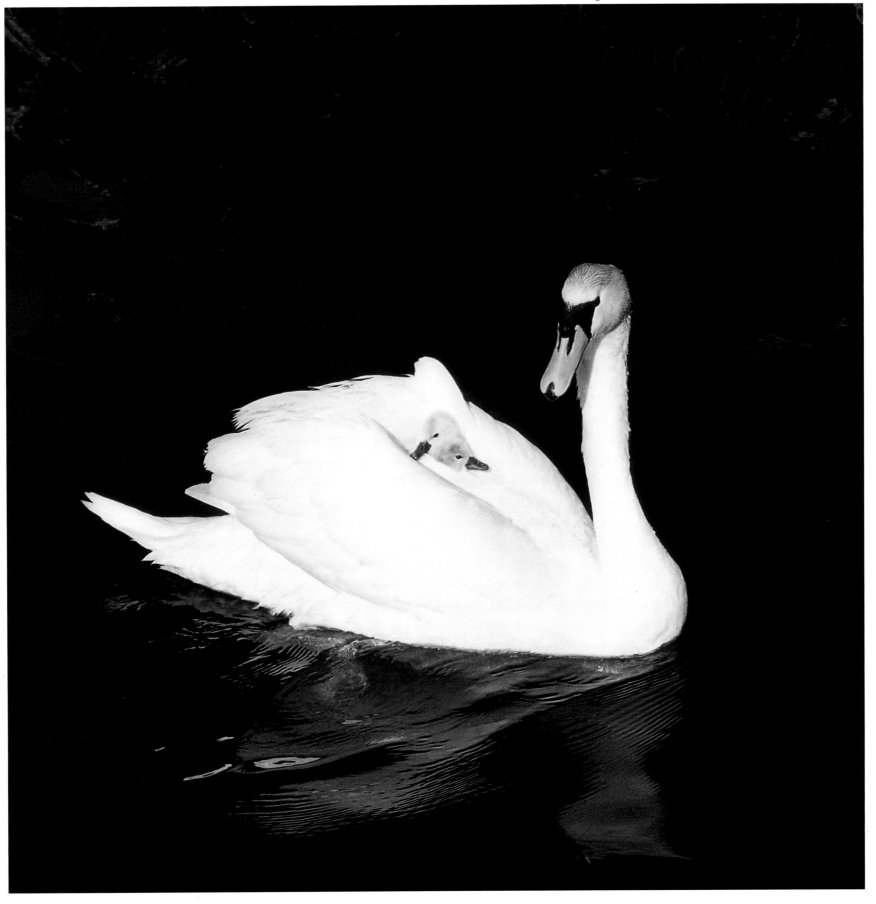

A swan and her cygnets on the Barrow Line between
Vicarstown and Monasterevin. *(Photograph Fiona Dwyer)*

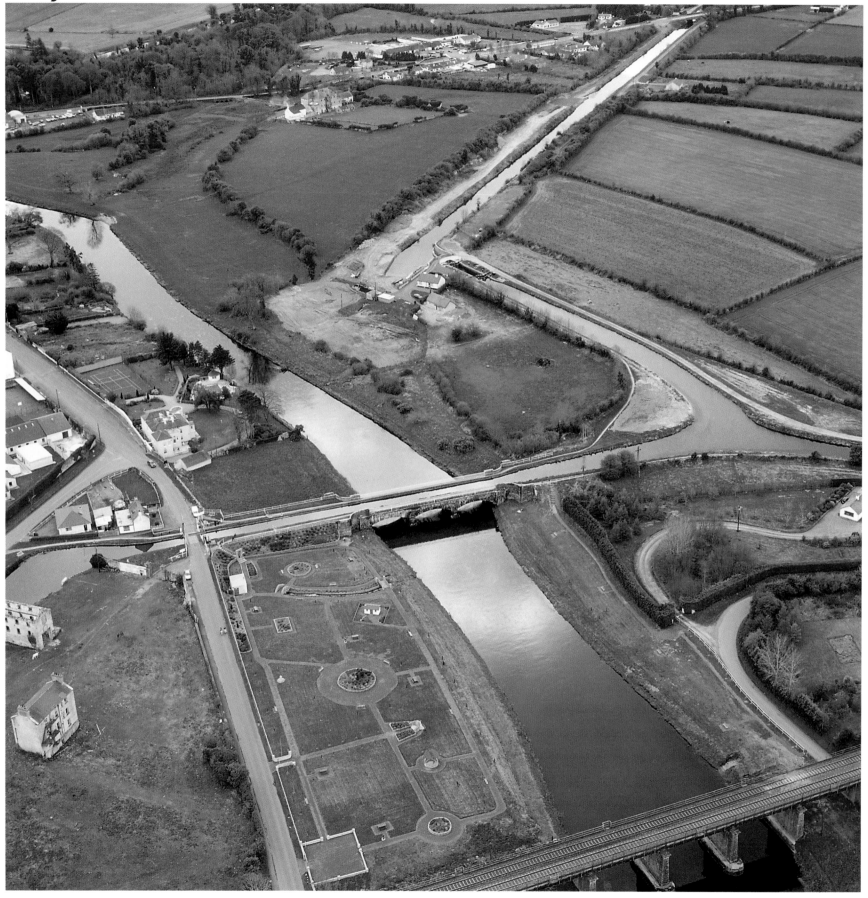

The canal from the top right heading in towards Lock 26, past the old Mountmellick Branch and crossing by aqueduct over the River Barrow in Monasterevin.

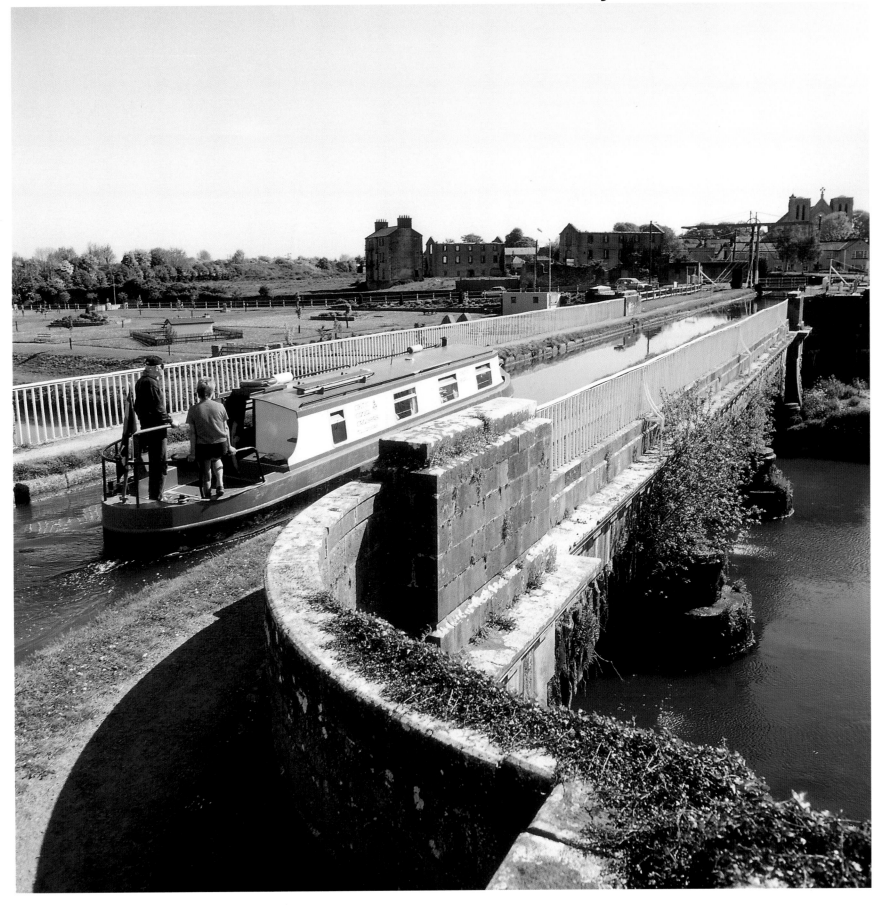

A narrowboat sailing over the aqueduct in Monasterevin which was completed in the 1820s.

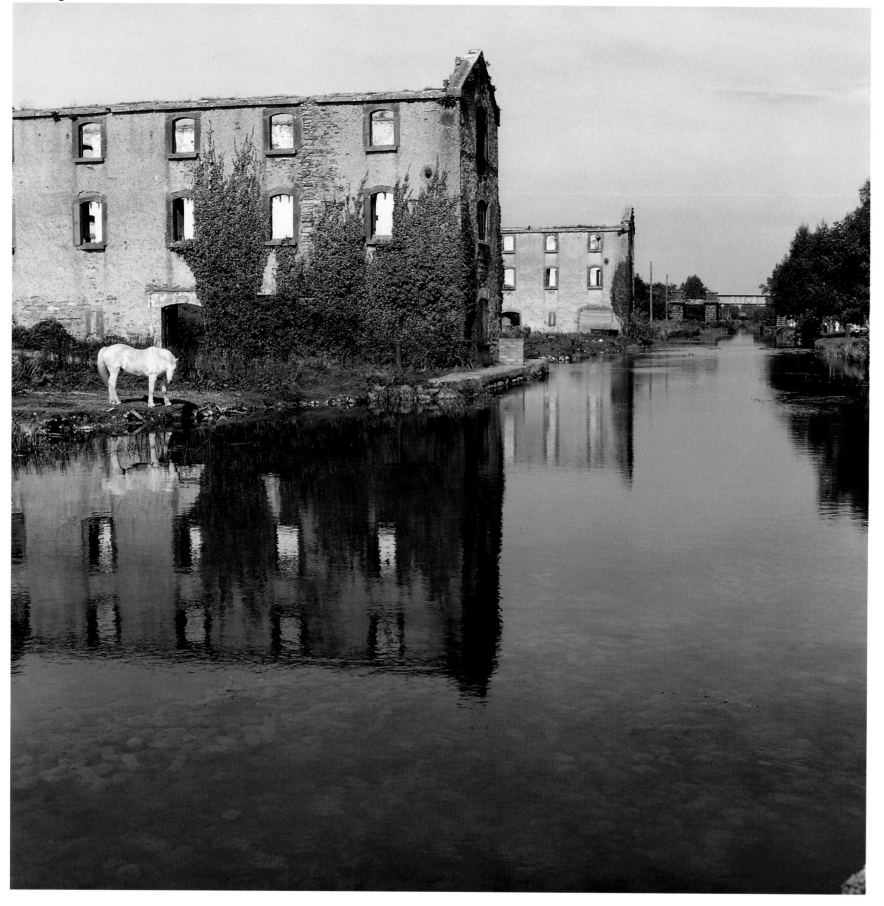

Old warehouses by the canal in Monasterevin, County Kildare.

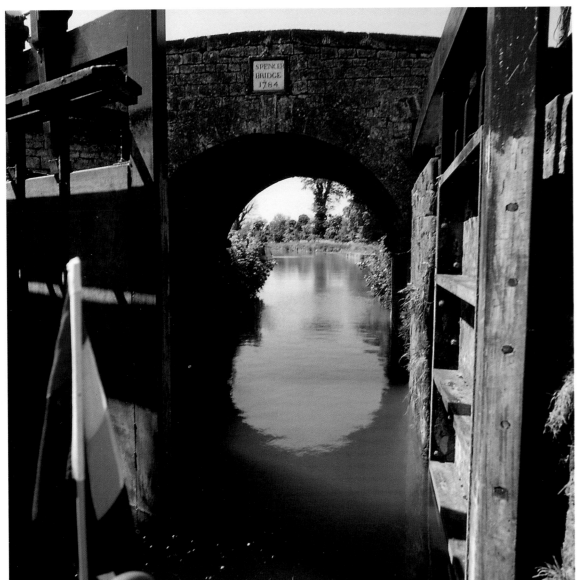

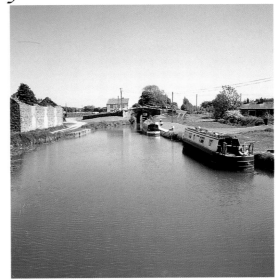

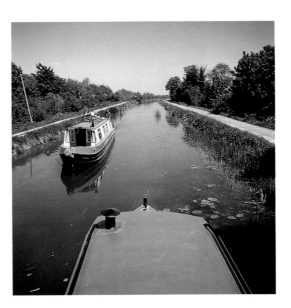

Spencer Bridge built in 1784, with *(top right)* the cruiser base in Rathangan and *(bottom right)* two narrowboats passing on the canal. Keep to the right!

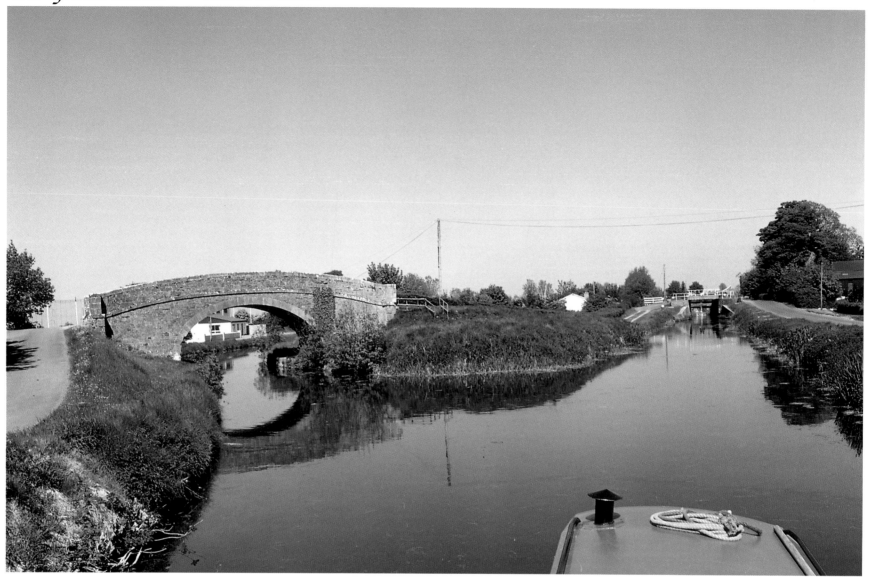

The divide between the New and Old Barrow Lines.

The approach towards the Milltown Feeder *(left)* which has the inscription 'Huband Bridge 1788' on one side and 'Greene Bridge 1799' on the other and *(right)* Pluckerstown Bridge on the Milltown Feeder, with clearance of only 1.8m!

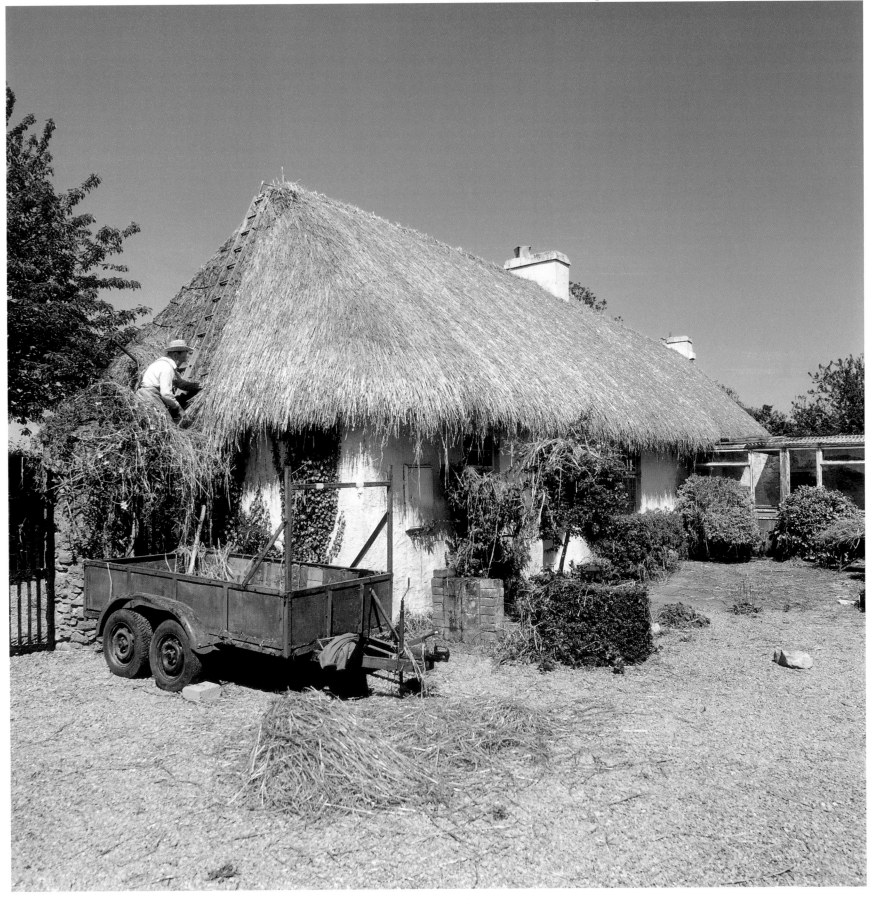

Old skills still live with a thatcher working on a house between Locks 21 and 20.

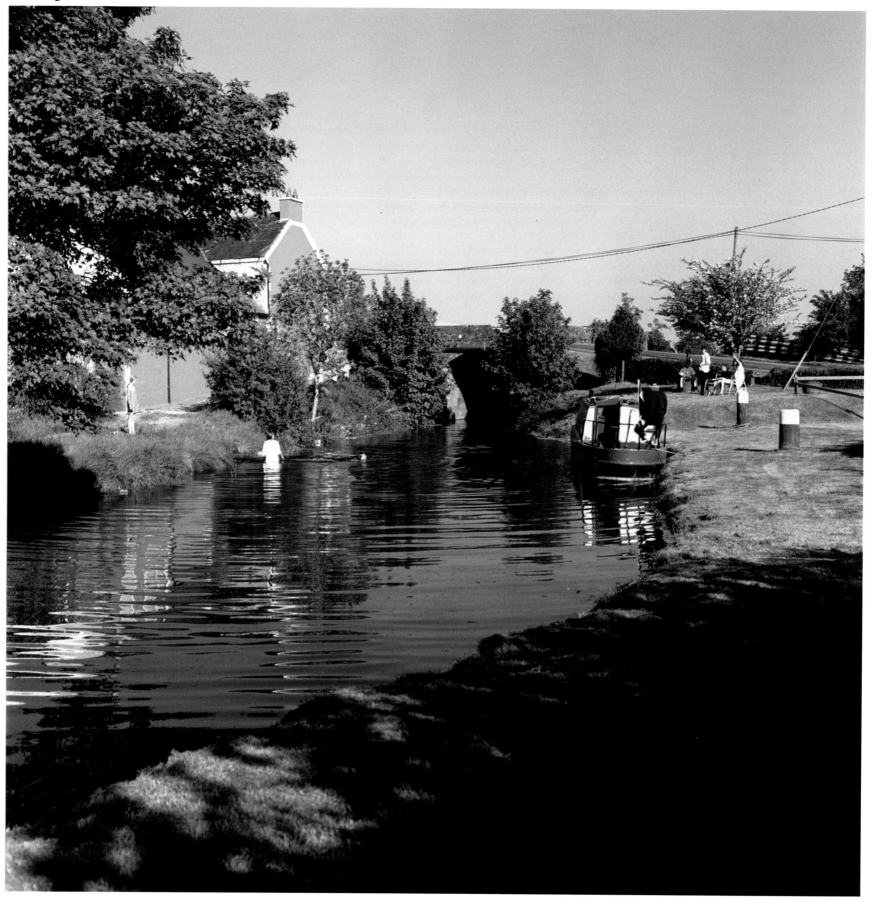

A glorious evening next to the bridge and pub at Milltown, County Kildare.

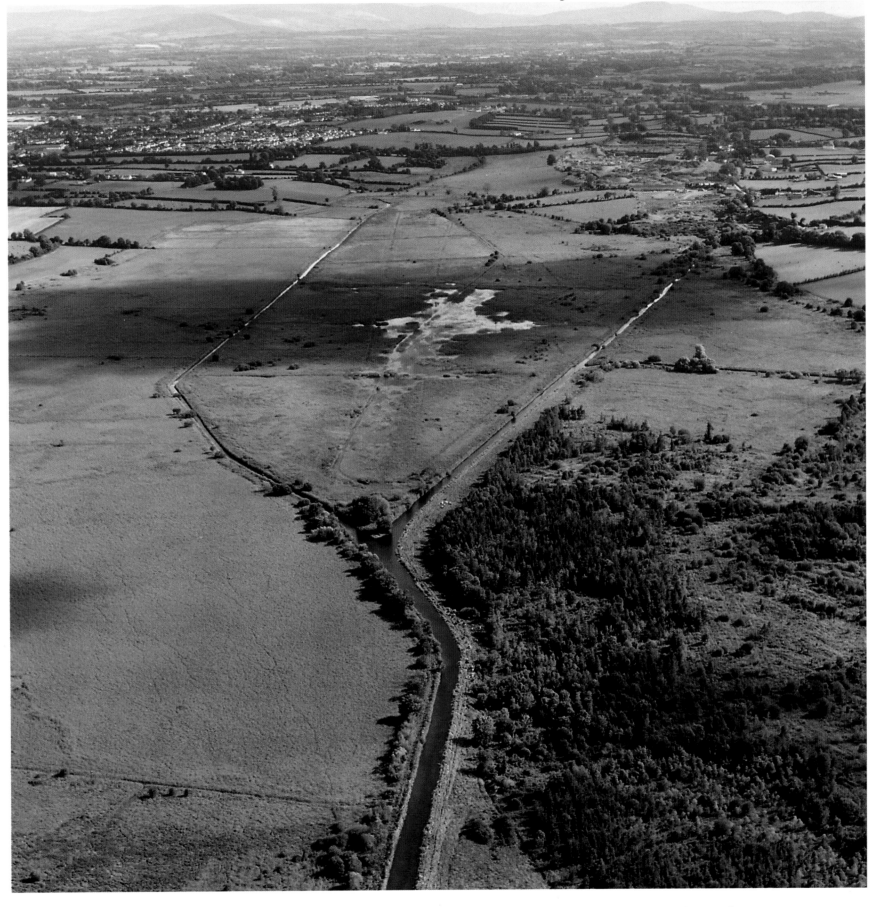

The Milltown Feeder, the main source of water at the summit of the Grand Canal
and feeding from 36 known springs in Pollardstown Fen.

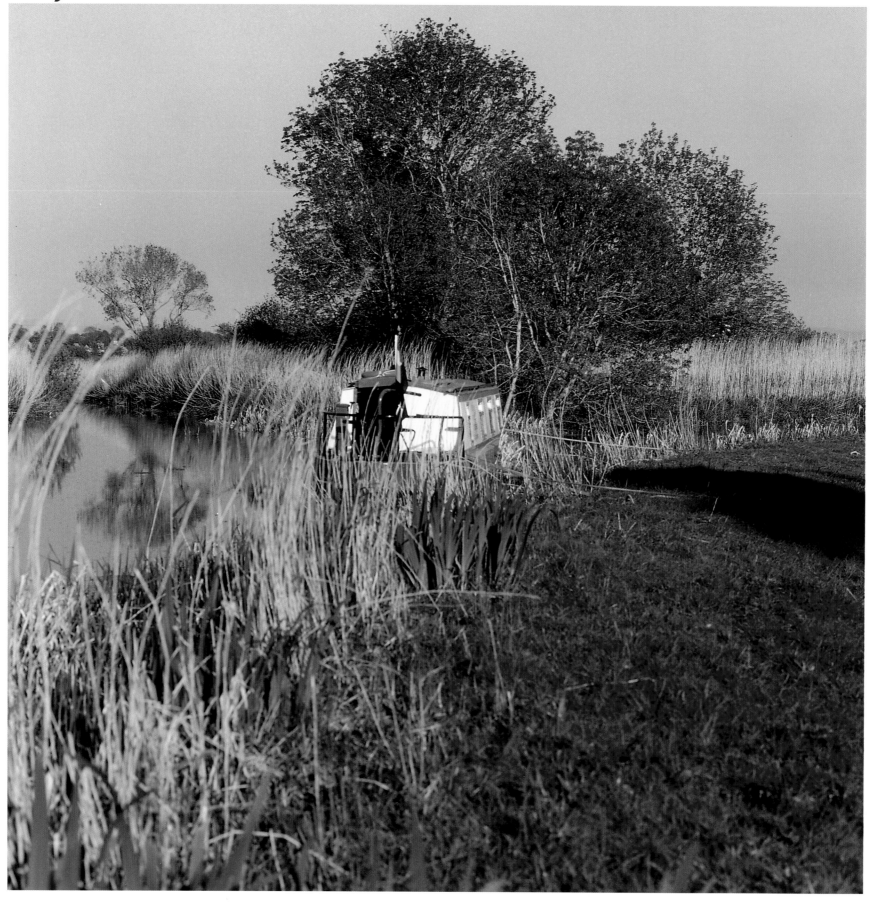

The perfect place to overnight, next to the Point of Gibraltar in Pollardstown Fen.
Facing page: The sun setting over Pollardstown Fen, a type of landscape
and vegetation widespread throughout Ireland almost 5,000 years ago.

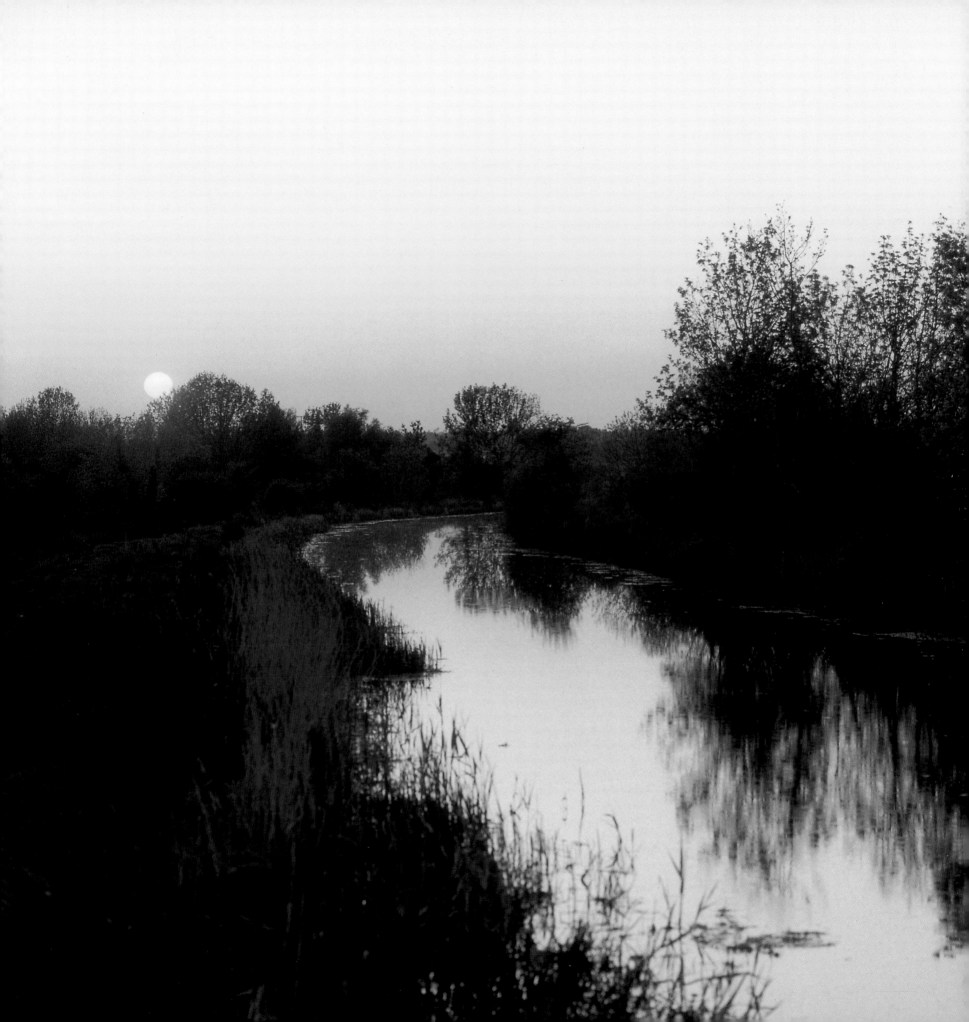

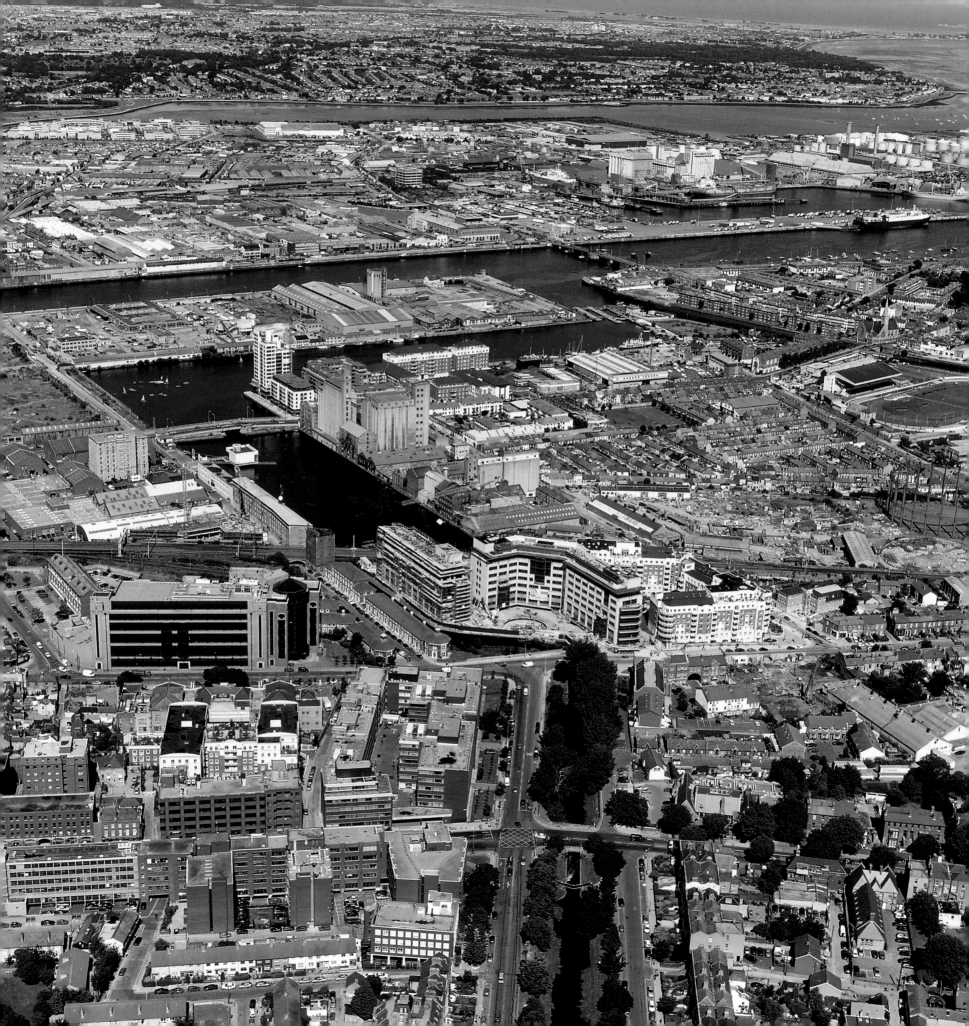

Facing page: The Ringsend Basin in Dublin Docks and leading out, at the bottom of the picture,
around a difficult corner under Maquay Bridge to the Circular Line of the Grand Canal.
Above: Locks as far as the eye can see from Lock 1 to Lock 8 at the start of the Main Line.

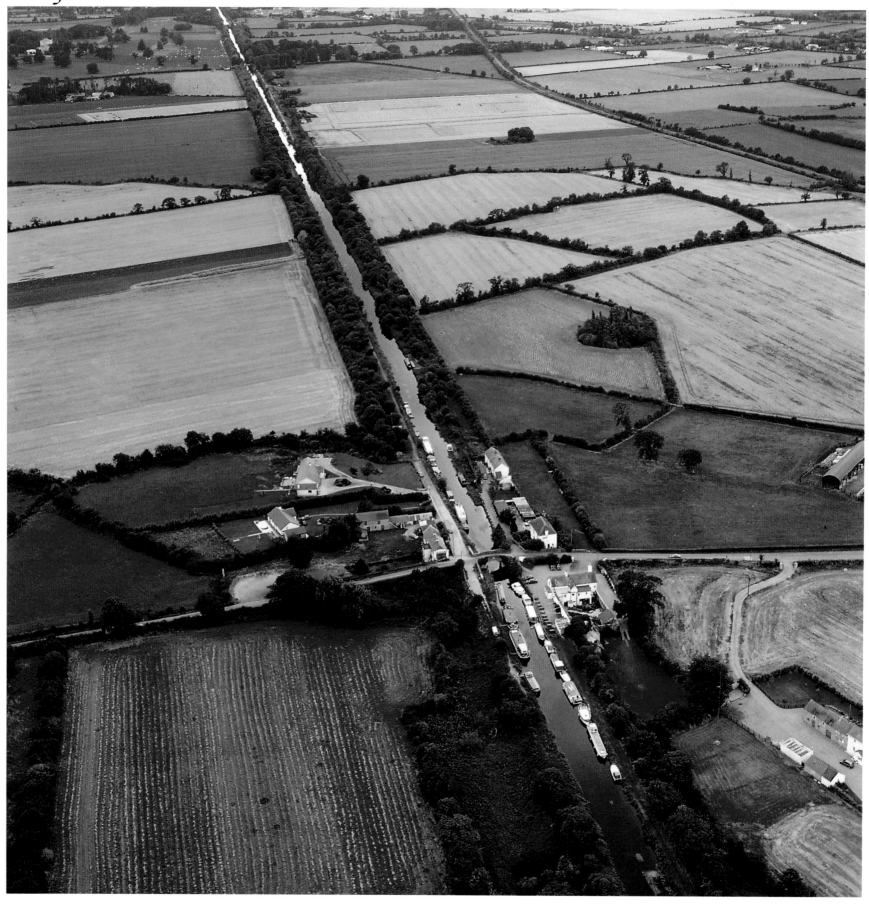

Hazelhatch Bridge 20.6km to the west of Dublin. *Facing page:* Looking back over
Killeen Golf Club in County Kildare towards Devonshire Bridge and next to Locks 15 and 16.

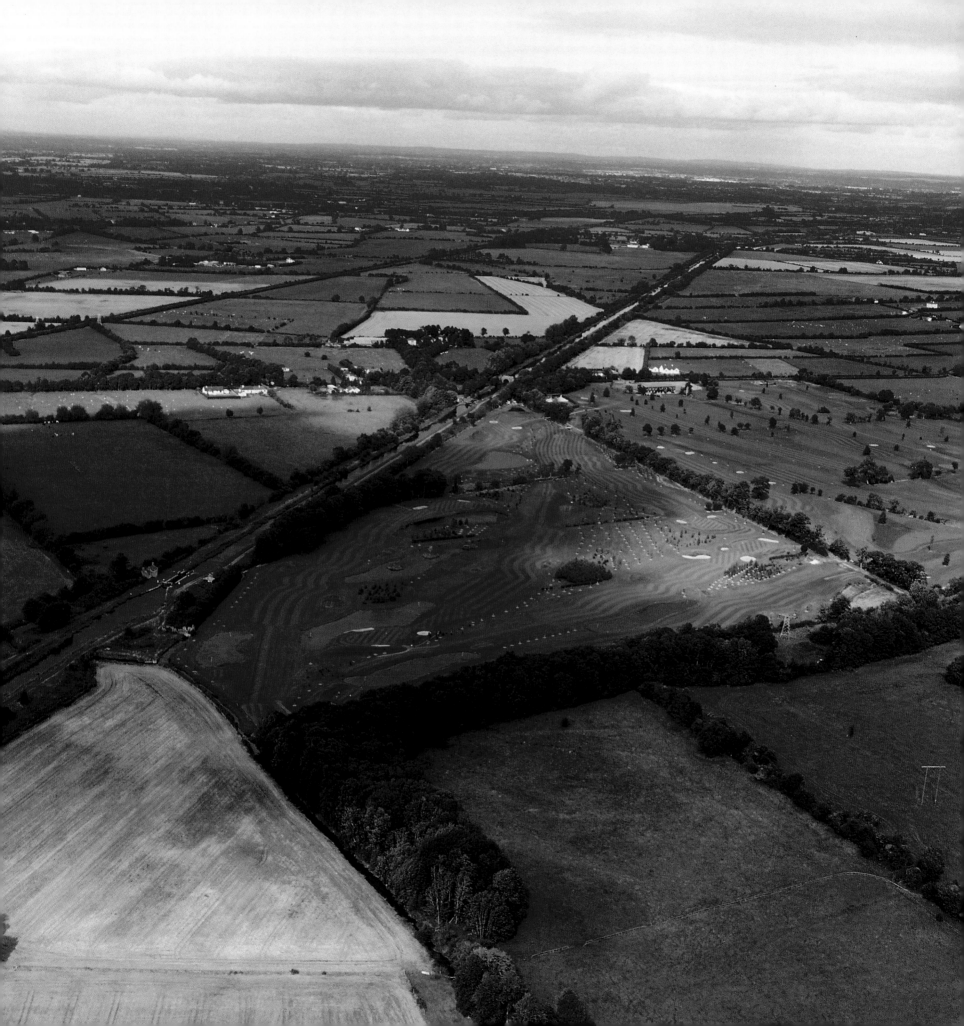

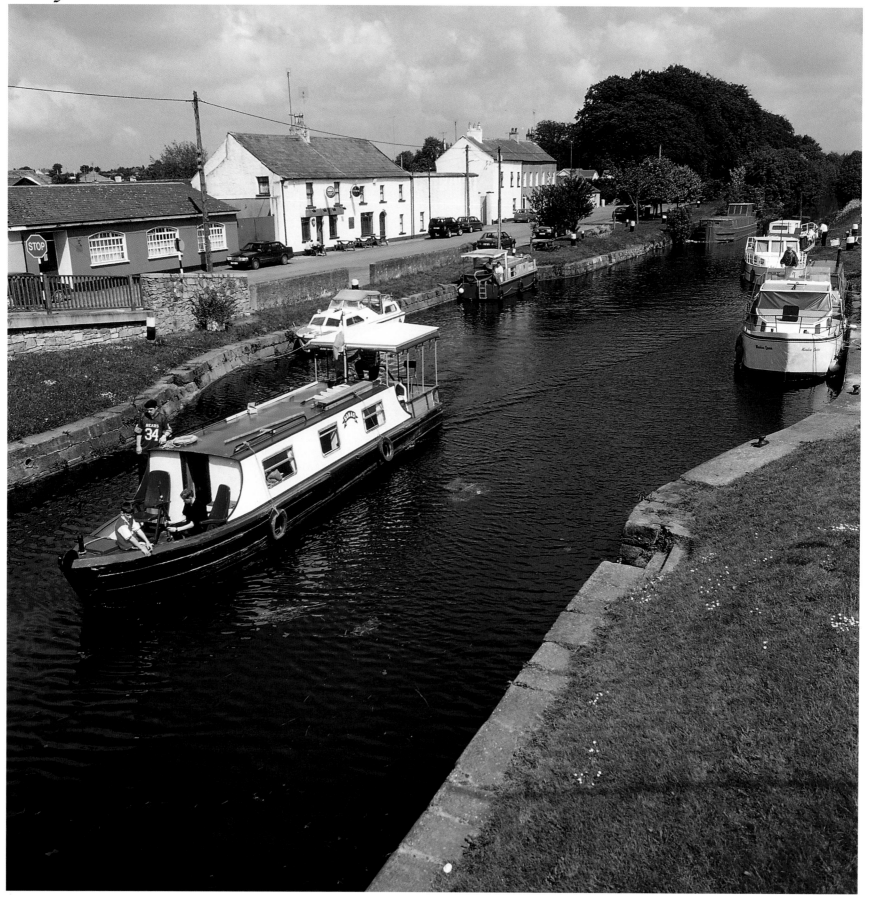

The Grand Canal passing Sallins 33.2km from Dublin.

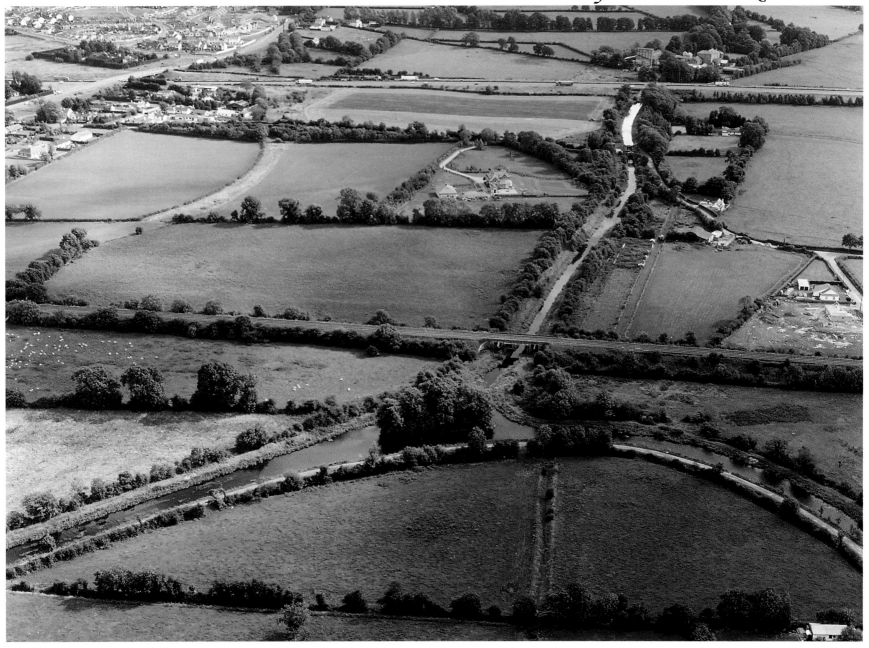

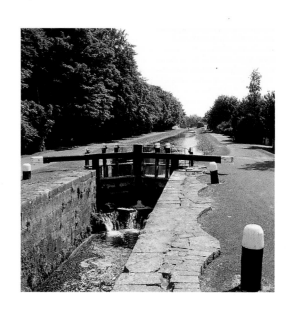

The Main Line travelling from left to right past Soldier's Island in the canal and at the entrance to the Naas Branch. Beautiful stonework features at Lock 5 on the way to Naas and looking towards Abbey Bridge.

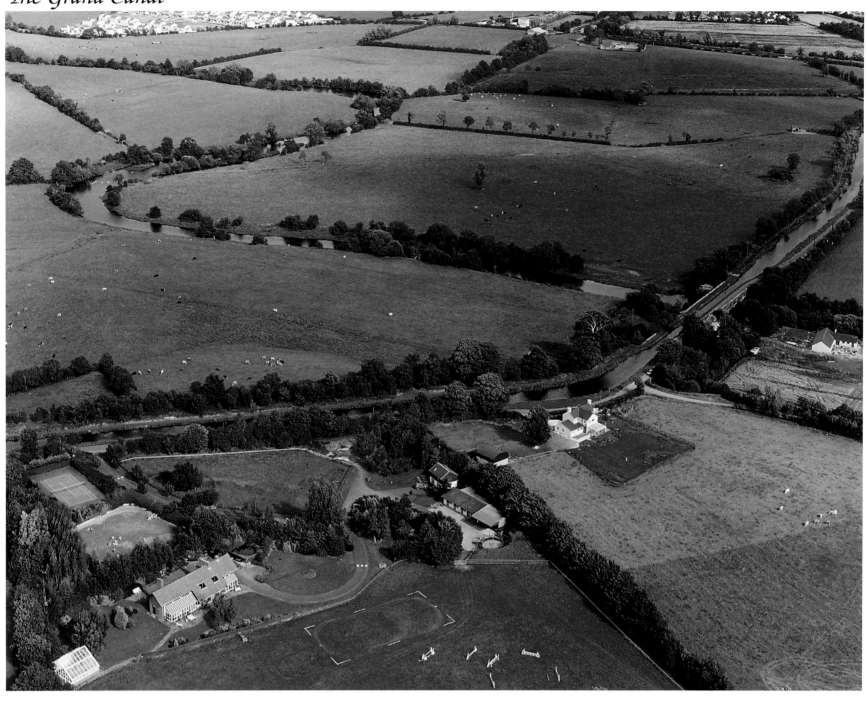

Back on the Main Line travelling from the right over the Leinster Aqueduct
and the River Liffey, 35km from Dublin.

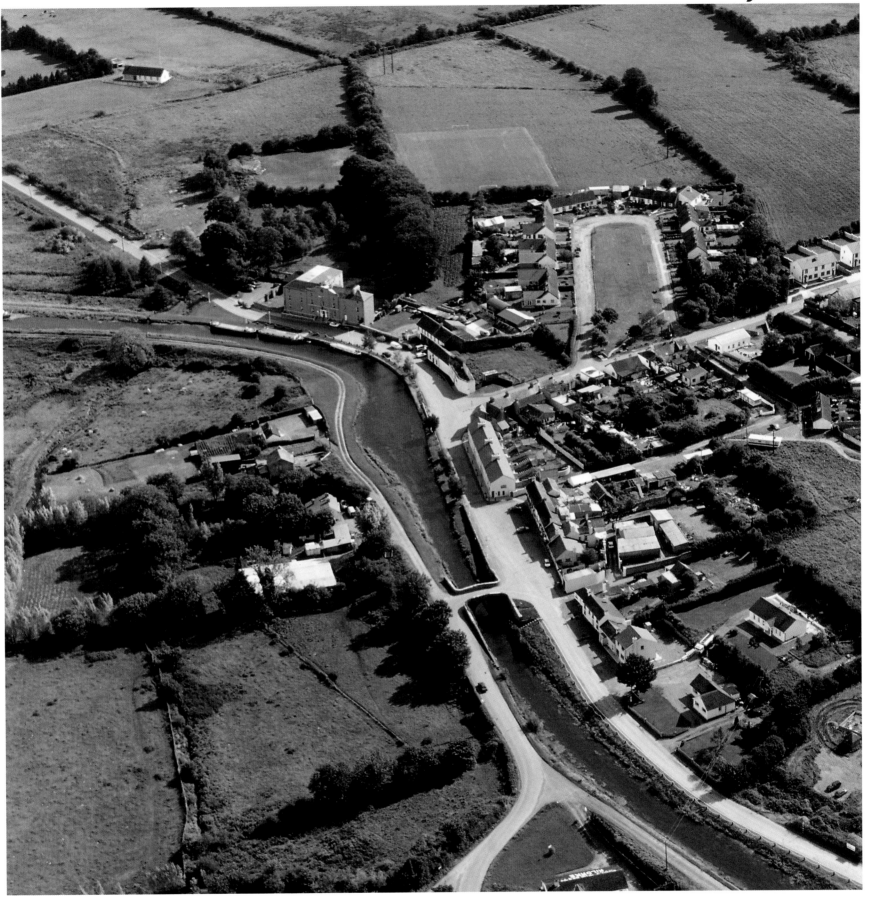

A short distance of 9.8km brings you to Robertstown with the old hotel which
ceased trading in 1849. A barge turning point can clearly be seen in the canal.

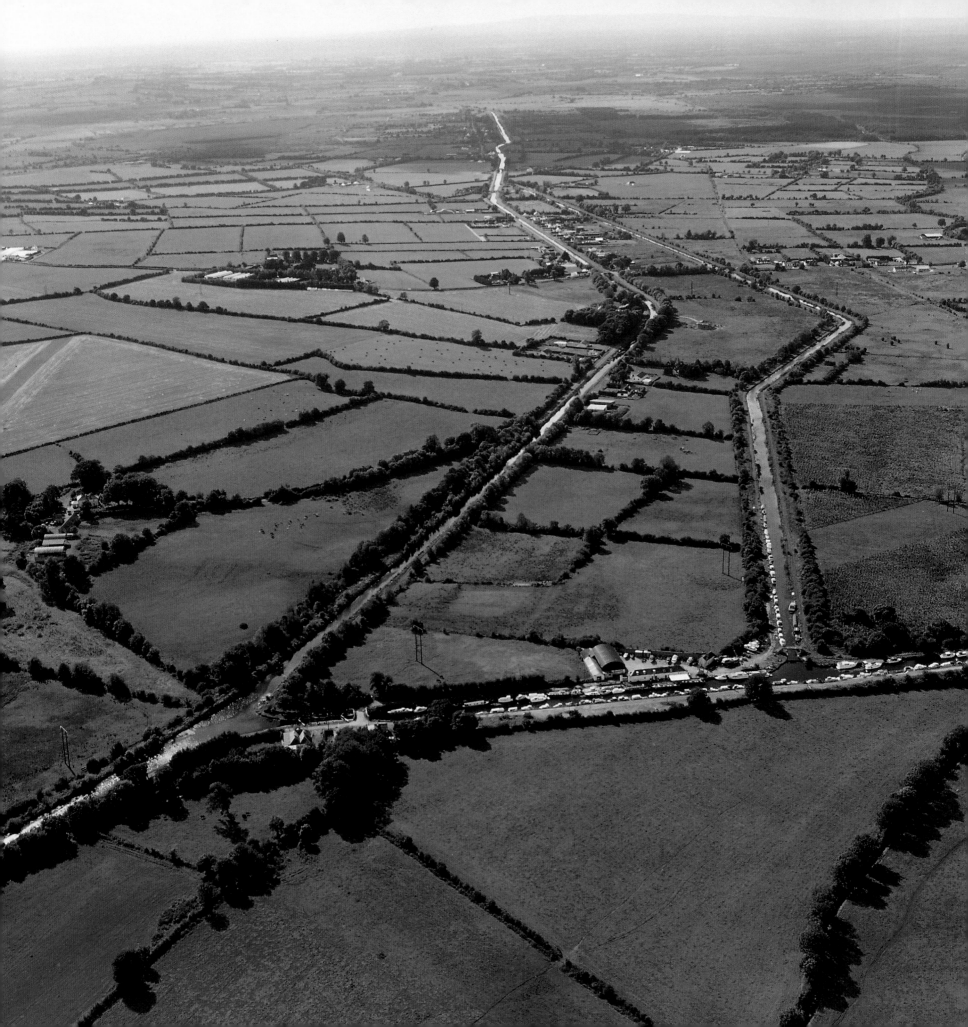

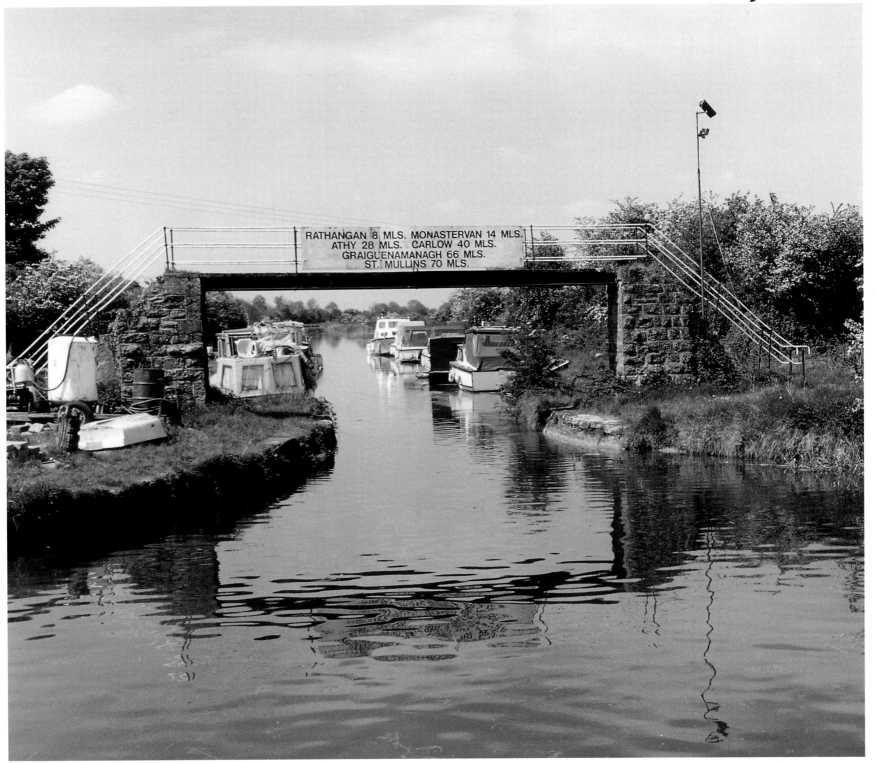

RATHANGAN 8 MLS. MONASTERVAN 14 MLS.
ATHY 28 MLS. CARLOW 40 MLS.
GRAIGUENAMANAGH 66 MLS.
ST. MULLINS 70 MLS.

Facing page: The Main Line entering the bottom left of the picture just before Lowtown and heading to the right towards the Shannon. The Old Barrow Line and New Barrow Line can clearly be seen heading to the south.

Above: The New Barrow Line with distances to the south printed on the footbridge.

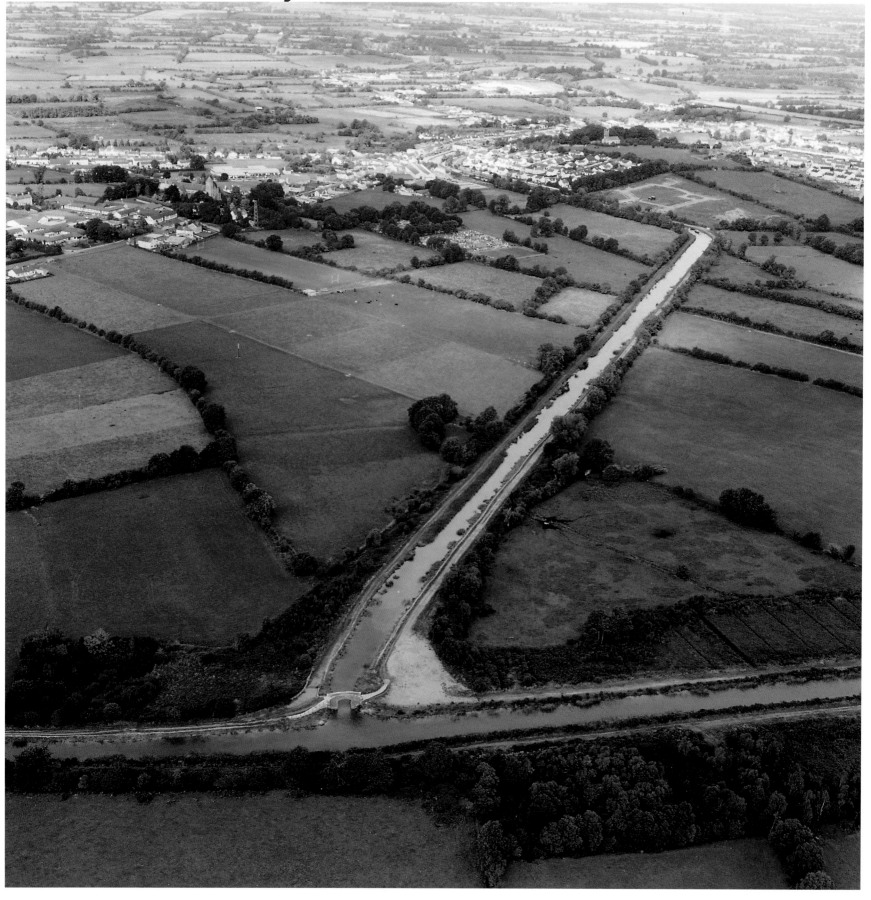

The Edenderry Branch heading north to the County Offaly town
where the harbour was completed in 1802.

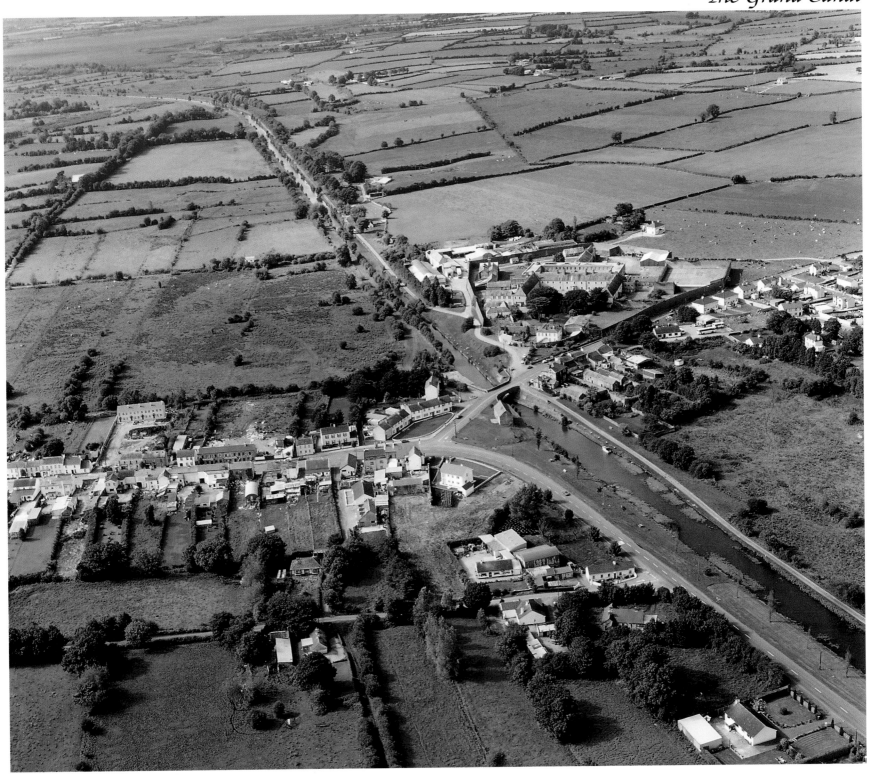

Molesworth Bridge at Daingean, County Offaly, 81.4km west of Dublin.

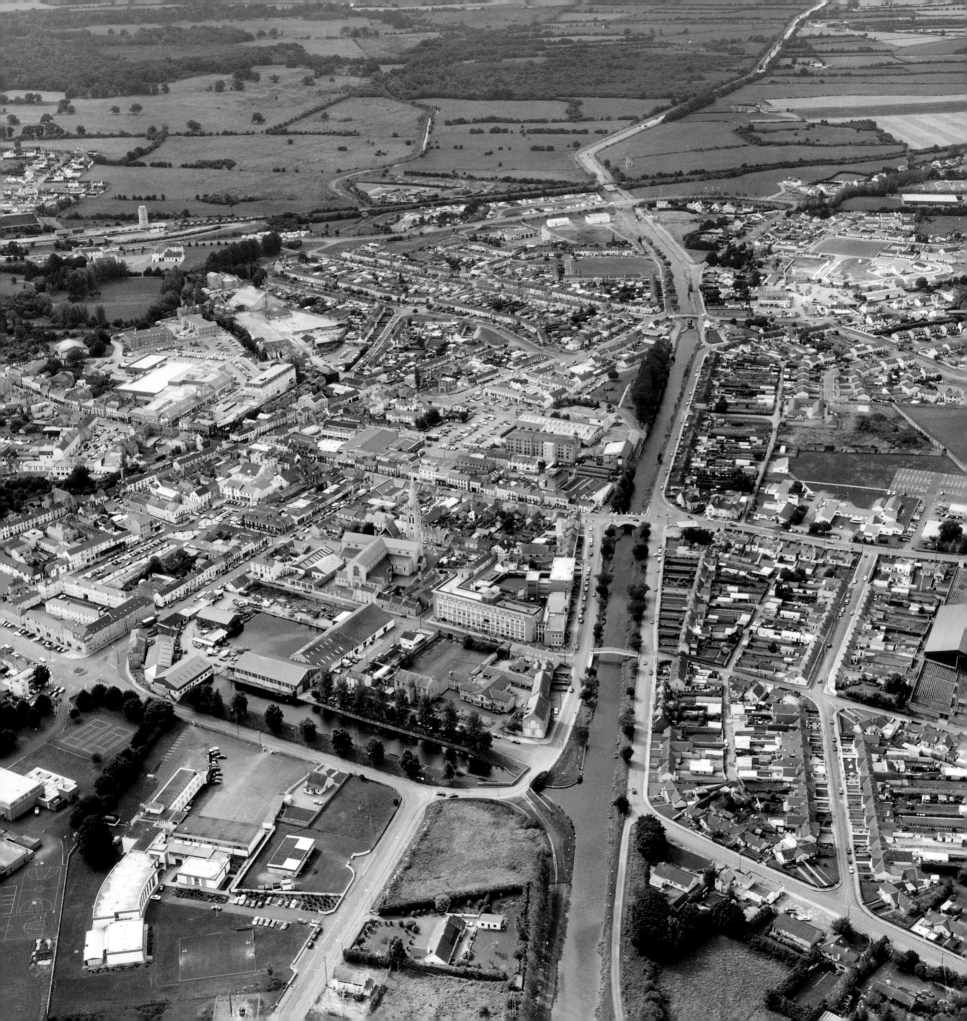

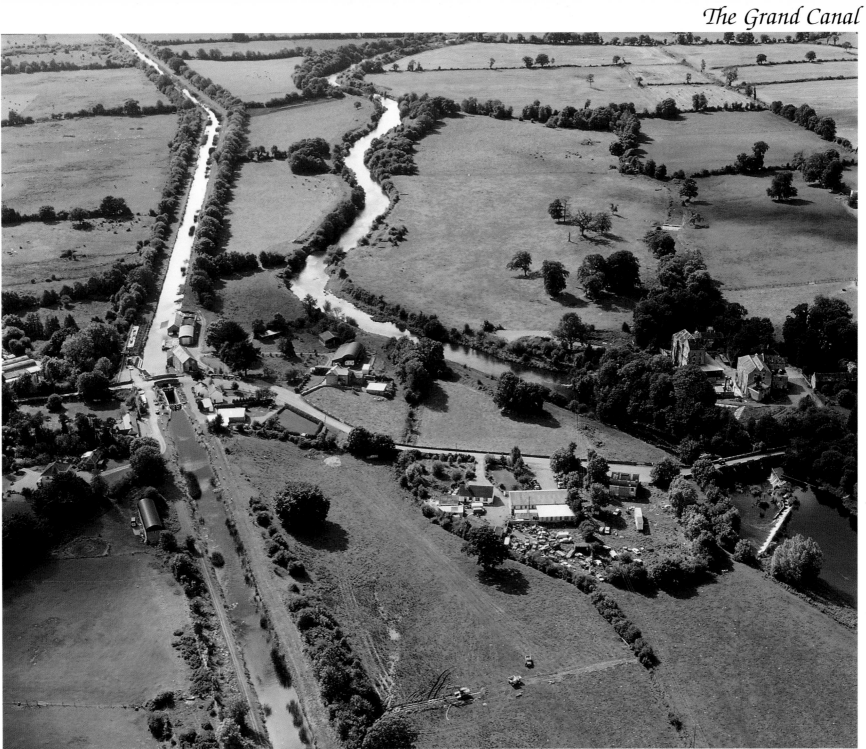

Facing page: The midland town of Tullamore with its tree-lined harbour in the foreground.
Above: The straight lines of the canal passing Belmont and Lock 33 with the River Brosna meandering along on the right.

Over: End of the line at Shannon Harbour with Locks 35 and 36 stepping down to the River Shannon. The Grand Canal has travelled 131km from Dublin.

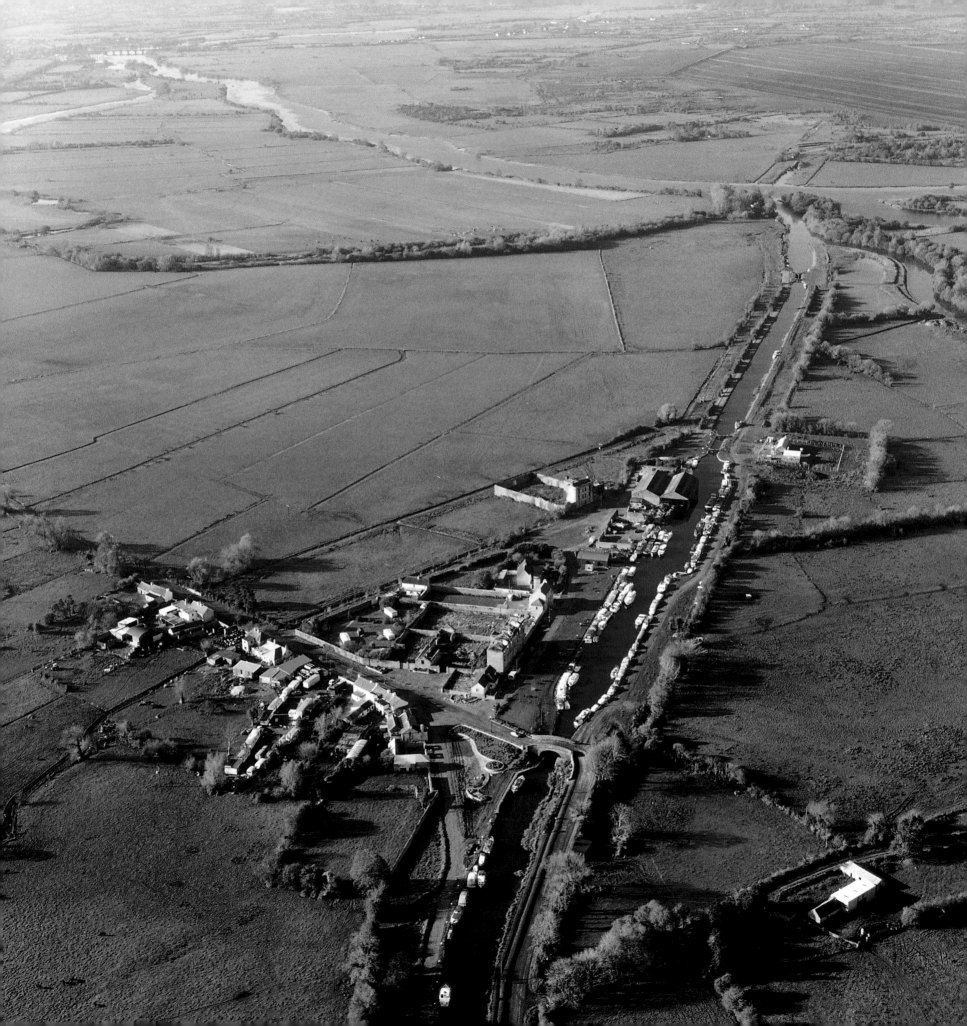

The Royal Canal

'The auld triangle goes jingle jangle all along the banks of the Royal Canal.'

Whereas the Grand Canal was chosen in 1796 as the preferred route from Dublin, reaching the Shannon in 1804, grants were initially approved for the Royal Canal in 1789 and it reached the Shannon near Tarmonbarry in 1817.

It is a credit to all concerned to see the incorporation of the Royal Canal over the M50 Motorway at Blanchardstown roundabout in Dublin.

Before Clonsilla, the canal passes through the Deep Sinking, a cut where the towpath is 9m above the water. For a lot of the journey, the Royal Canal travels in harmony with the railway line from Dublin towards the northwest of Ireland. They can both be seen next to each other at Maynooth, Enfield and especially over the River Boyne in County Meath where the railway viaduct is next to the canal aqueduct.

There is a pleasant harbour at Thomastown and then rather a lot of hard work with locks 18 to 25 being spaced approximately 0.5km apart and leading to the summit of the Royal Canal.

The main source of water for the Royal Canal is the Lough Owel feeder which leads 3.6km to the north of the canal, entering it in the town of Mullingar.

The stonework on the southern shore of Lough Owel and leading to the Royal Canal Sluice House and the feeder is well worth a visit. Unlike the Milltown feeder on the Grand Canal, you cannot navigate this stretch of water.

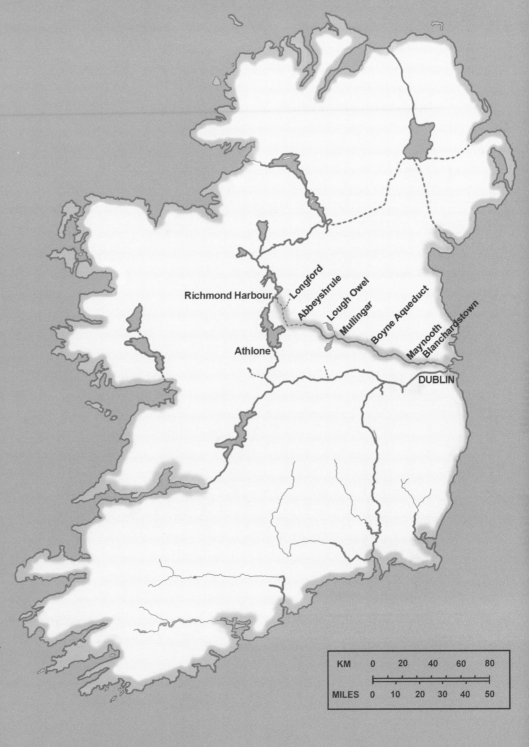

The Royal Canal travels through much more difficult terrain than its competitor to the south but this in turn makes it a far more interesting waterway. Writing this in 1999, it must be said that progress is being made to open the canal past Abbeyshrule and onwards to beautiful Richmond Harbour at Cloondara in County Longford. Many of us look forward to the day when it will be possible to cruise the Royal Canal from Dublin to the Shannon.

In the 1830s the annual tonnage on the Royal Canal was recorded at 80,000 tons and 40,000 passengers. This subsequently declined but there was a brief revival of trade from 1939 to 1945 during the Emergency Years.

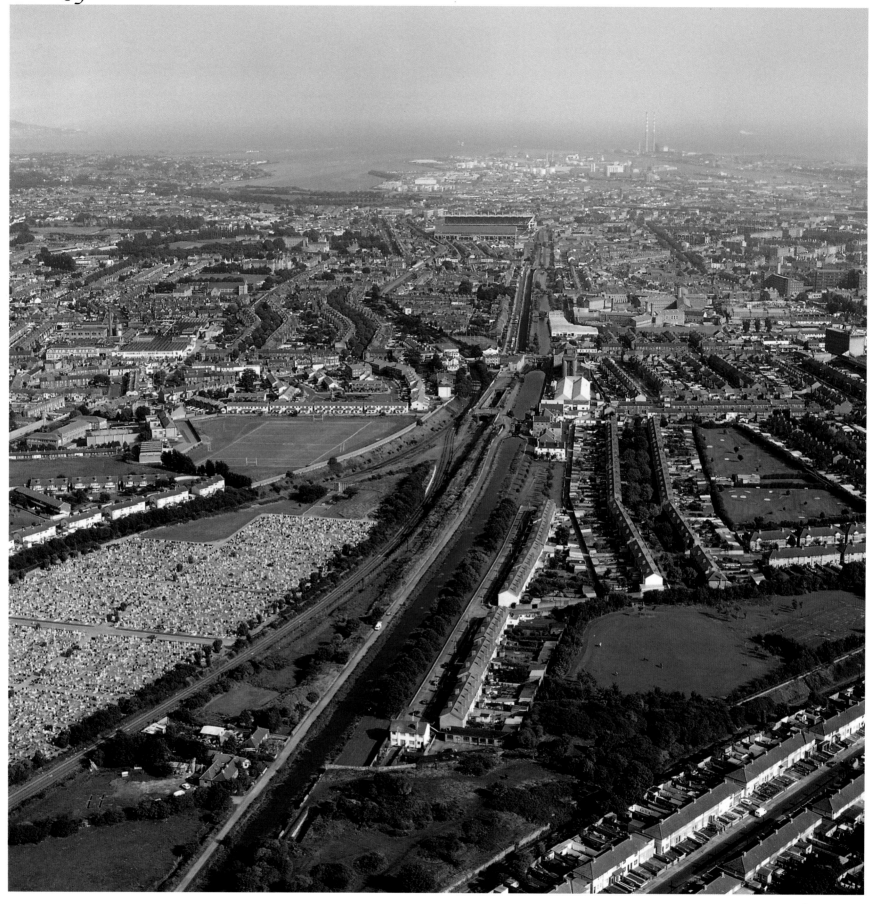

After the First Lock in Dublin, the Royal Canal climbs steeply through double locks 2 to 6 passing Croke Park, Mountjoy Prison and Glasnevin Cemetery.

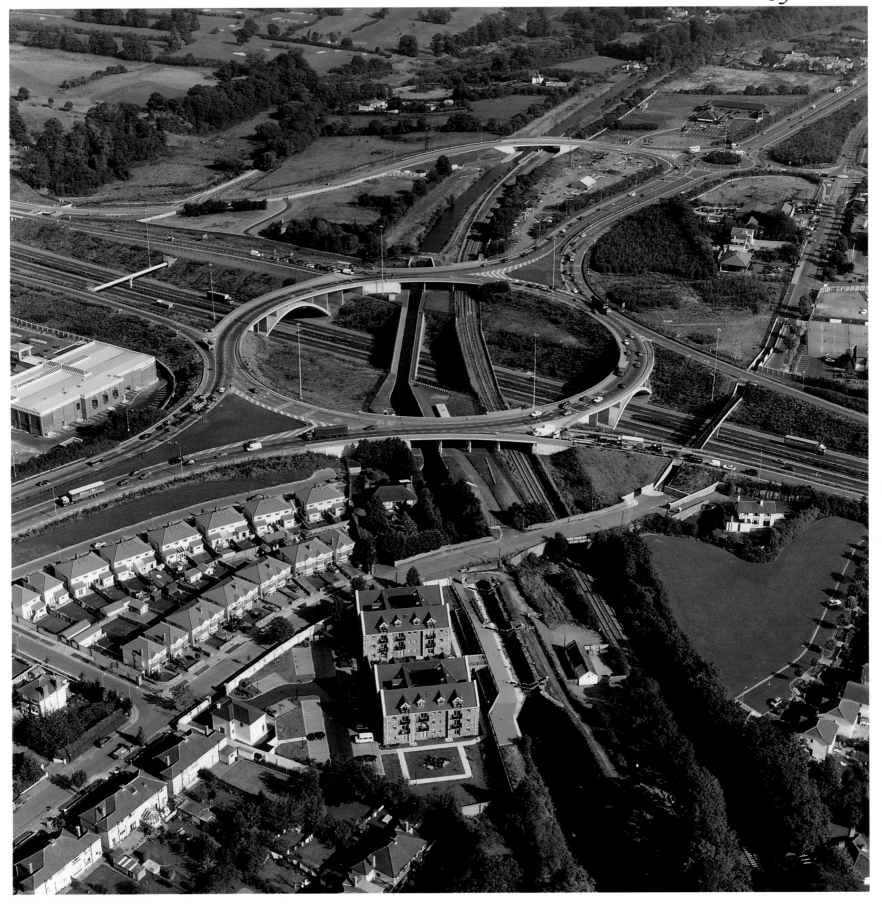

Road, rail and the Royal Canal at Blanchardstown Roundabout over the M50 Motorway.
Double Lock 12 is in the foreground.

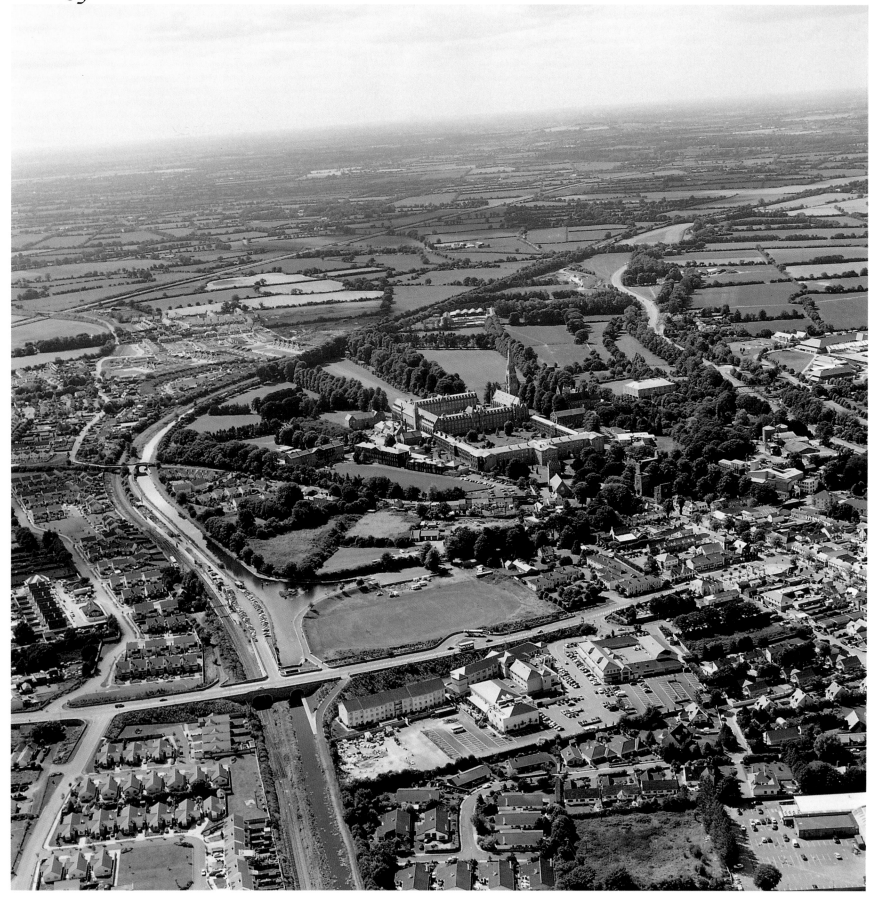

The canal curving around St Patrick's College, Maynooth, County Kildare, 26.3km
from Dublin. St Patrick's was founded in 1749 at the instigation of
Edmund Burke for the education of young Catholic Irishmen.

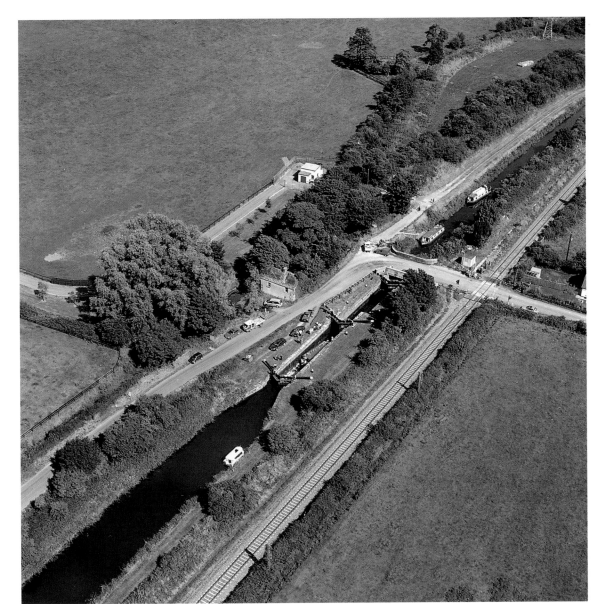

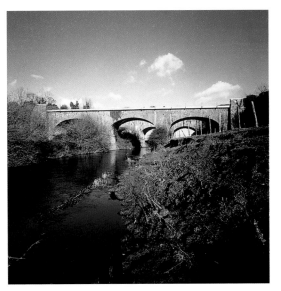

Narrowboats travelling through Fern's Lock 15 between Kilcock and Enfield on the Royal Canal Amenity Group Jubilee Cruise from Dublin to Abbeyshrule in August 1999. The park at Enfield harbour *(above right)* and the impressive three-arched Boyne Viaduct and Boyne Aqueduct *(below)*.

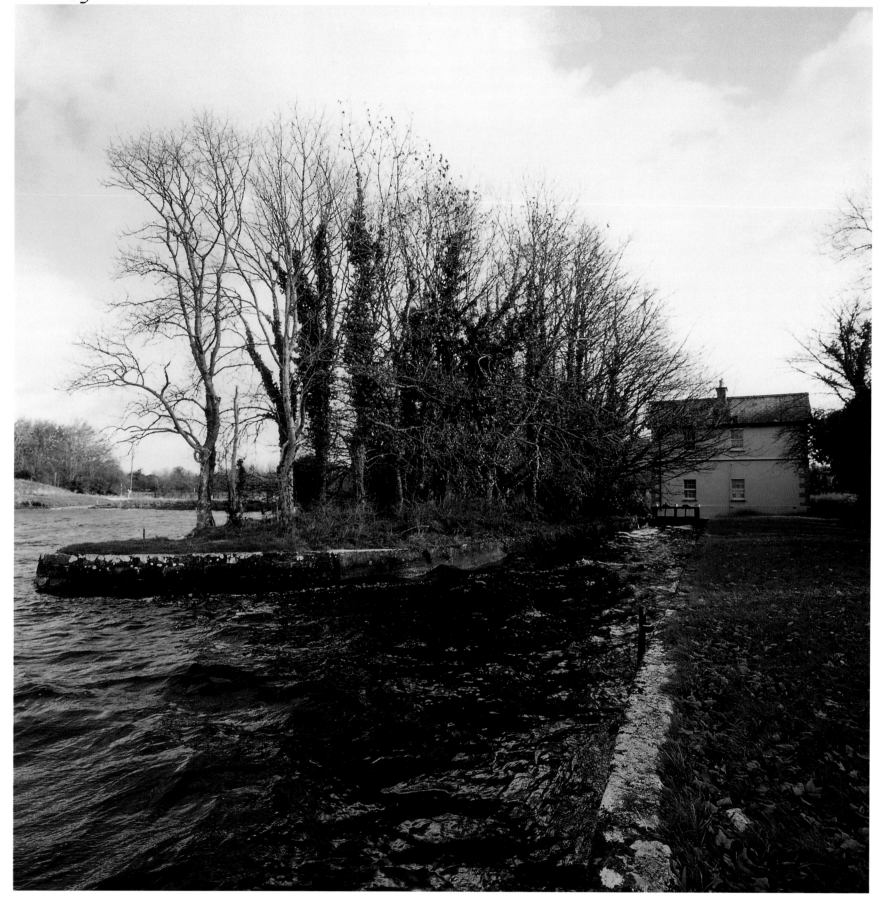

The channel leading to the Royal Canal Sluice House and the Lough Owel Feeder,
the main source of water for the Royal Canal 3.6km to the south.

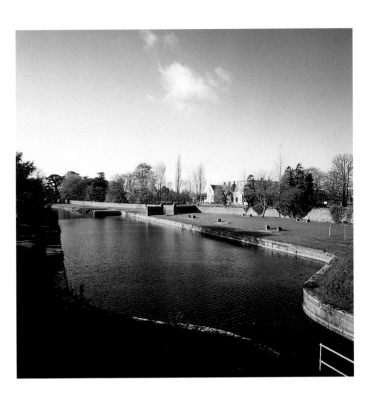

The harbour and slip in Mullingar
85.5km from Dublin.

Webbs Bridge at Abbeyshrule,
County Longford. The newer and
lower road bridge blocking the
Royal Canal was clearly visible
in 1998.

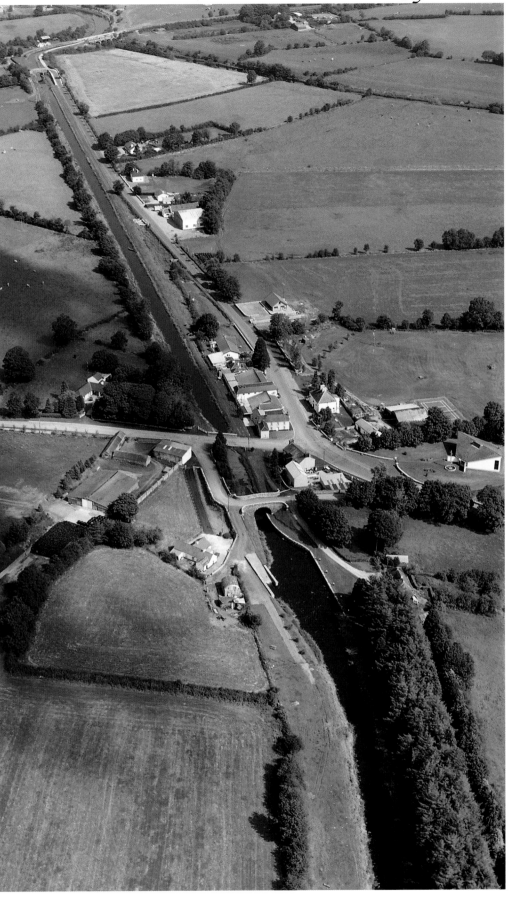

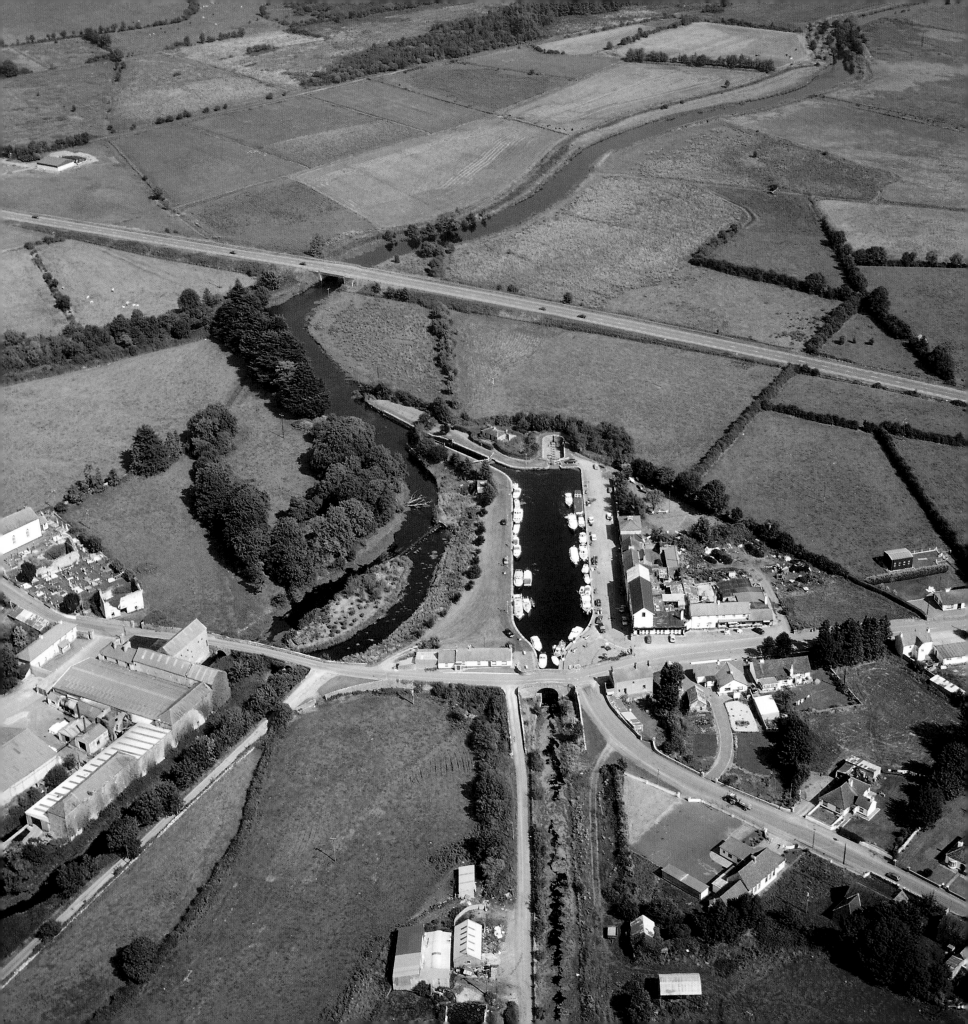

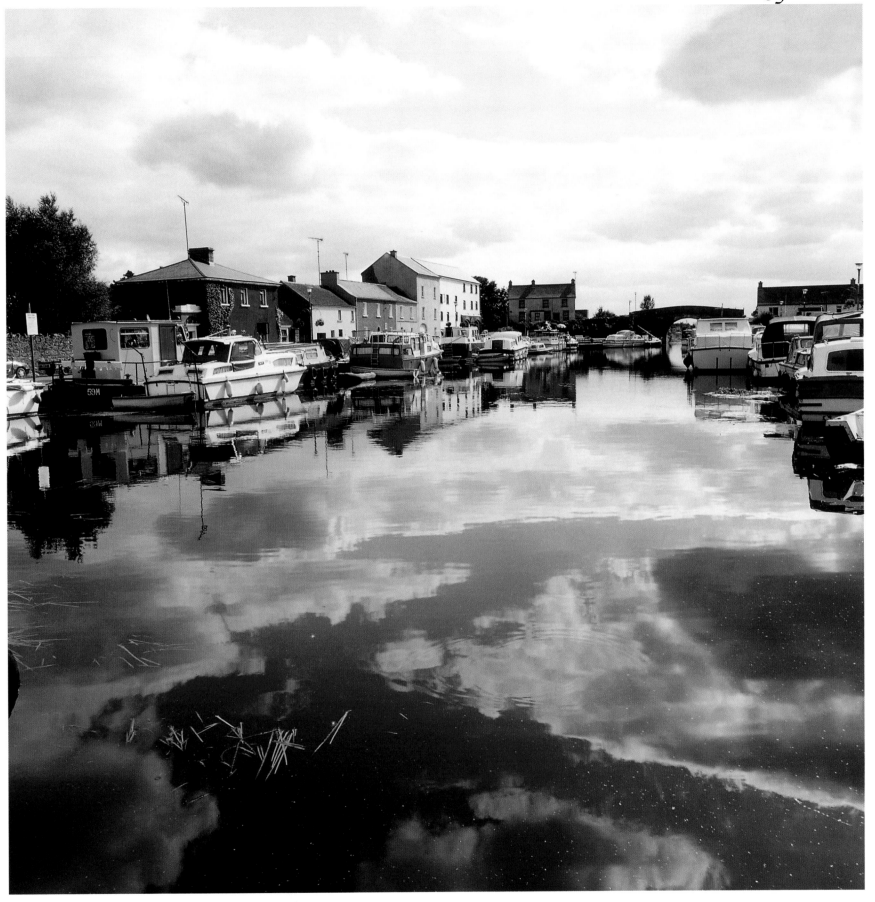

Facing page: In 1817, the Royal Canal was completed to Richmond Harbour, Cloondara, County Longford, entering at the bottom of the picture, and overgrown in 1998. *Above:* The peace and beauty of Richmond Harbour which happily can be reached from the Shannon Navigation.

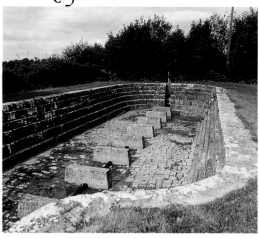

The restored Graving Dock or Dry Dock at Richmond Harbour and *(below)* Cloondara Lock, a distance of 145.45km from Dublin and gateway to the Shannon Navigation.

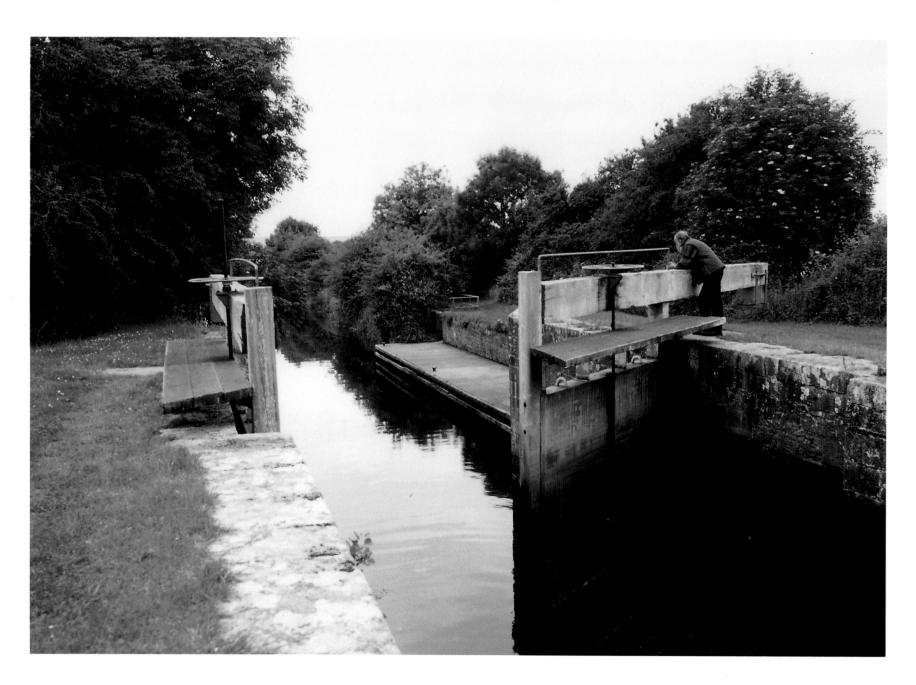

The Shannon Navigation

As a main artery through the heart of Ireland, the River Shannon has provided access to the Irish Midlands since ancient times.

Today, instead of paddling a dug-out canoe, one can choose a modern cruiser from the excellent fleet available. You can sail on the large loughs or propel yourself by whatever method you fancy.

The distance from Limerick to the top of the navigation is 215km.

The Lower Shannon Navigation takes you from the old lock at Sarsfield Bridge in Limerick to Ardnacrusha Dam where you will rise 30.5m through a double chamber and then on to Killaloe.

The Shannon Navigation commences at Killaloe in County Clare and leads you into Lough Derg which stretches north for a distance of 35km. There are eight harbours with hostelries on the edges of the lough and a visit to the monastic settlement on Holy Island will take you back in time.

Portumna in County Galway at the top of Lough Derg leads you (at the formal bridge opening times) on an interesting journey through Victoria Lock at Meelick, past Banagher, the entrance of the Grand Canal at Shannon Harbour and on past Shannonbridge. Clonmacnoise was once the crossroads of Ireland, a monastic settlement founded on the edge of the river by St Ciarán in about 545 AD and quite fascinating.

Another lock is encountered in the midland town of Athlone which in turn leads to Lough Ree, famous for its Yacht Club which claims to be the second oldest in the world.

Lanesborough is 31.2km north of Athlone and the top of Lough Ree. The Shannon passes the entrance to the Royal Canal and Richmond Harbour, Cloondara, and then continues north past Tarmonbarry.

Between the lock and bridge at Roosky, cruisers tie up on the rather picturesque eastern tree-lined riverbank. Continuing up the Shannon you pass from Lough Bofan to Lough Boderg and you can cruise west to explore Carnadoe waters. These lead you to Grange Lough and Kilglass Lough.

Back on the main navigation, Albert Lock brings you into the Jamestown Canal and on to the large cruiser base at Carrick-on-Shannon.

There are three cruising options to the north of Carrick. The first is via the Boyle River which takes you in a north-west direction to Lough Key with its National Park. The second is to the northeast and along the Shannon - Erne Waterway. The third is to Drumshanbo and Lough Allen at the northern end of the Shannon Navigation and only 12m higher than at its start in Killaloe.

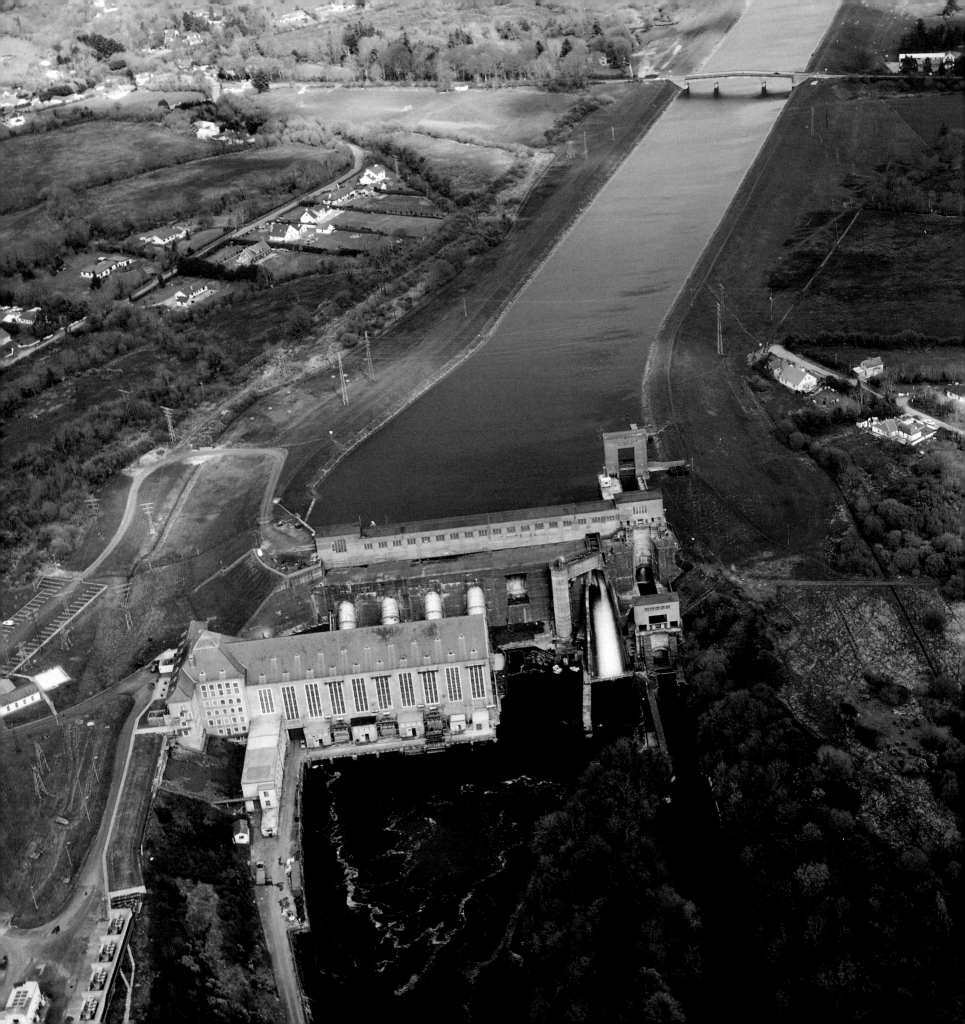

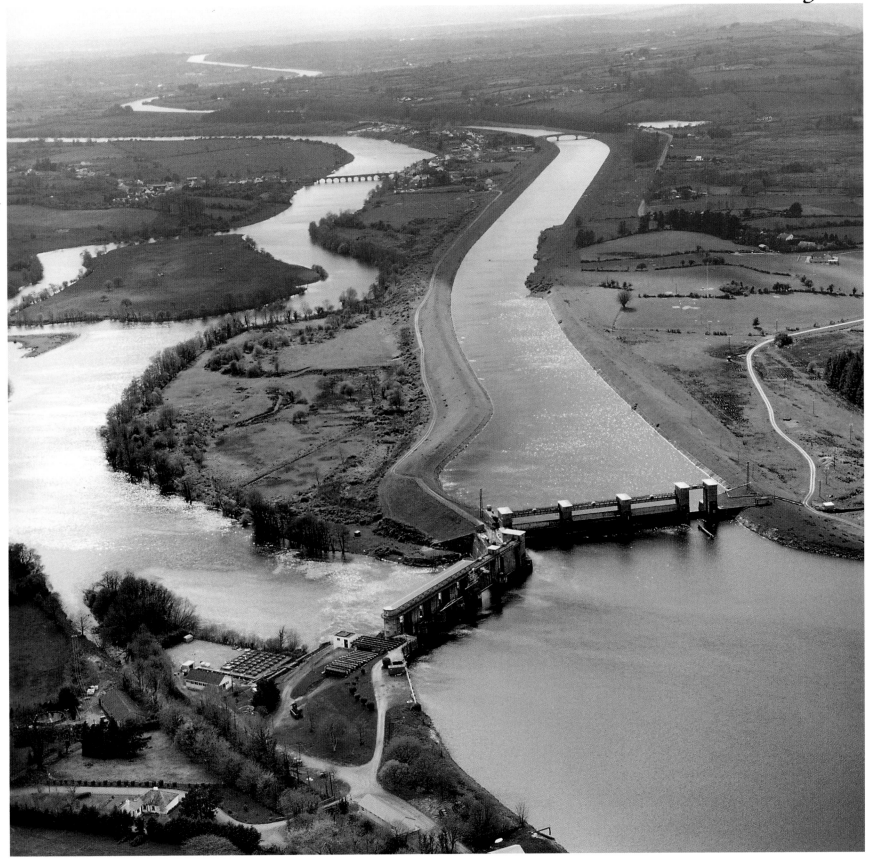

Facing page: Ardnacrusha Dam with a double-chamber lock and a rise and fall of 30.5m. There can be serious turbulence below the cut from the tailrace of the power station when it is discharging.
Above: Looking back over the headrace to Ardnacrusha at Parteen, with the Shannon River flowing to the left towards O'Brien's Bridge.

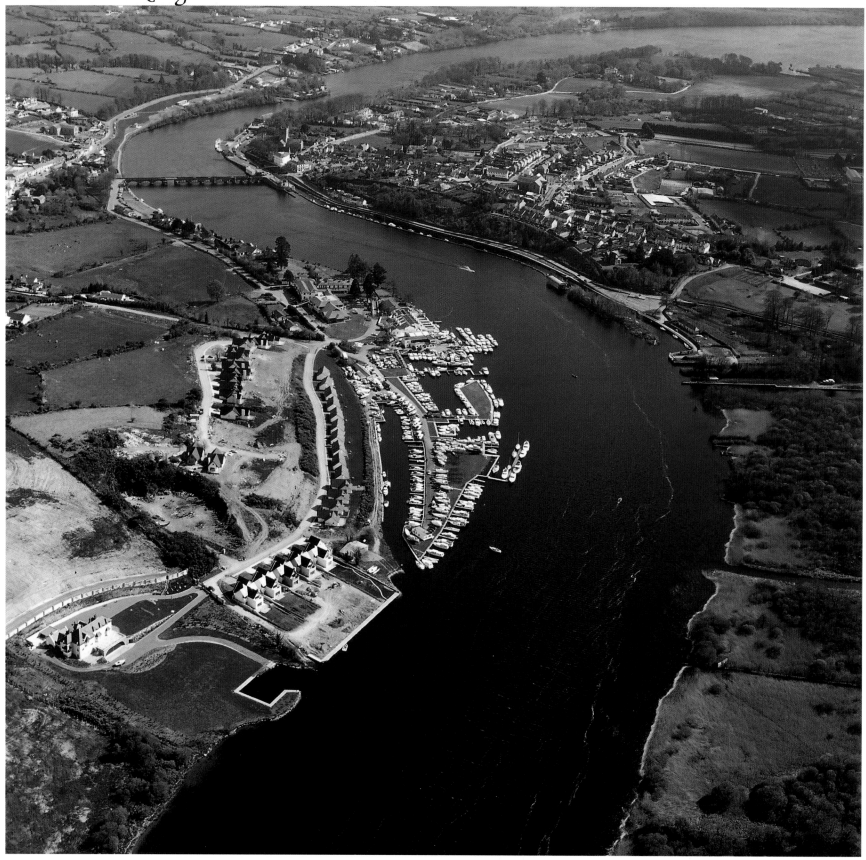

A view to the south with Ballina in County Tipperary on the left and Killaloe in County Clare on the right. Charter boats cannot be taken down the Shannon from Killaloe.
Facing page: Inishcealtra (Holy Island) in Lough Derg, 2km offshore from Mountshannon. A beautiful and seemingly remote island site, Inishcealtra was an important place of pilgrimage from its foundation in the seventh century until the seventeenth century.

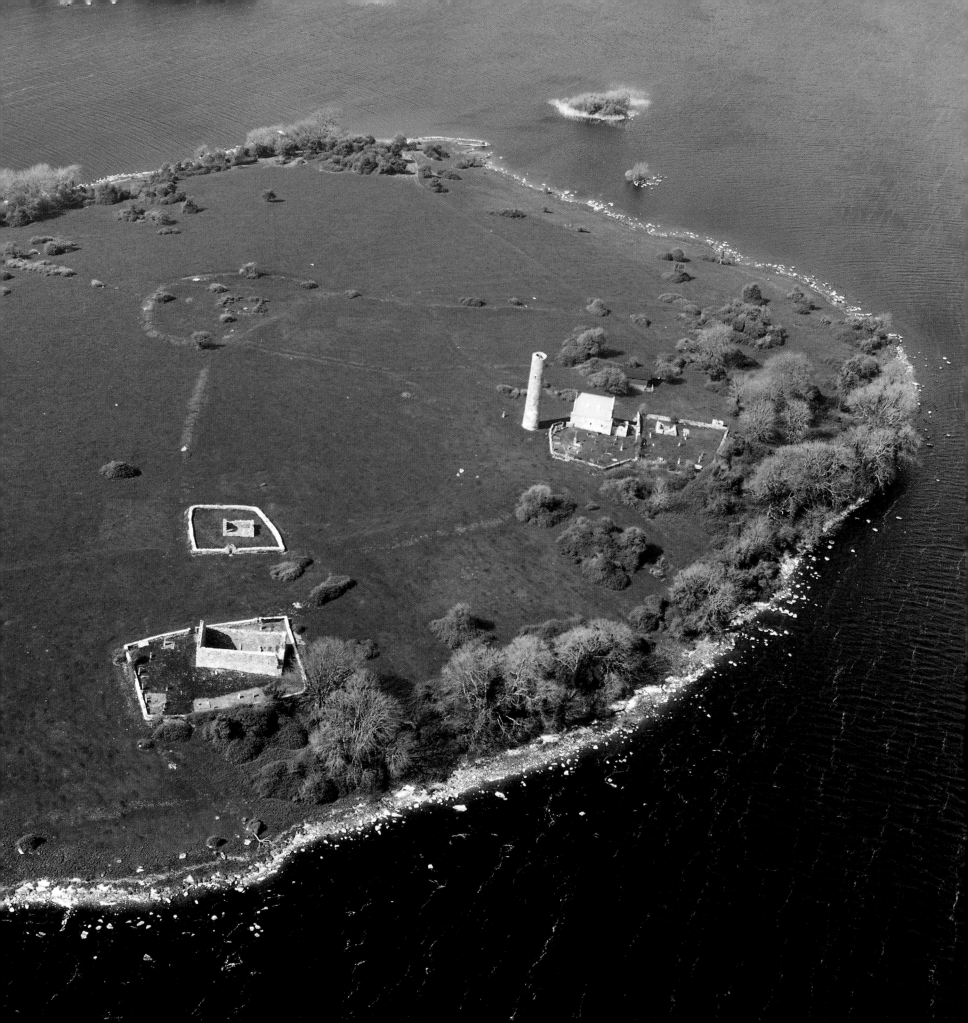

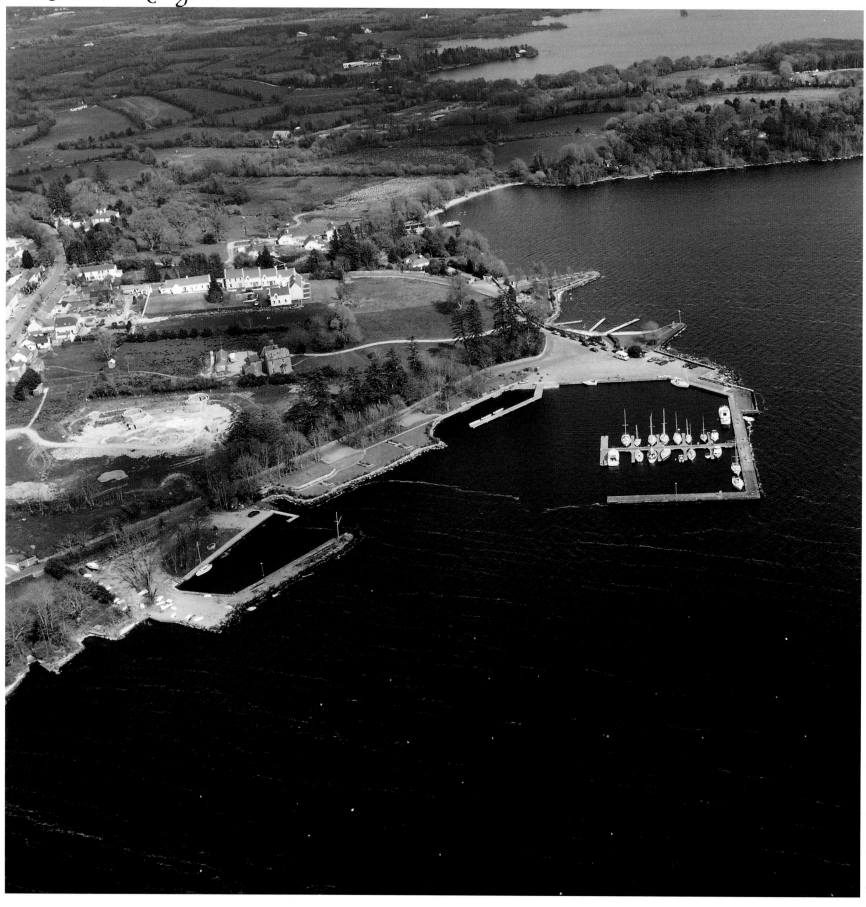

The harbour at Mountshannon on the west shoreline of Lough Derg in County Clare.
Facing page: Mountshannon harbour on a June holiday weekend.

The sheltered harbour of Dromann about 9km up the shoreline from Mountshannon.
Facing page: The charter basin at Williamstown Harbour with Dromann in the distance.

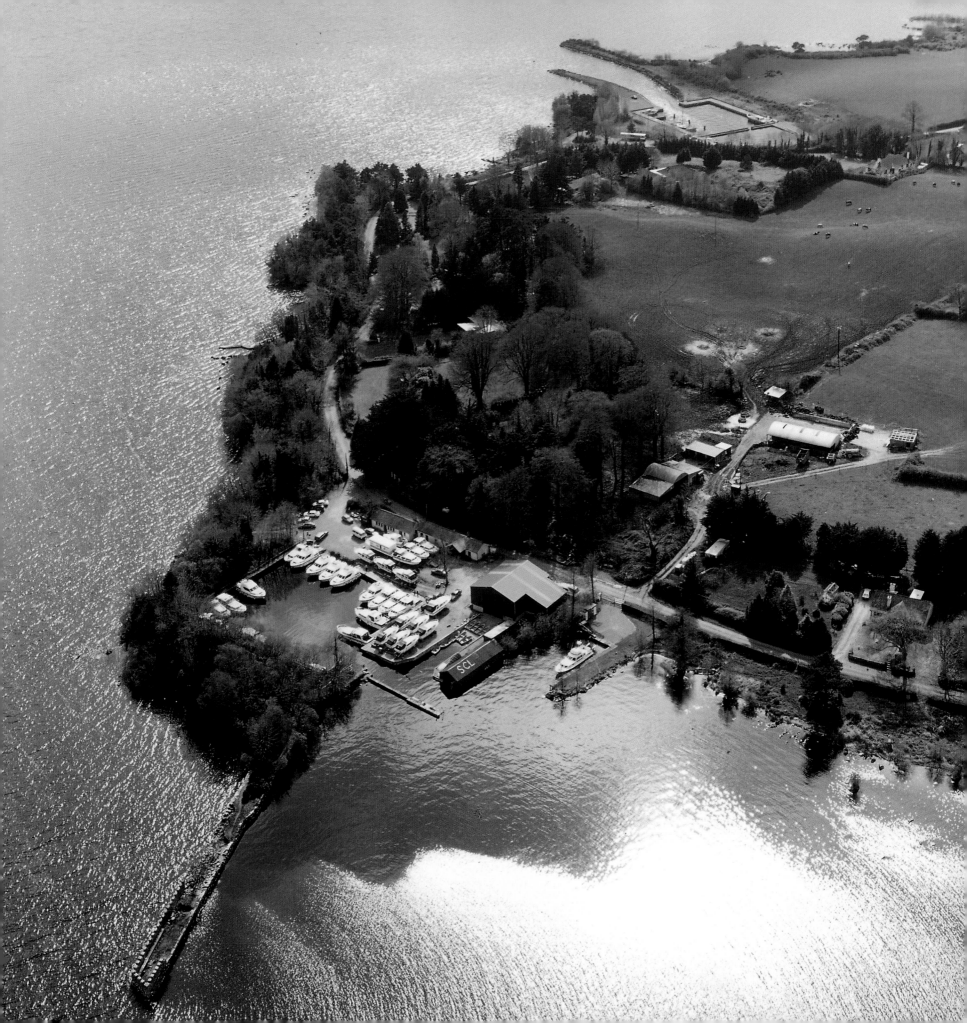

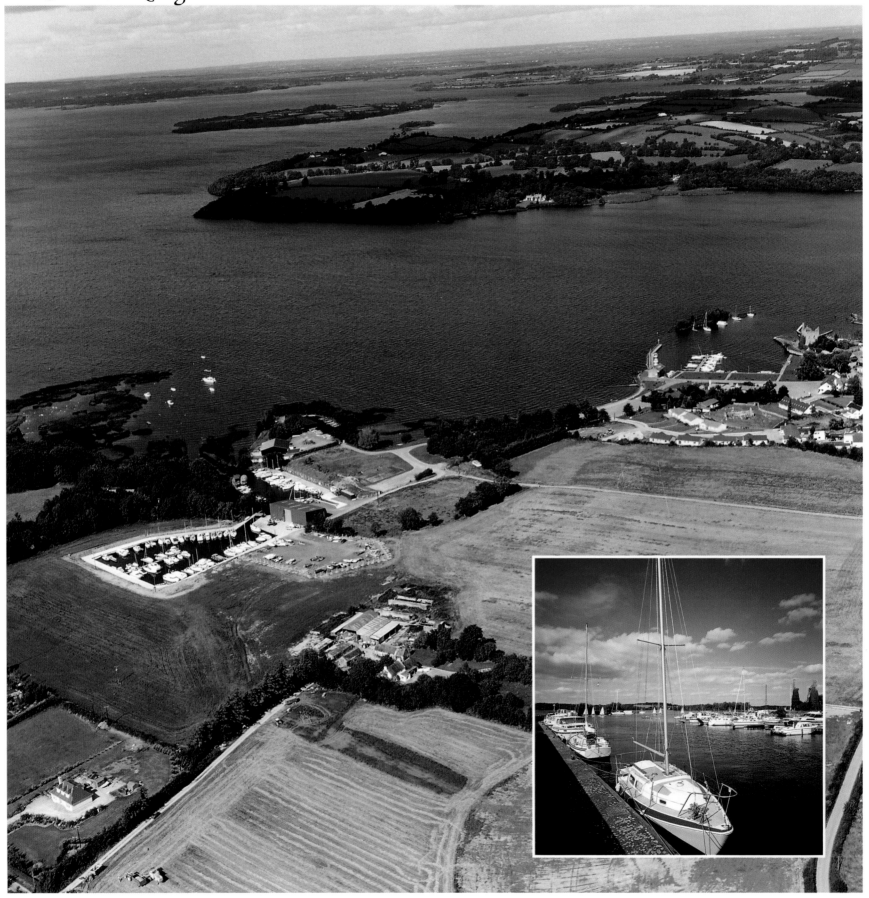

Dromineer halfway up Lough Derg on the east shoreline in County Tipperary.
Facing page: Castle Harbour, Portumna, County Galway, at the northern end of Lough Derg.

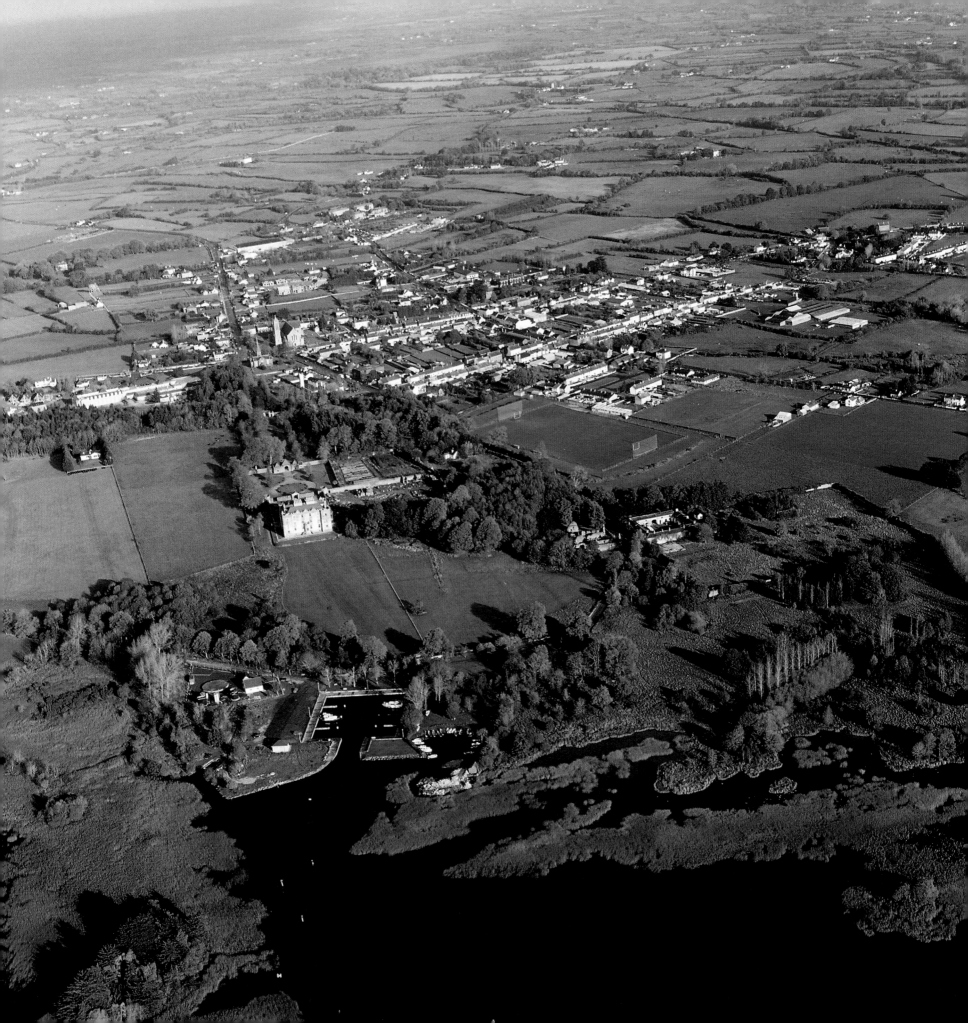

A family cruiser leaving Castle Harbour, Portumna *(left)*, and Portumna opening bridge and charter harbour *(below)*.

Facing page: Victoria Lock at Meelick which was constructed in the 1840s.

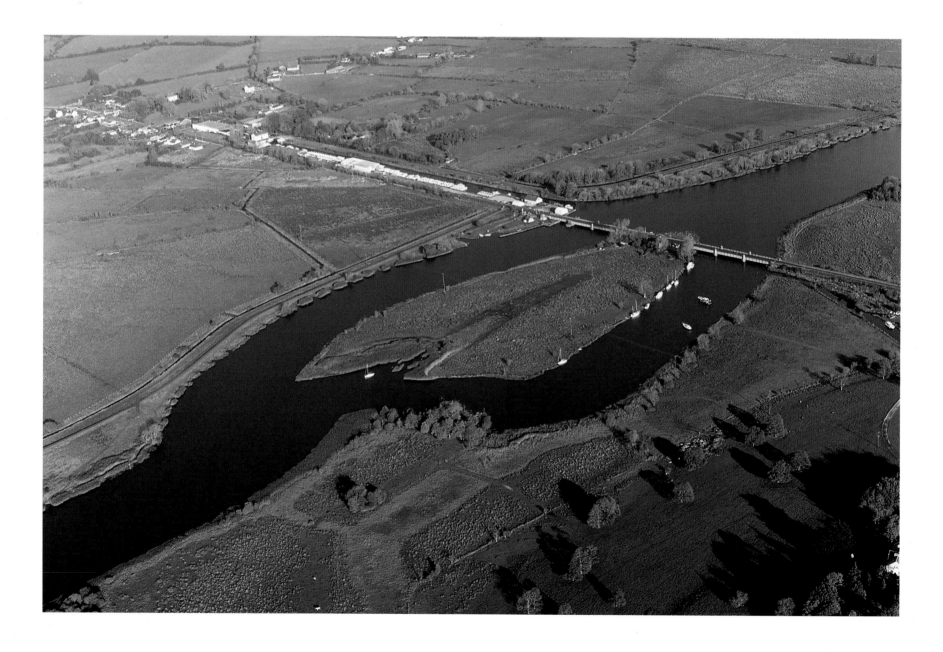

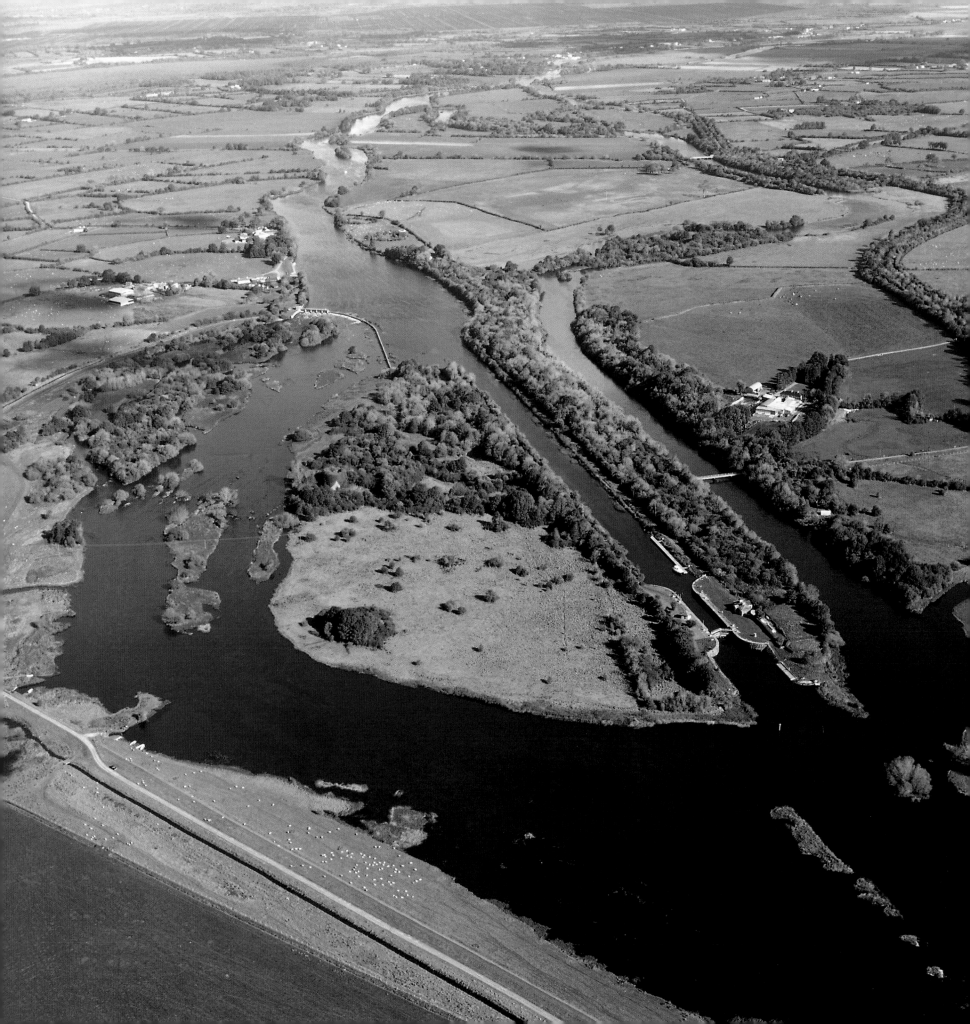

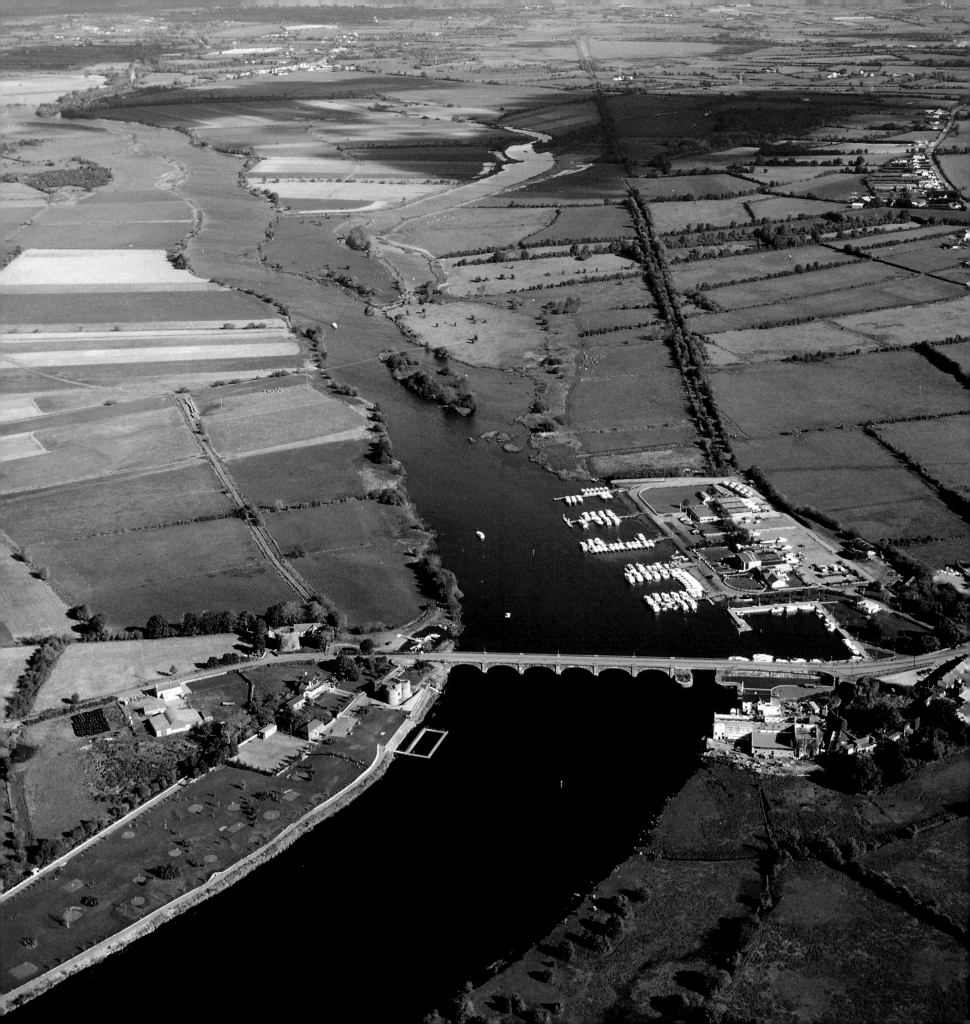

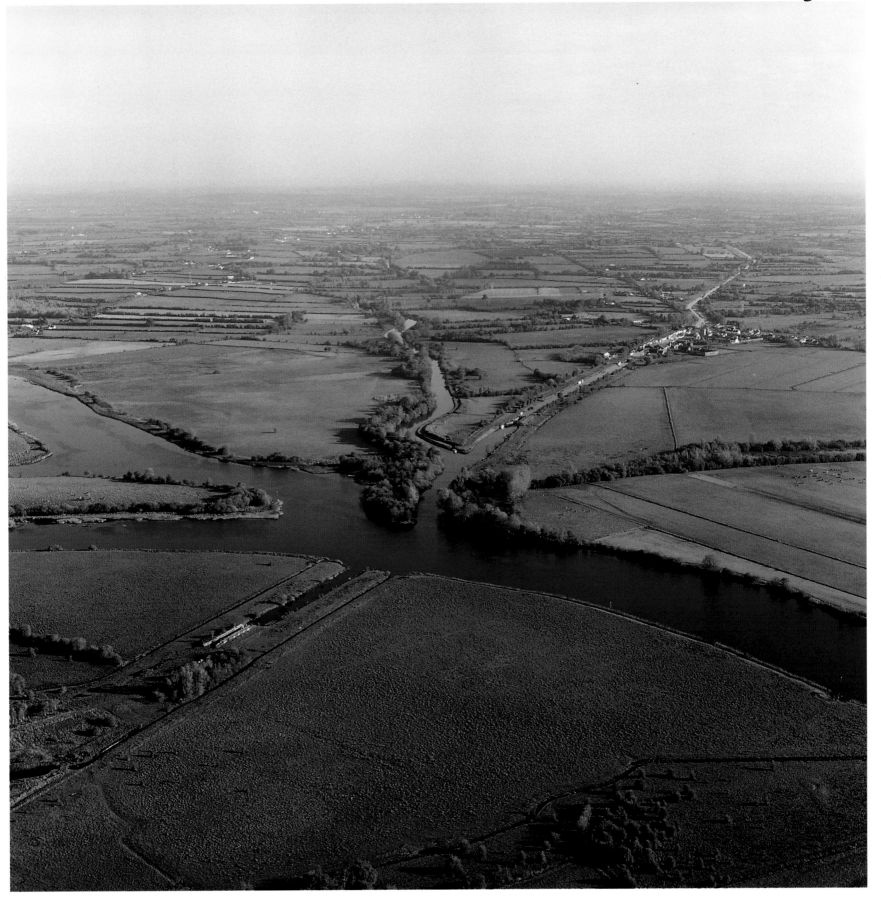

Facing page: The town and bridge at Banagher, County Offaly, where an excellent new harbour was constructed in recent years. *Above*: The Shannon Navigation passing the entrance to the Grand Canal and Shannon Harbour. The entrance to the old Ballinasloe Canal can be seen in the foreground.

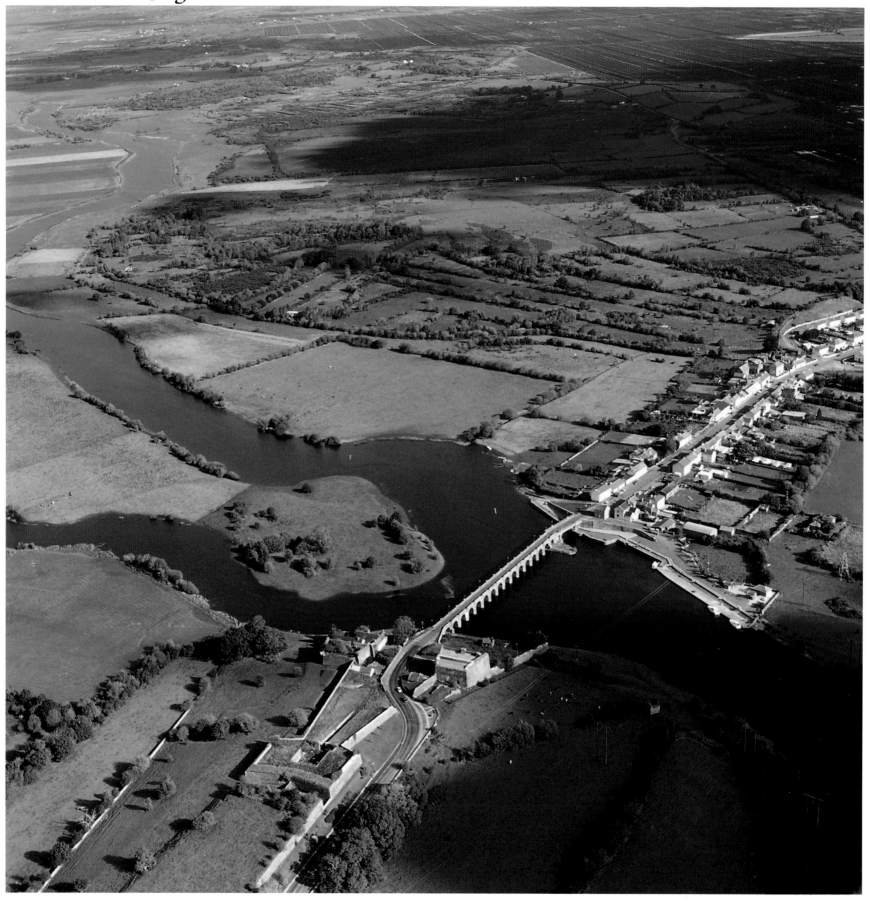

The magnificent Shannonbridge which was built in 1757.
The anti-Napoleonic fortifications were completed in 1817.
Facing page: The Shannon meandering around Clonmacnoise, the ancient crossroads of Ireland.

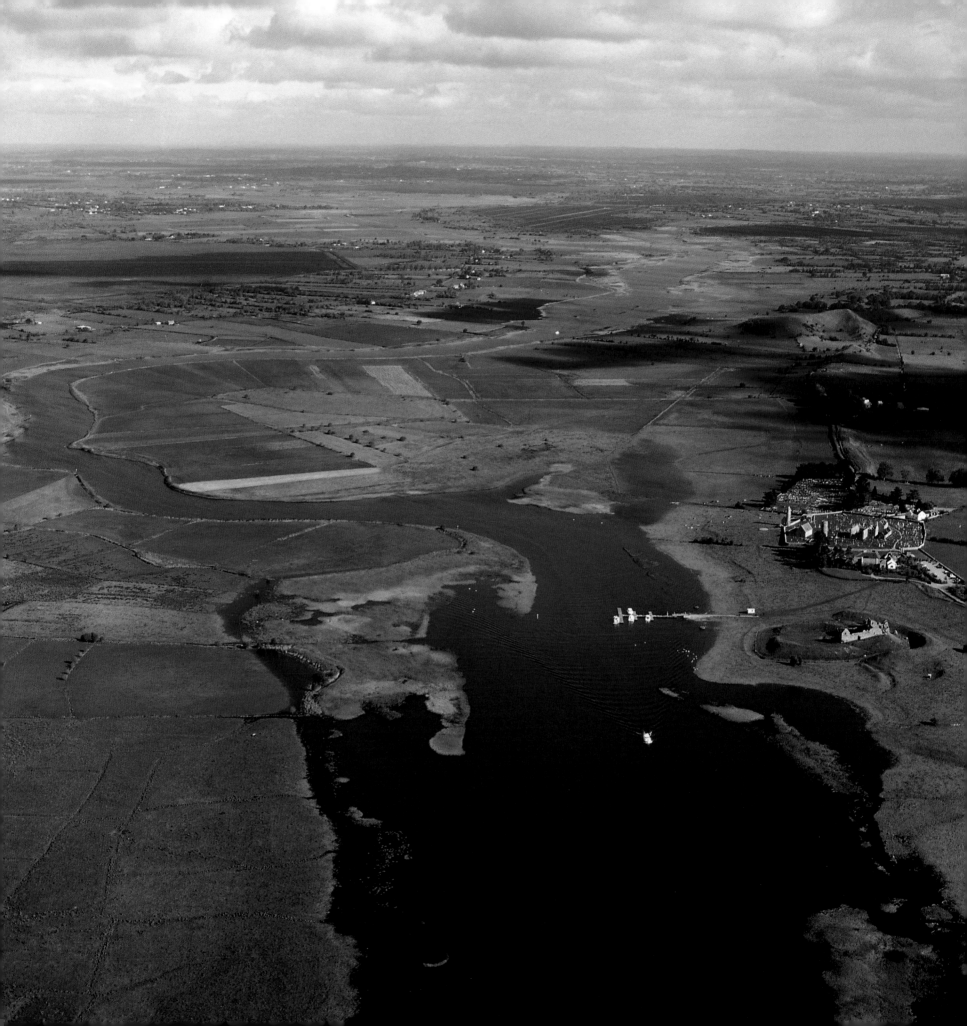

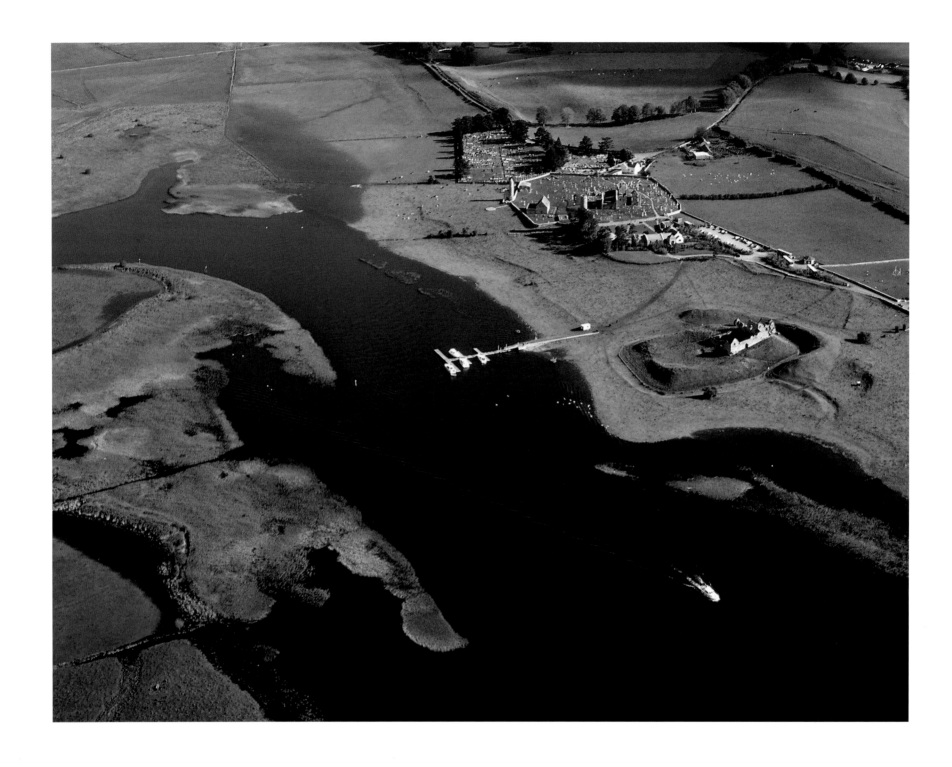

A closer look at the monastic ruins of Clonmacnoise which was founded
by St Ciarán in about 545 AD. Once a great collegiate school and centre of early Irish art, it
attracted thousands of students and survived countless plunderings over several centuries.

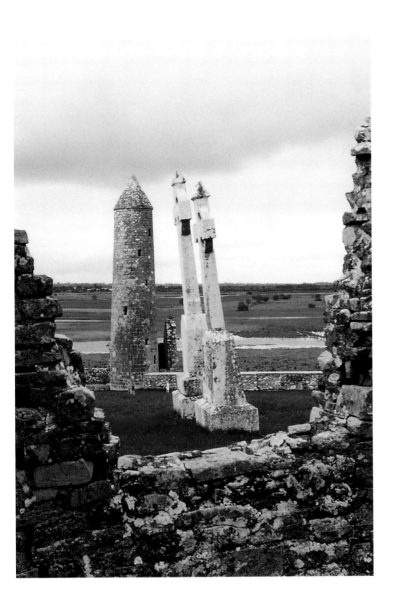

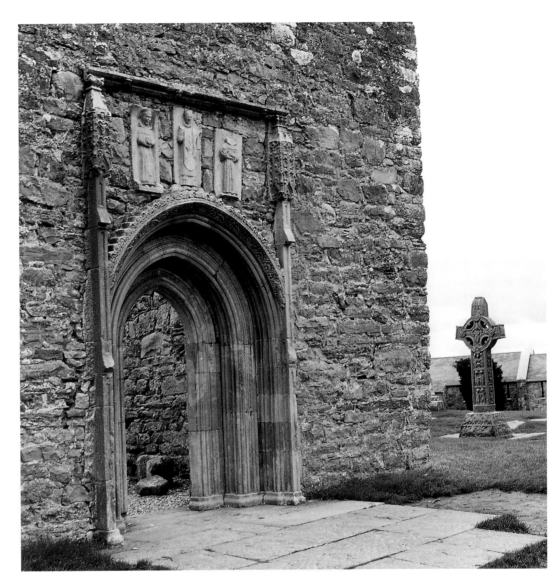

Left: Distinctive Irish High Crosses with the Round Tower known as Temple Finghin.

Right: The magnificent north doorway of the Cathedral with the carved figures
of Saints Dominic, Patrick and Francis.

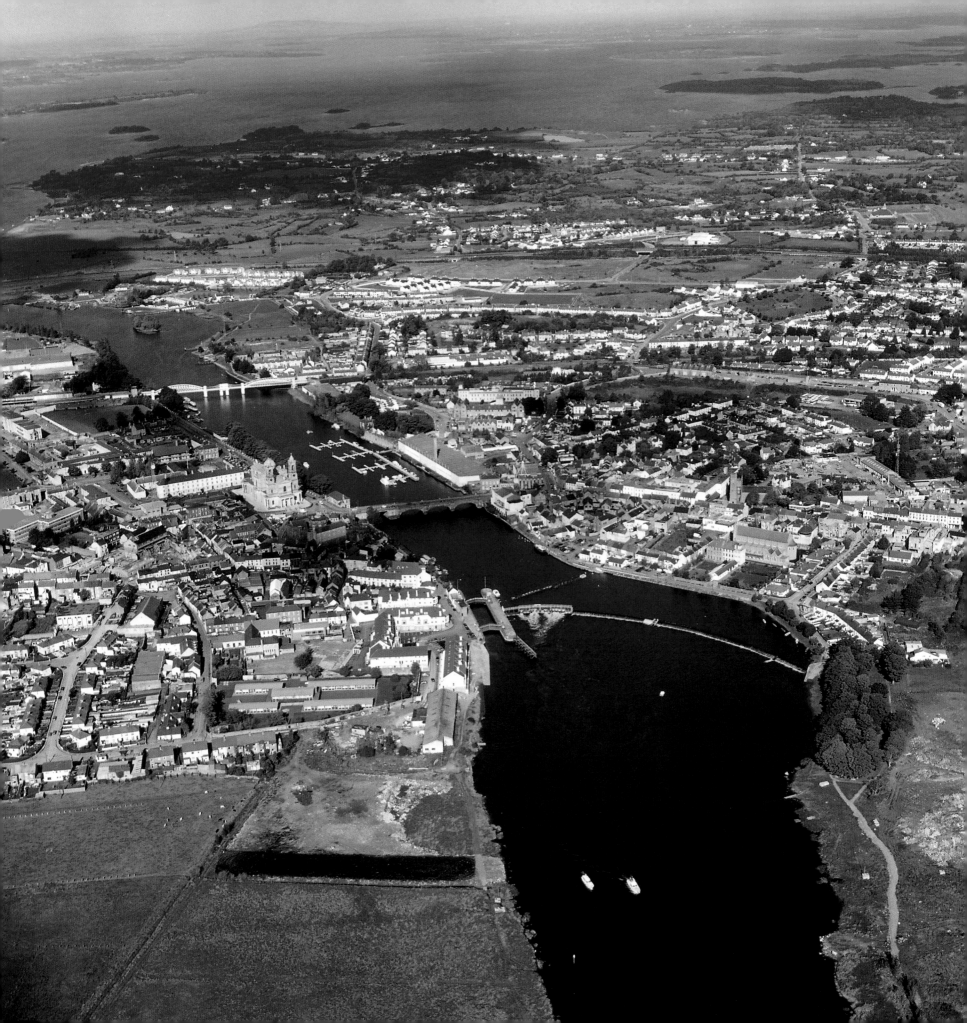

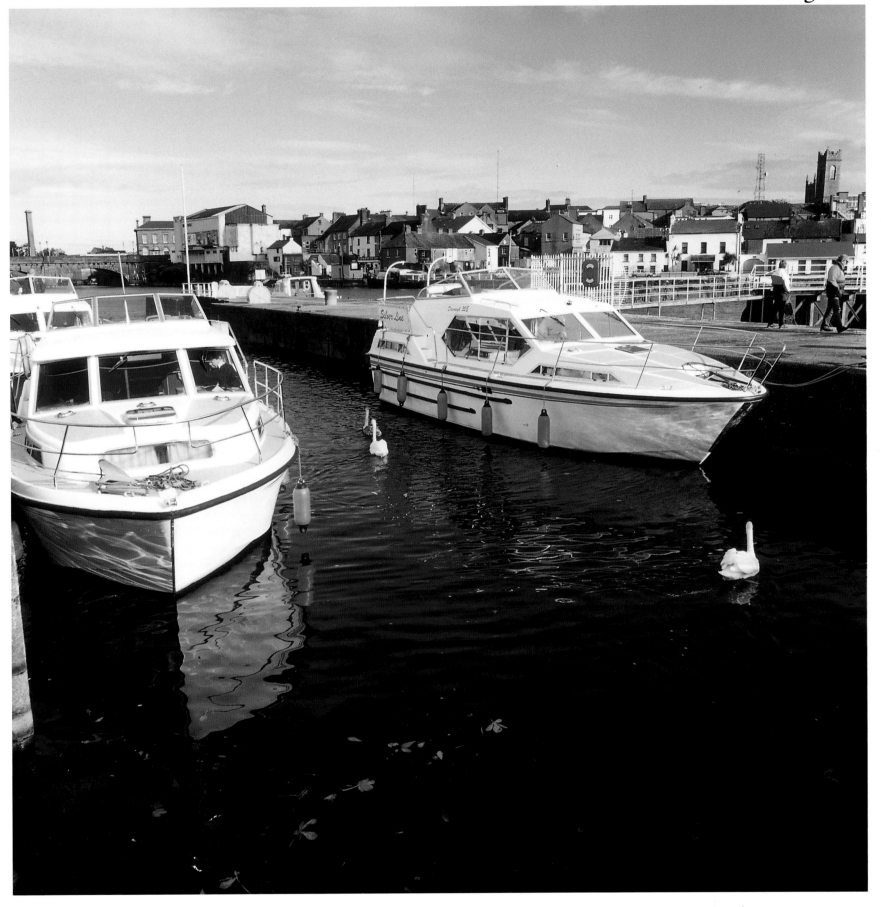

Facing page: Athlone in County Westmeath from the south, with the approaches to Lough Ree beyond the railway bridge. *Above:* Cruisers descending through Athlone Lock.

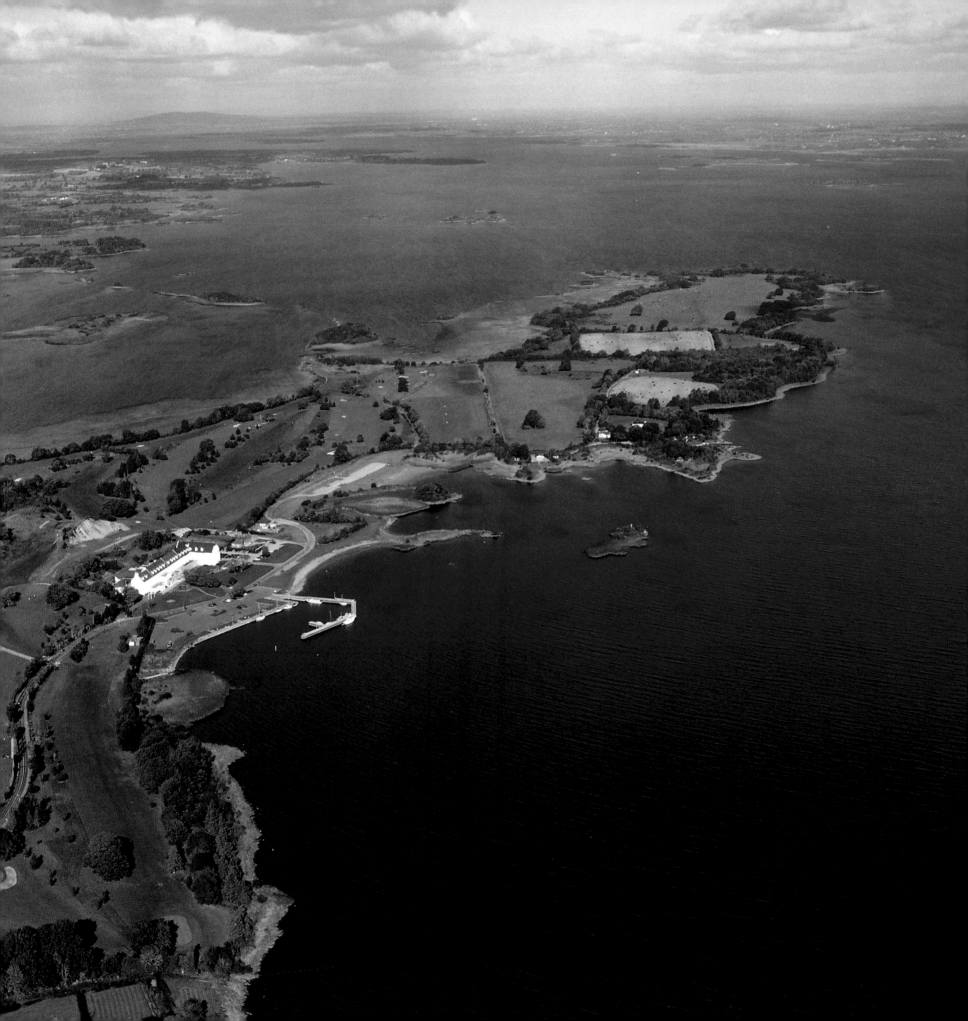

Facing page: The harbour and hotel at Hodson Bay, County Roscommon, with Lough Ree stretching away in the distance. *Above:* Ballykeeran Harbour in Killinure Lough, County Westmeath, off the east side of Lough Ree.

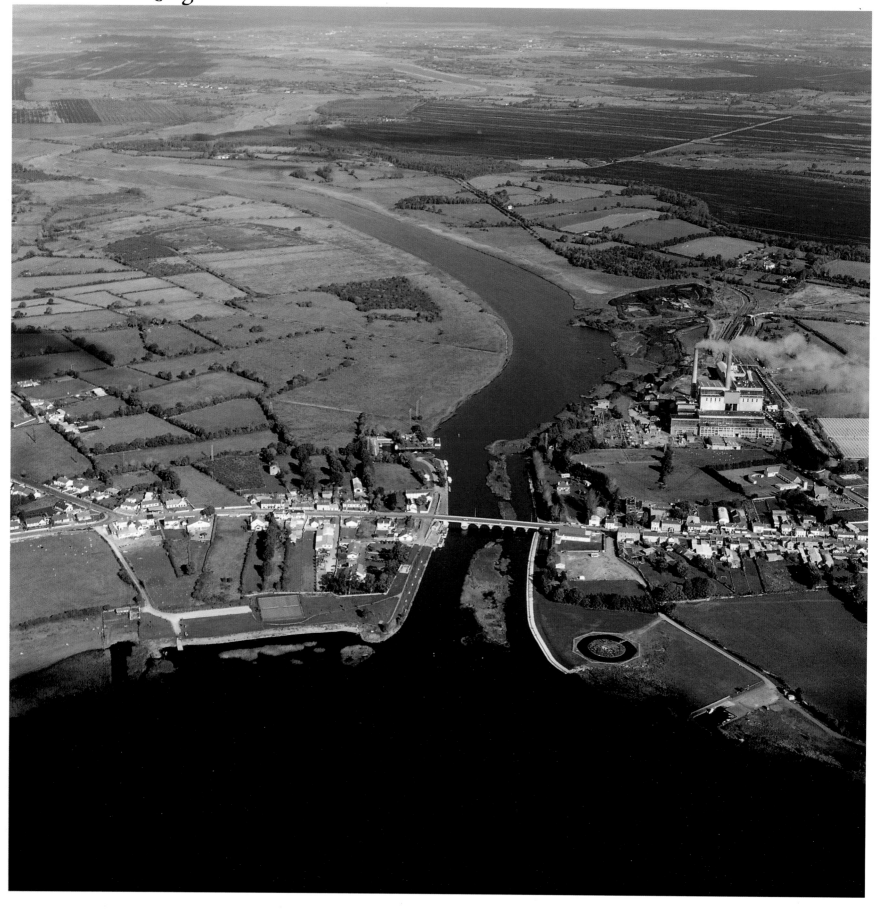

Lanesborough in County Longford, at the north end of Lough Ree.
Facing page: Tarmonbarry, just north of Richmond Harbour at Cloondara and the end of the Royal Canal.
The lock leads up to the opening bridge next to the very welcoming Roscommon village.

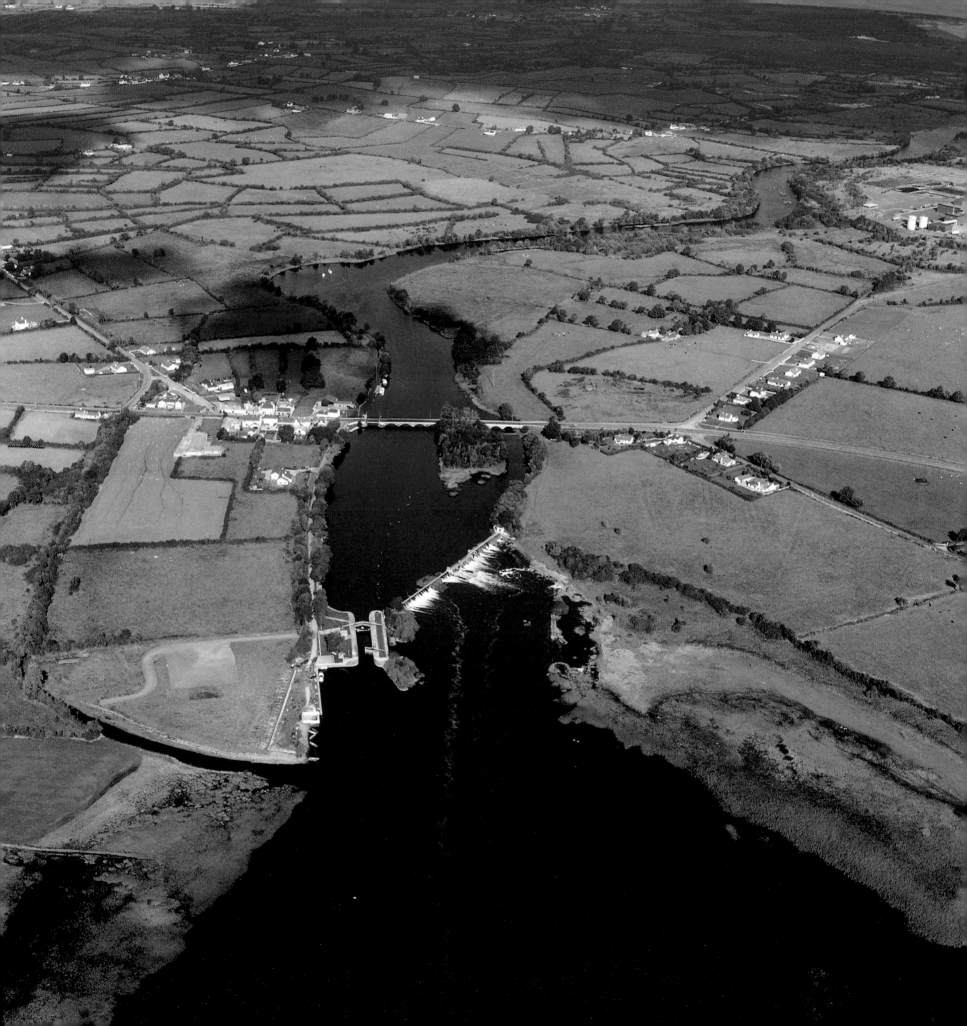

Roosky Lock, County Leitrim, quite busy in the summer. The red cast-iron sluice box, built in 1848, houses the modern hydraulic lock-operating mechanism.

Facing page: Roosky Lock and Weir with the village and bridge in the distance.

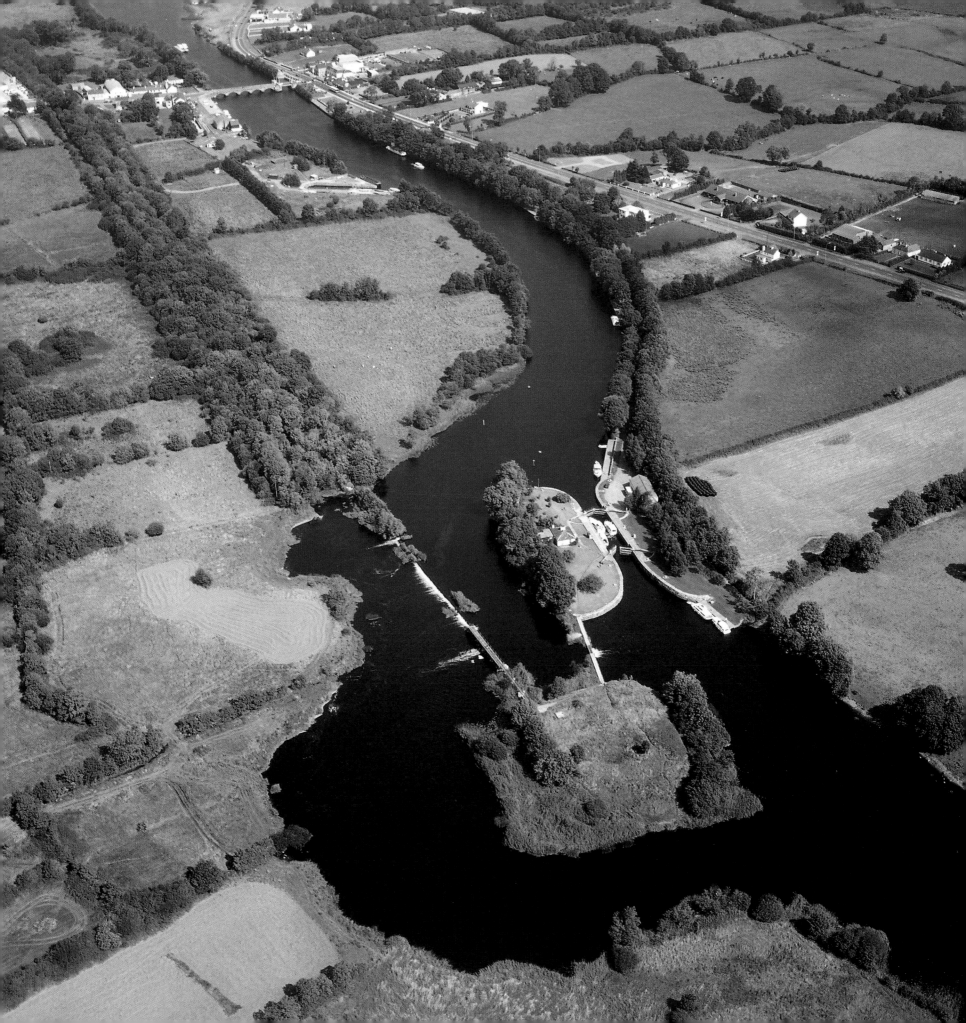

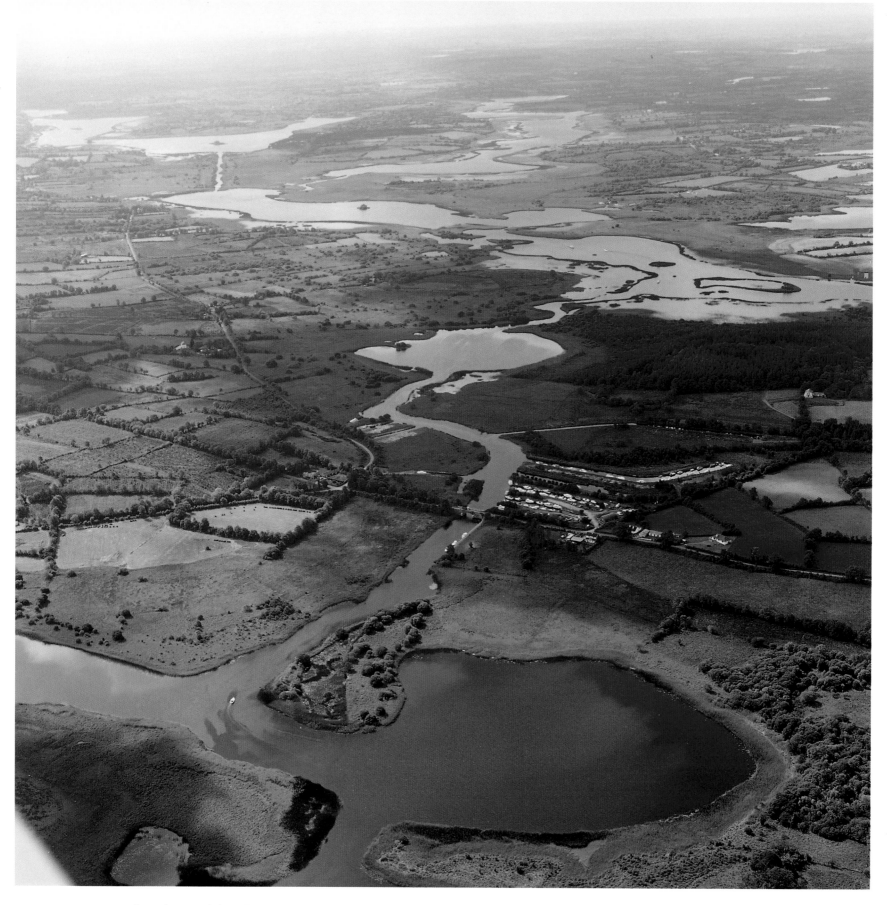

The channel leading west from the Shannon to Carnadoe Waters in County Roscommon
and onward by narrow winding channels to Grange Lough and Kilglass Lough.

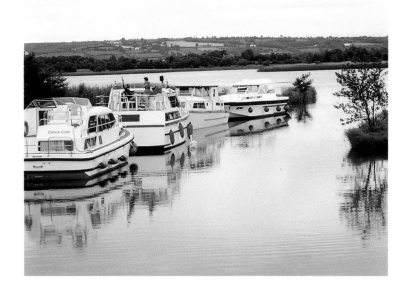

Cruisers staying overnight at Grange Quay
and *(below)* the pleasure of rowing.

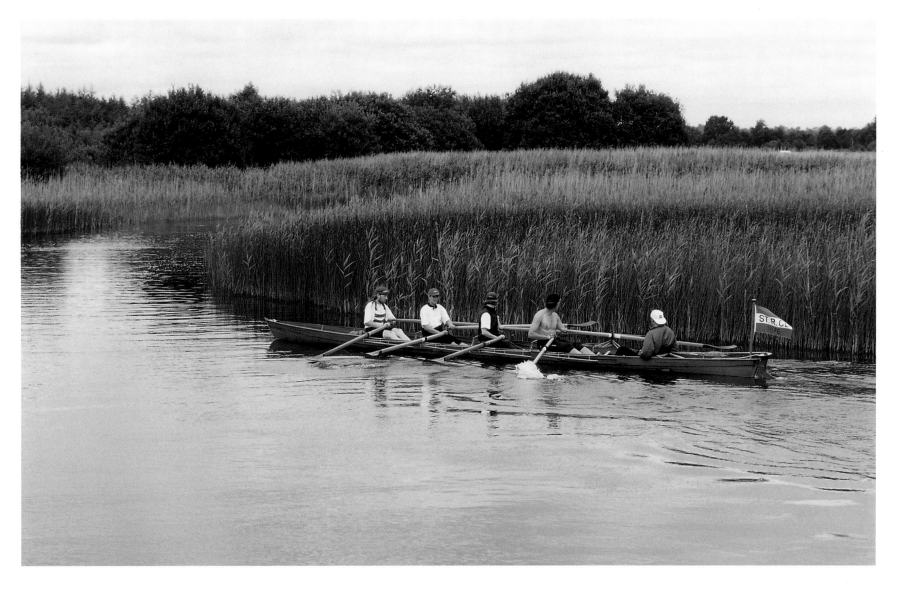

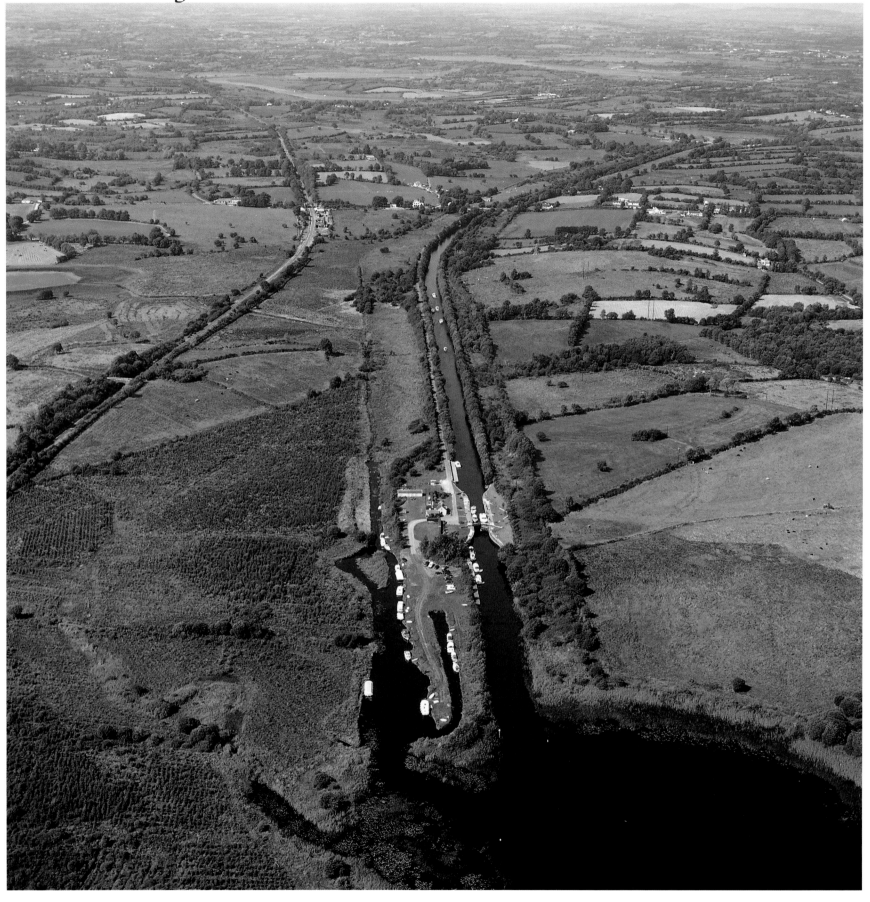

Albert Lock, County Roscommon, leading to the Jamestown Canal
which was constructed in the 1770s.

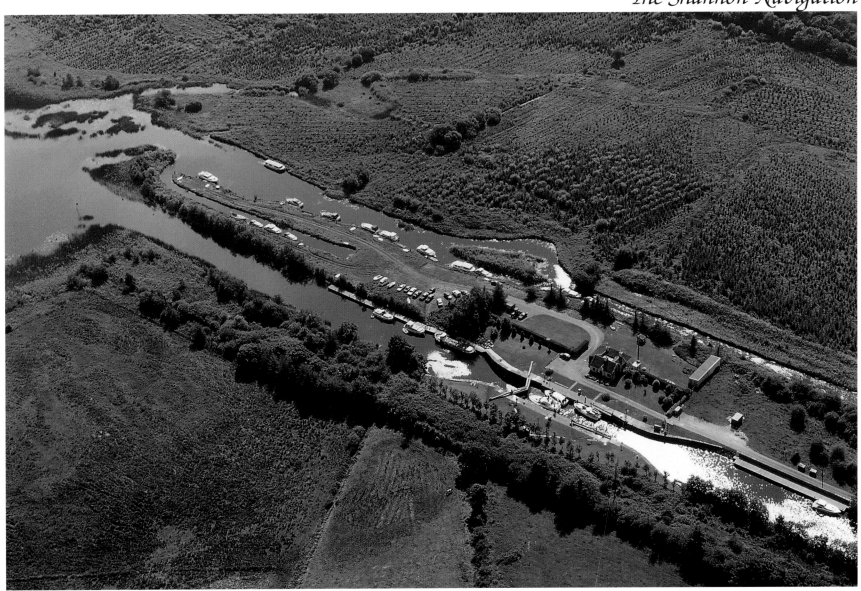

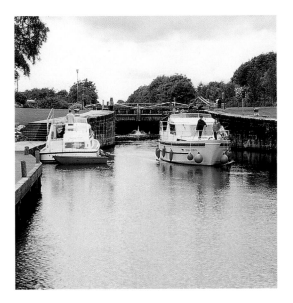

A closer look at Albert Lock and *(below)* navigating a Shannon lock.

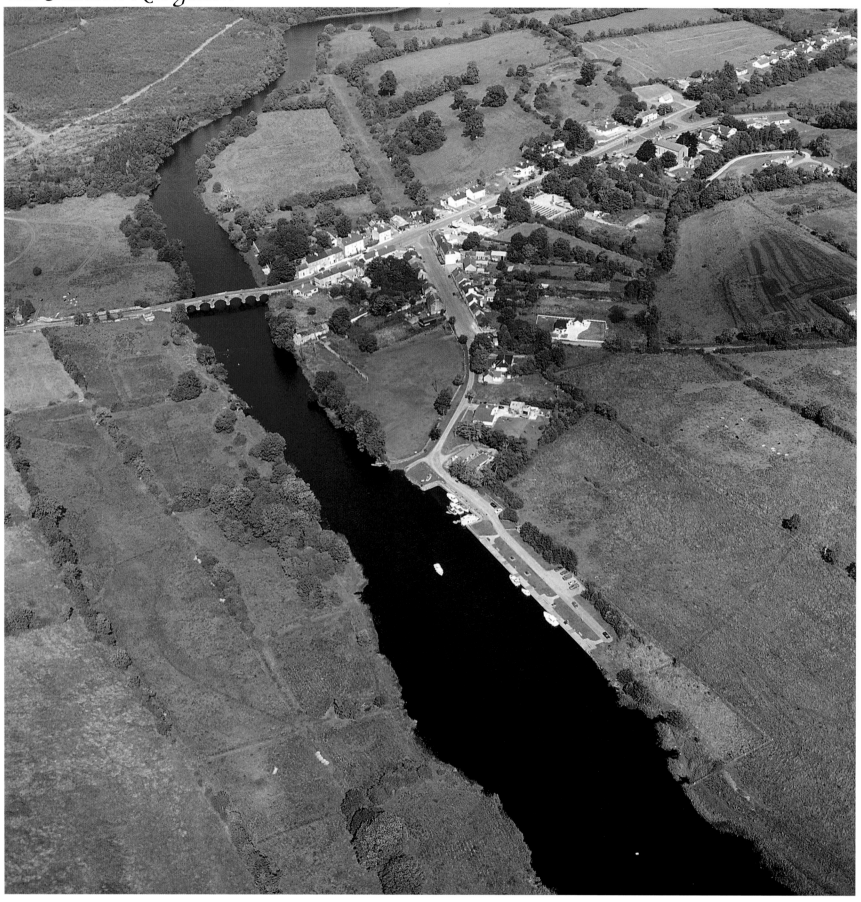

The quay and village of Drumsna, County Leitrim, at the southern end of the Jamestown Canal.

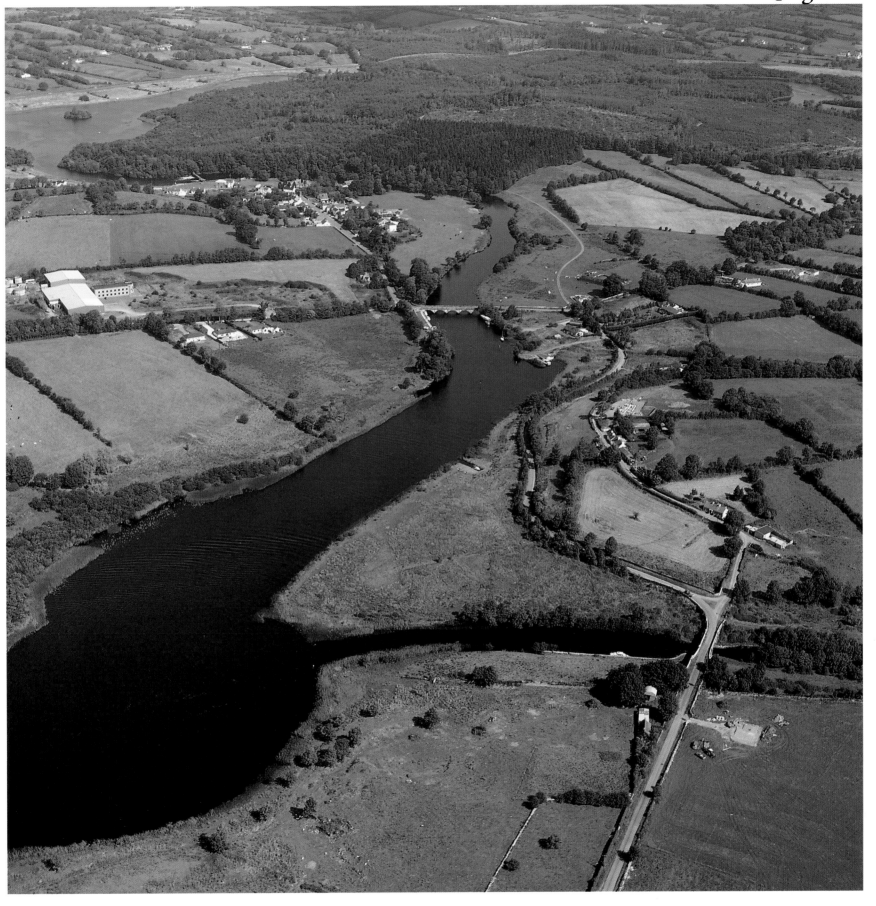

The northern end of the Jamestown Canal coming in from the right with the navigation
going left for Carrick-on-Shannon or right to Jamestown village.

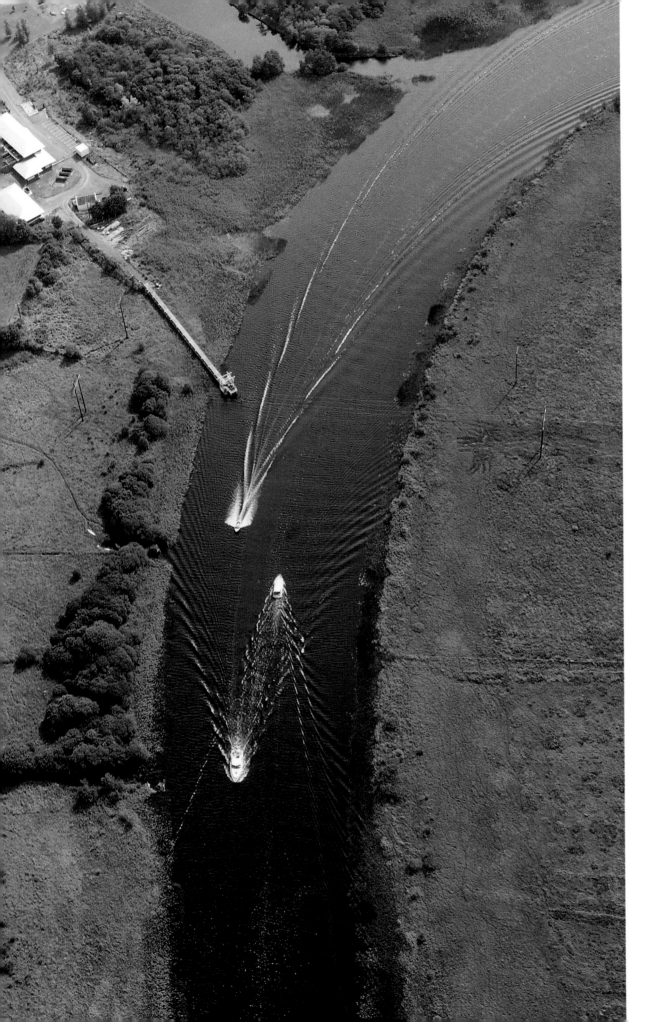

Boats passing on the Shannon and *(below)* the marina at Rosebank to the south of Carrick-on-Shannon.

Facing page: The town and cruiser base of Carrick-on-Shannon viewed from the southeast. The turning to the northwest 2.5km upstream for the Boyle River and Lough Key is clearly visible. The Shannon Navigation to Leitrim and Lough Allen heads to the northeast near the top right of the picture.

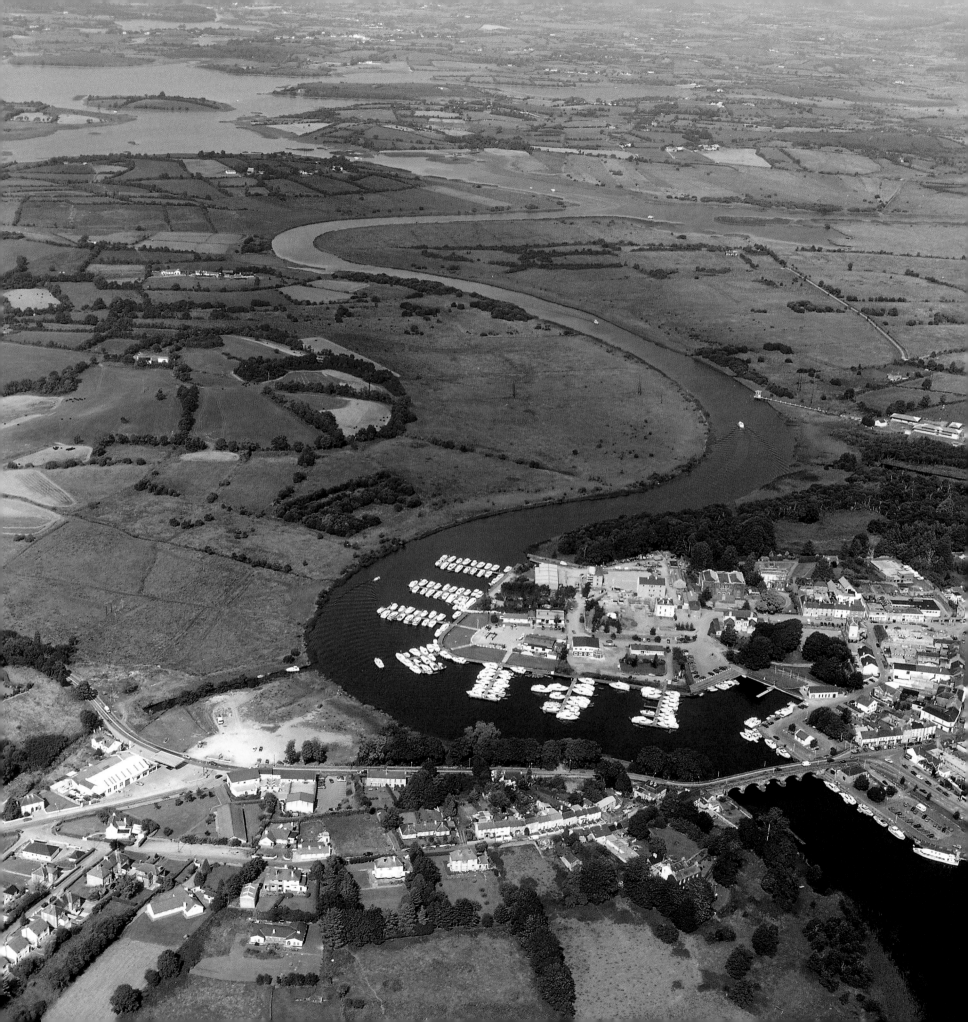

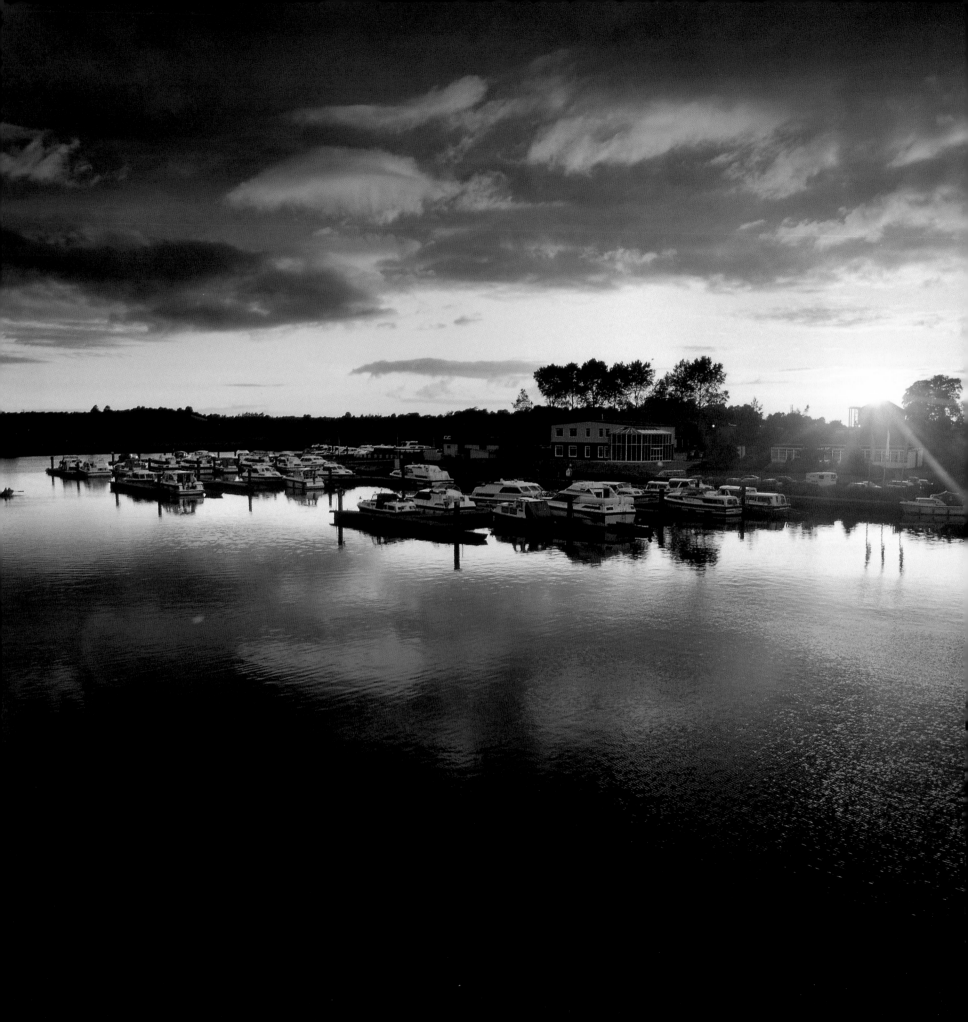

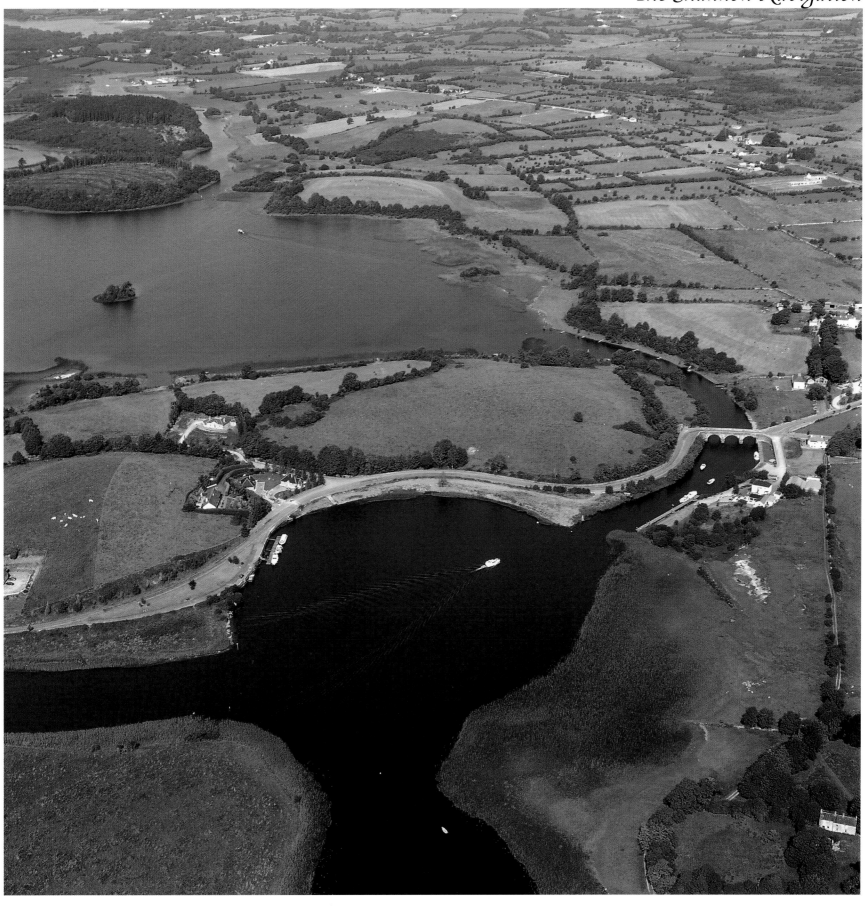

Facing page: Sunset over Carrick-on-Shannon.
Above: Travelling up the Boyle River to Cootehall, County Roscommon,
with Oakport Lough beyond the bridge.

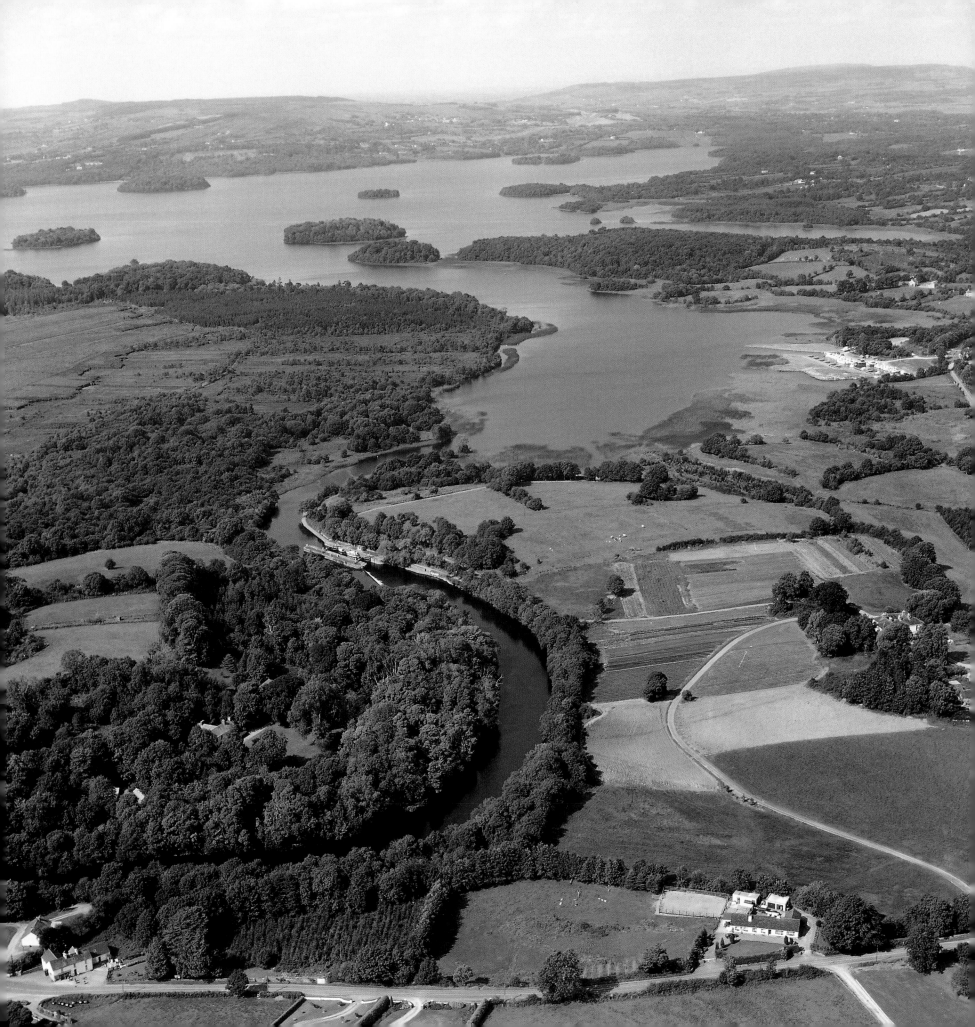

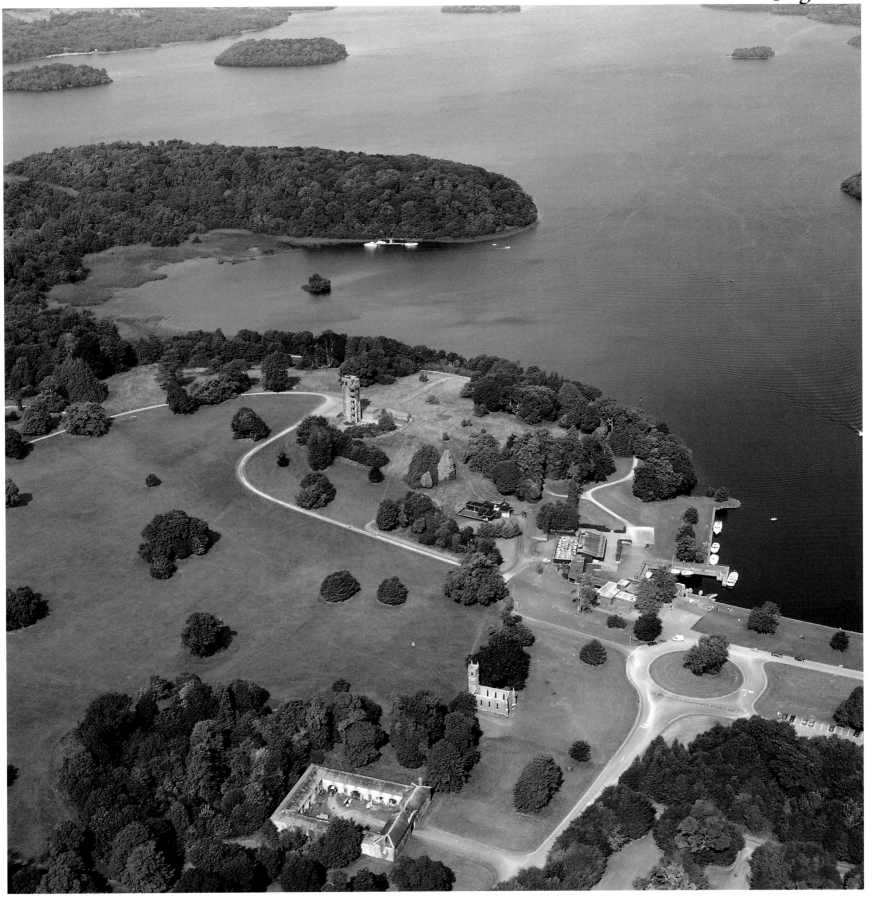

Facing page: The Boyle River leading to Clarendon Lock and Lough Key.
Above: Lough Key National Park with the farm buildings
of Rockingham House in the foreground.

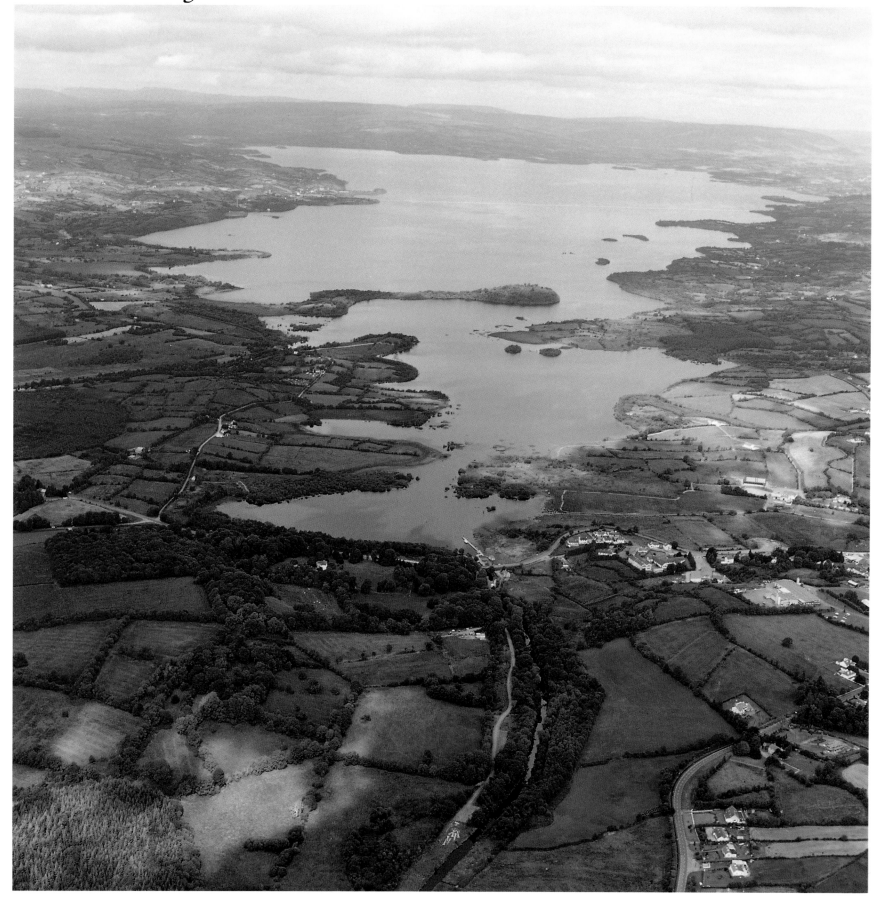

The Lough Allen Canal leading past Drumshanbo to Lough Allen, at the northern end
of the Shannon Navigation and 215km from Limerick.

The Shannon - Erne Waterway

Referred to sometimes as the Ballinamore/ Ballyconnell Canal, this waterway operated from 1860 to 1869 and was built to provide a link from Belfast to the Shannon and on to Limerick. The 61-kilometre waterway cost £250,000 and was never constructed to the required specification. During its years of commercial operation, tolls of £18 were collected from eight boats.

During the 1990s, the Shannon - Erne Waterway was not only restored but was developed into a very modern and user-friendly waterway with locks operated by an automatic system.

From the western end you enter the Shannon - Erne Waterway near the village of Leitrim. Heading east you travel up through eight locks including three close together at Kilclare before entering a spectacular rock cut which leads you into Lough Scur at the summit of the navigation.

The Shannon Navigation from Killaloe to Lough Allen rises a mere 12m. The Shannon - Erne from Leitrim rises twice that figure to Lough Scur. On the way up you will have been navigating on the Shannon marker system, a red circular marker on the left or port side and a black square marker on the right or starboard side. Passing Whiskey Island in Lough Scur, you enter the Erne Navigation marker system with white and red semi-circular markers. Craft must pass on the side painted white.

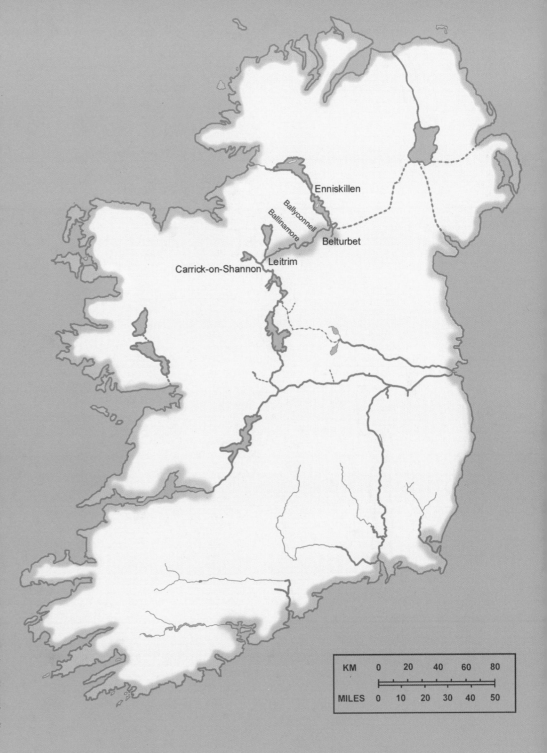

On the southern shore you come to the quayside and village of Keshcarrigan. From here you have to treat the navigation markers with great respect as you travel a very narrow channel leading down and eastwards along the waterway.

You sail past the golf course and arrive at Ballinamore where there are three different mooring options, one above Lock 6 and two below. This is an interesting town with friendly pubs.

Heading east, you enter Lough Gardice, the largest on the navigation with Haughton's Mooring just beyond it. From here the waterway takes you to the town of Ballyconnell and finally by the Woodford River down to the Erne Navigation.

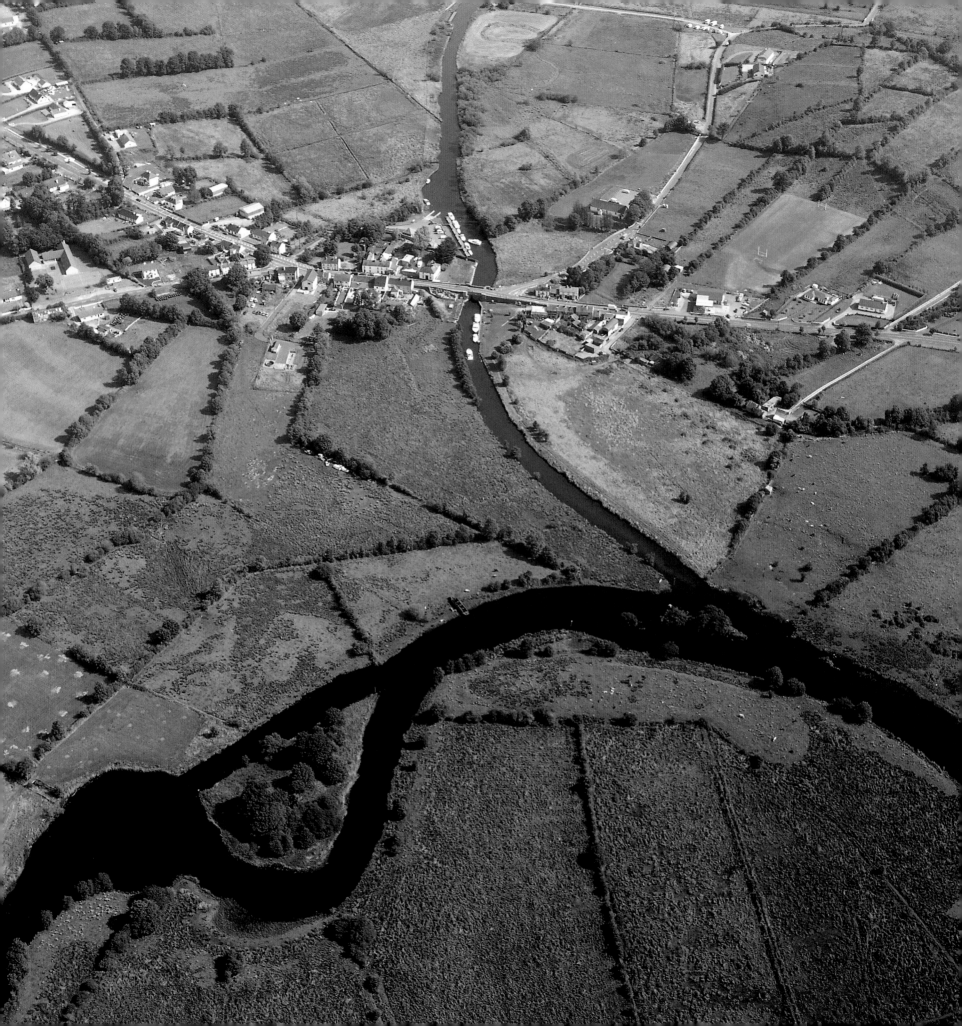

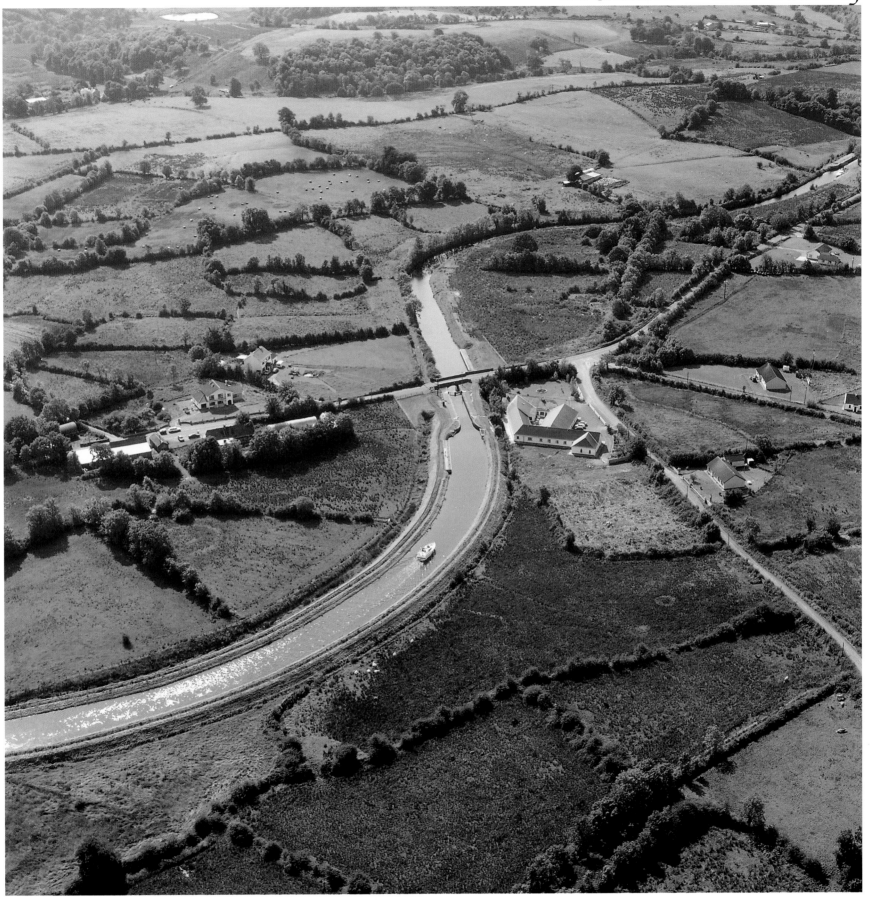

Facing page: The Shannon - Erne Waterway heading up and east from the Shannon to the start of the navigation at Leitrim village. *Above:* A cruiser heading back towards Lisconor Lock 12.

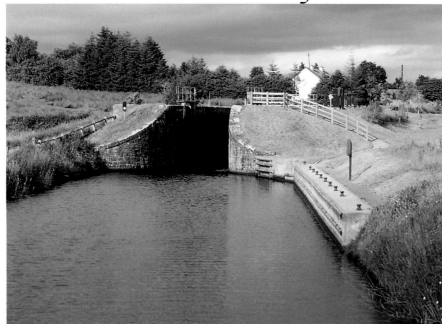

Green light to enter Kilclare Lower Lock.

A cruiser between Kilclare Lower and Middle Lock.

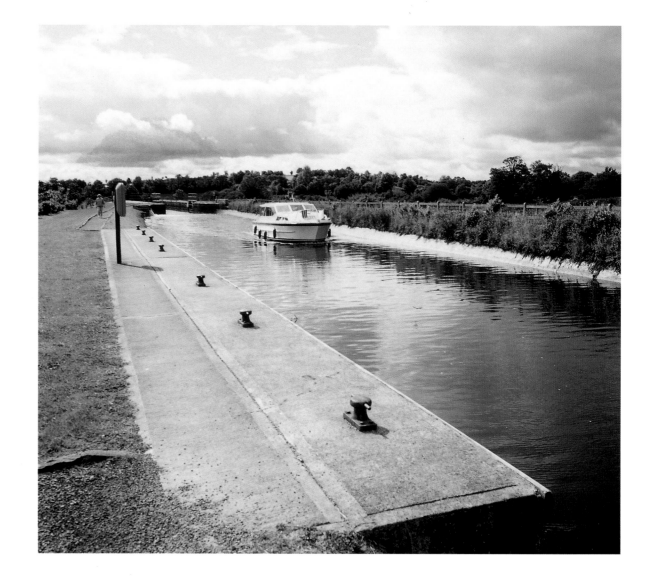

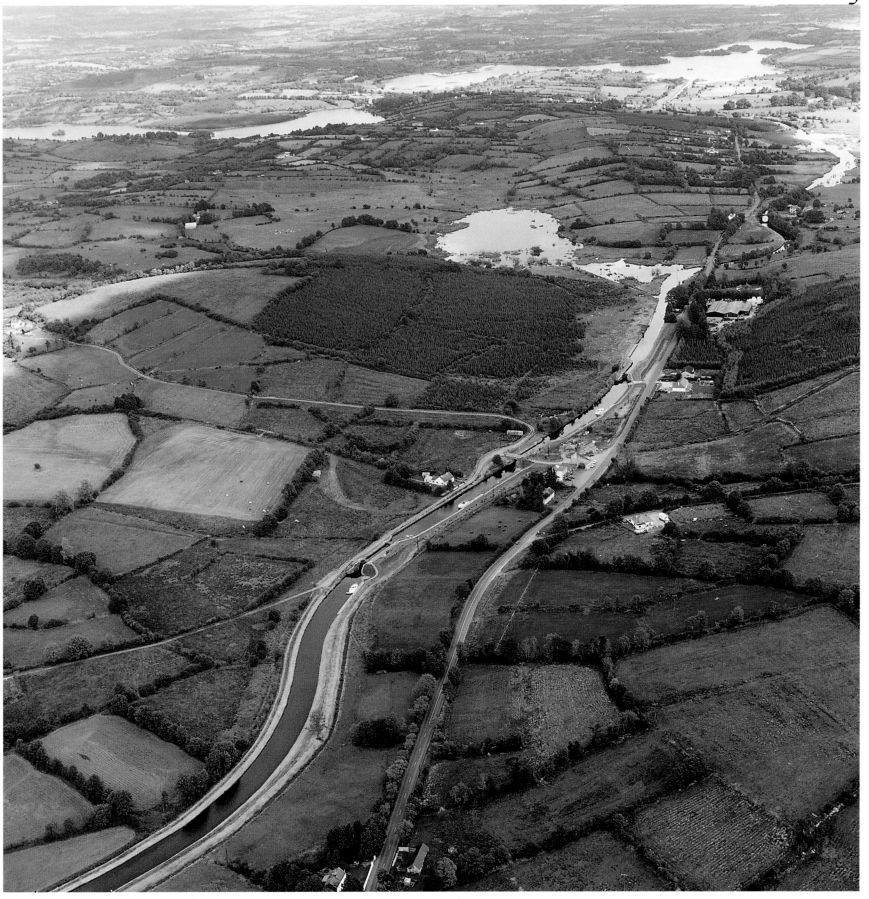

The Shannon - Erne Waterway rising up through Kilclare
Lower, Middle and Upper Locks 11, 10 and 9.

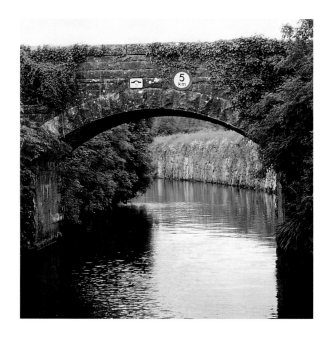

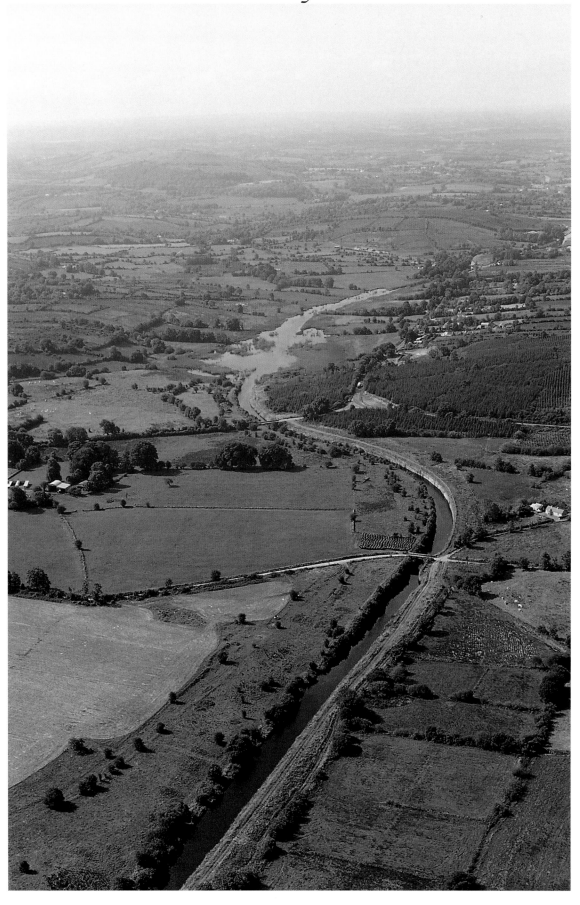

Looking back over the rock cut between Drumaleague Lough and Lough Scur and a close up view of the rock face near bridge Number 11.

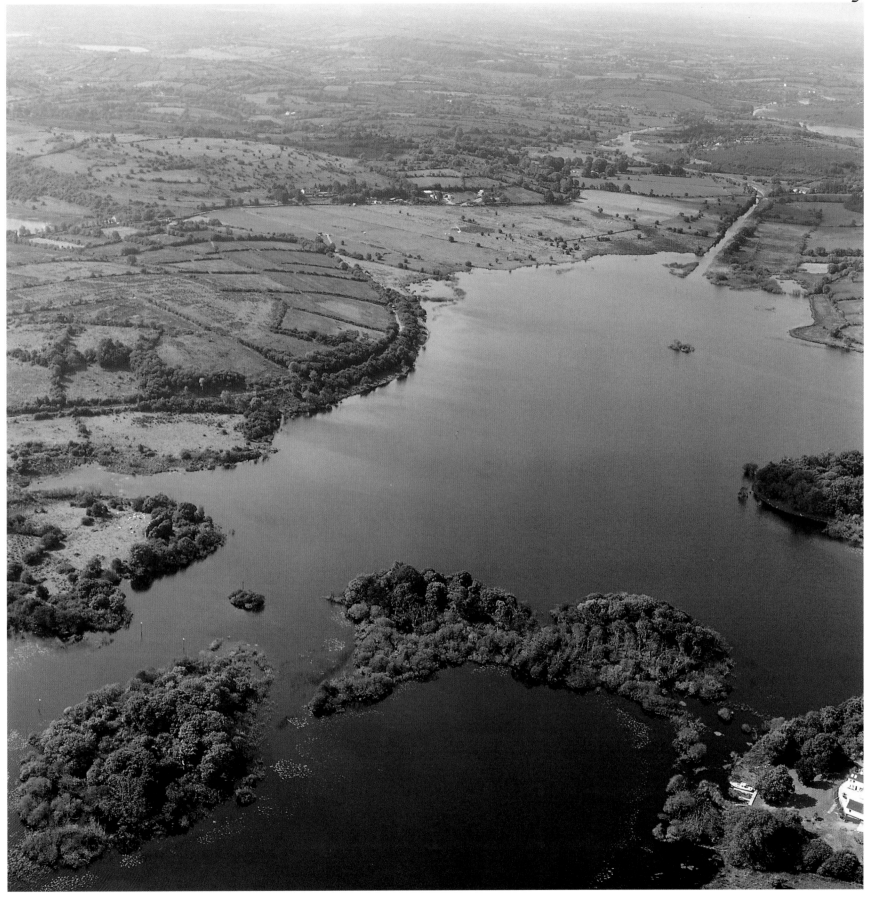

Lough Scur, the summit level of the Irish inland waterways system, viewed from the northeast.

Changeover point in Lough Scur from the Shannon System Markers, red on left and black on right going upstream, to the Erne Marker System, where craft must pass on the side painted white.

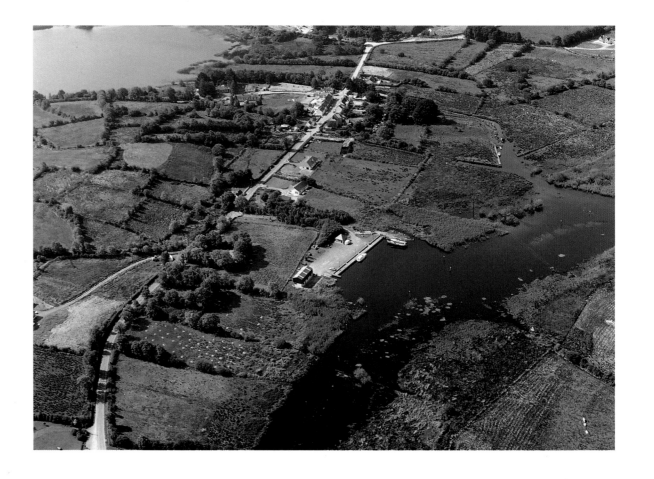

A view down on Keshcarrigan Quay in County Leitrim.

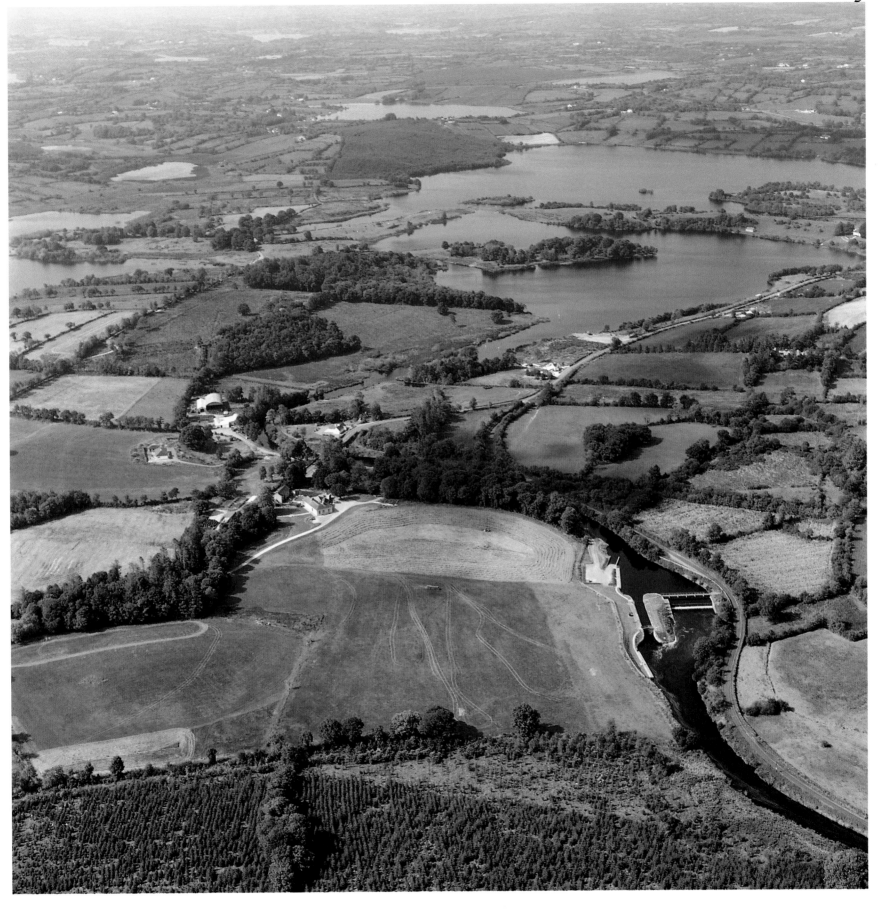

Ballyduff Lock 7 from the east with a backdrop of Kiltybardan Lough.

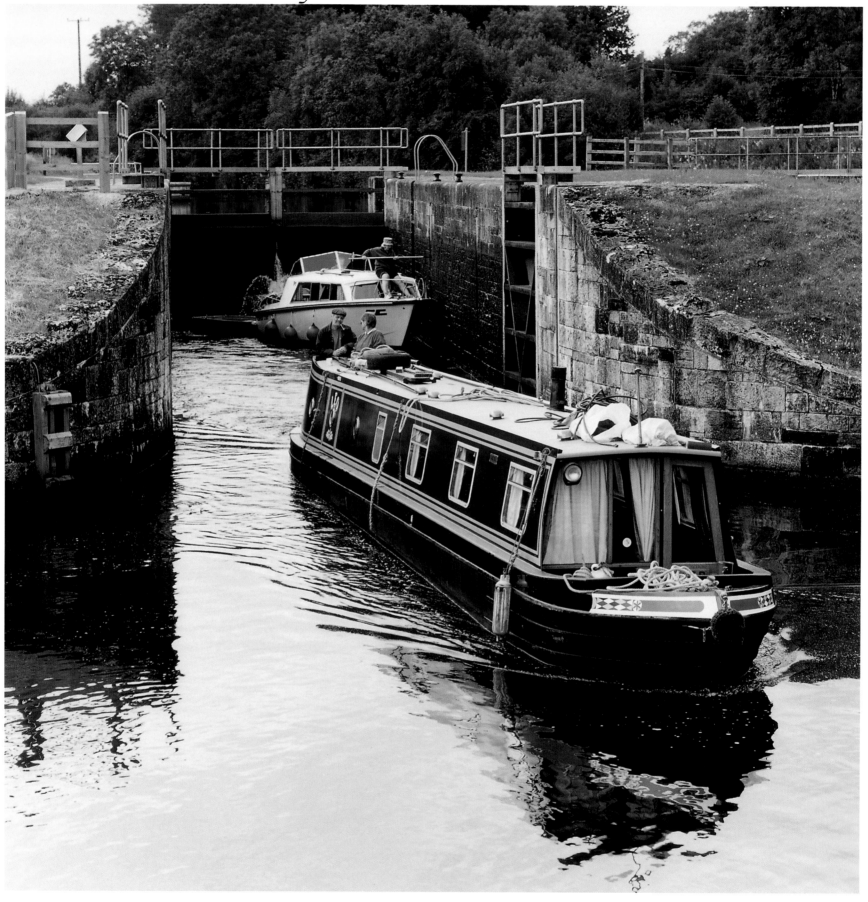

A narrowboat leaving Ballyduff Lock. *Facing page:* The town of Ballinamore
in County Leitrim with excellent quaysides above, below and in the town.

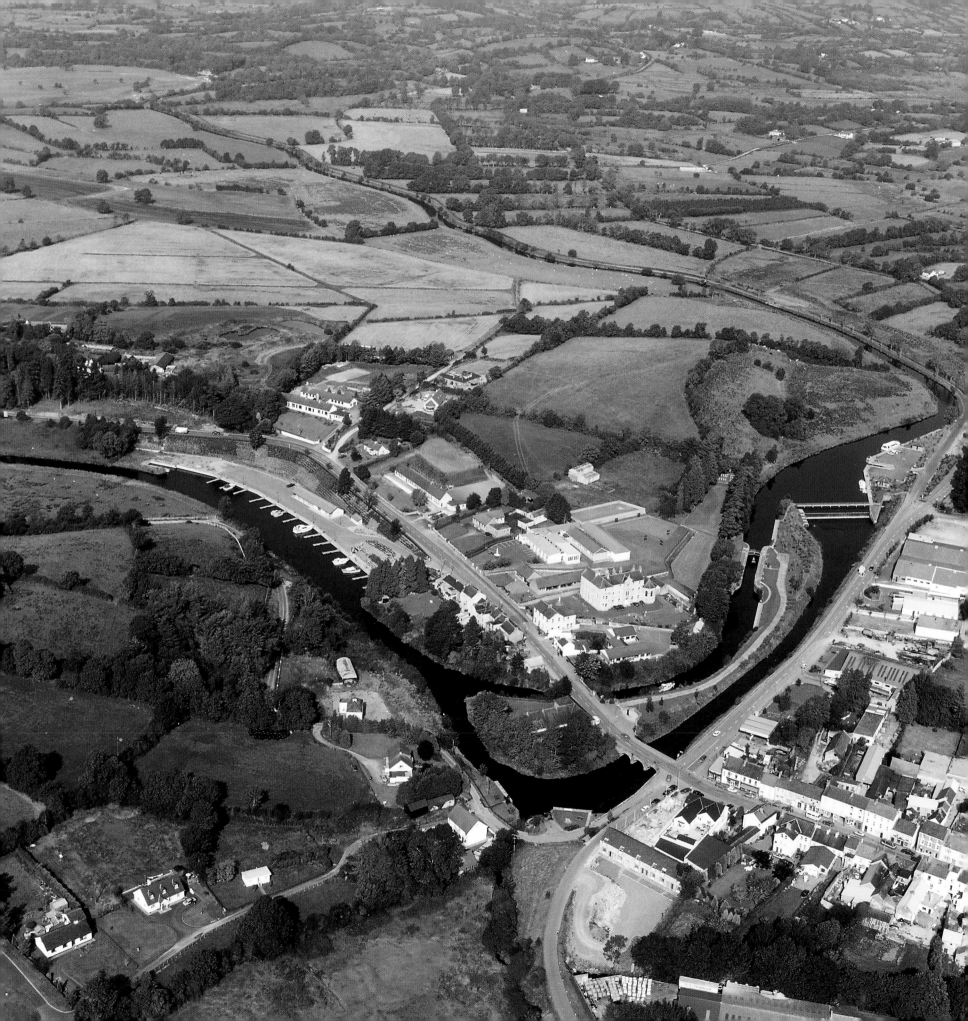

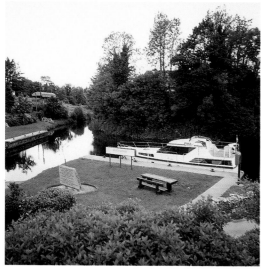

The quay in Ballinamore and *(below)* the Waterway passing down from right to left through Ardrum Lock 5.

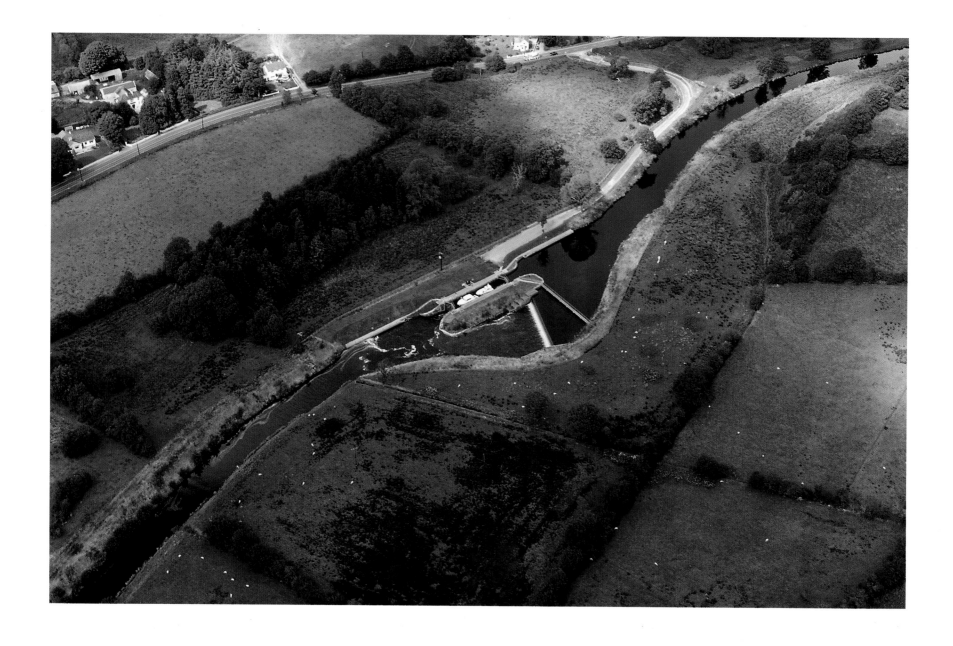

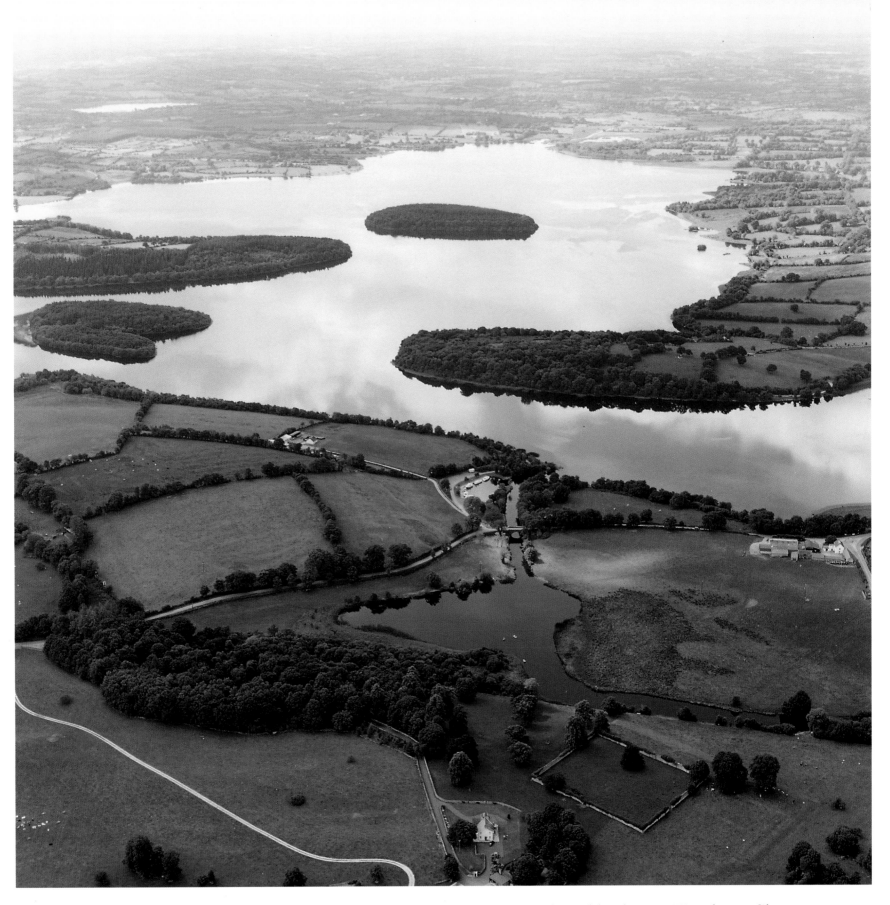

Garadice Lough, the largest on the Shannon - Erne Waterway, viewed back over Haughtons Shore.

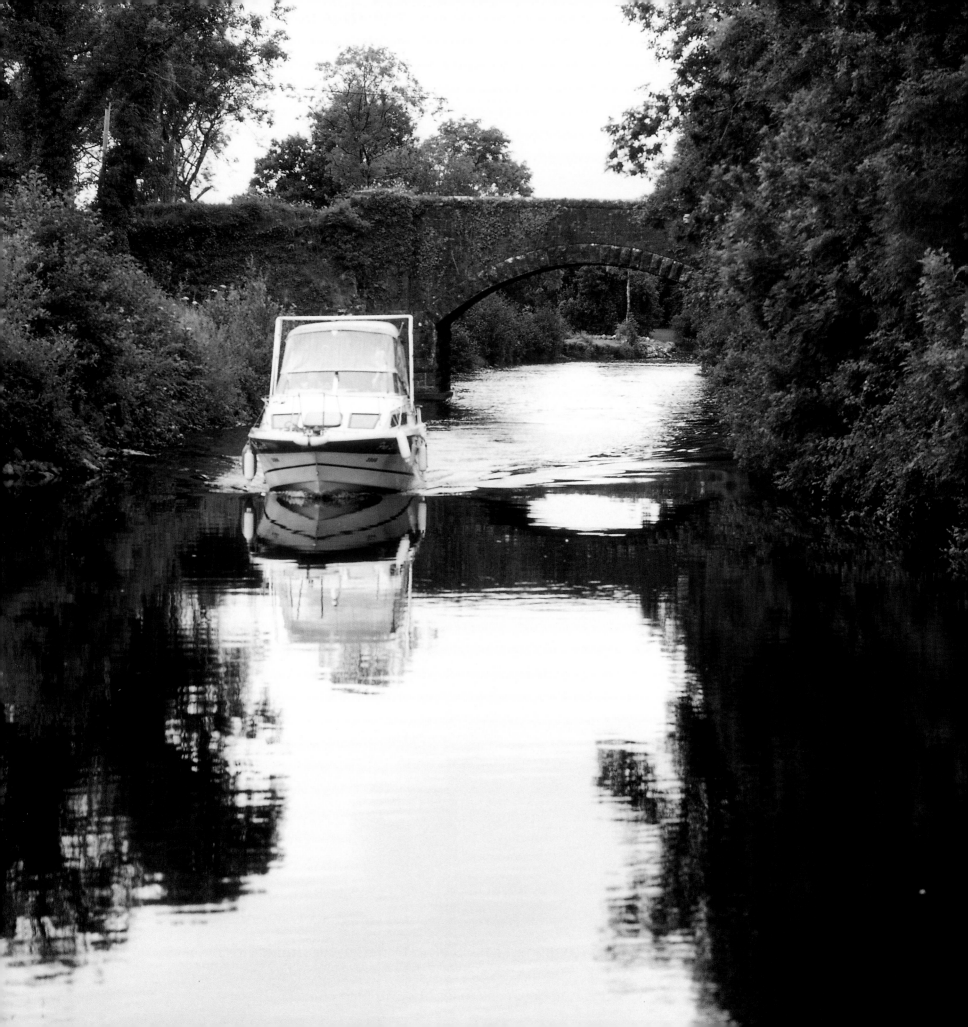

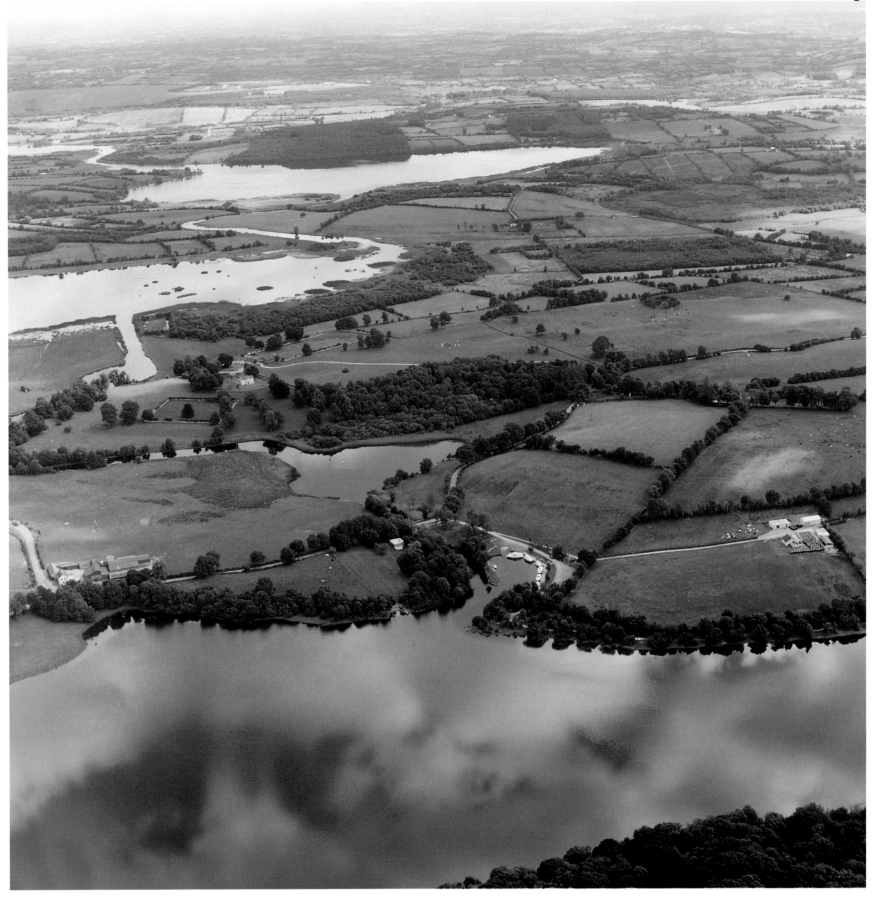

Facing page: A cruiser having just passed beneath Ballinacur Bridge close
to Haughtons Shore. *Above:* The mooring at Haughtons Shore with the waterway
weaving its way to the east, between County Leitrim and County Cavan.

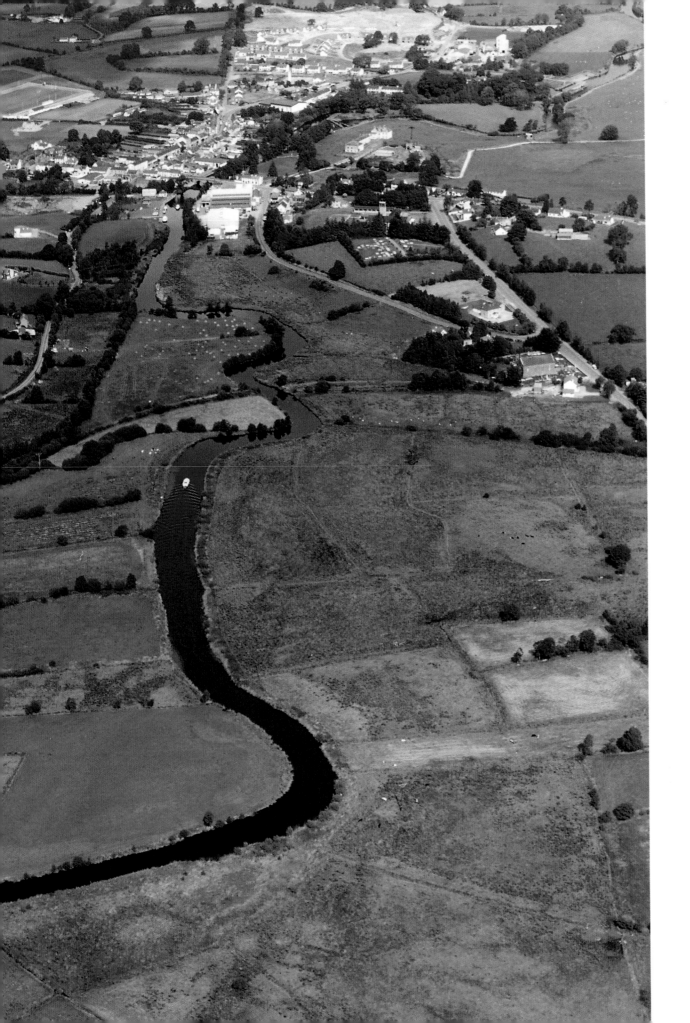

The waterway meandering its way into Ballyconnell, County Cavan, and a closer look at Ballyconnell Quayside.

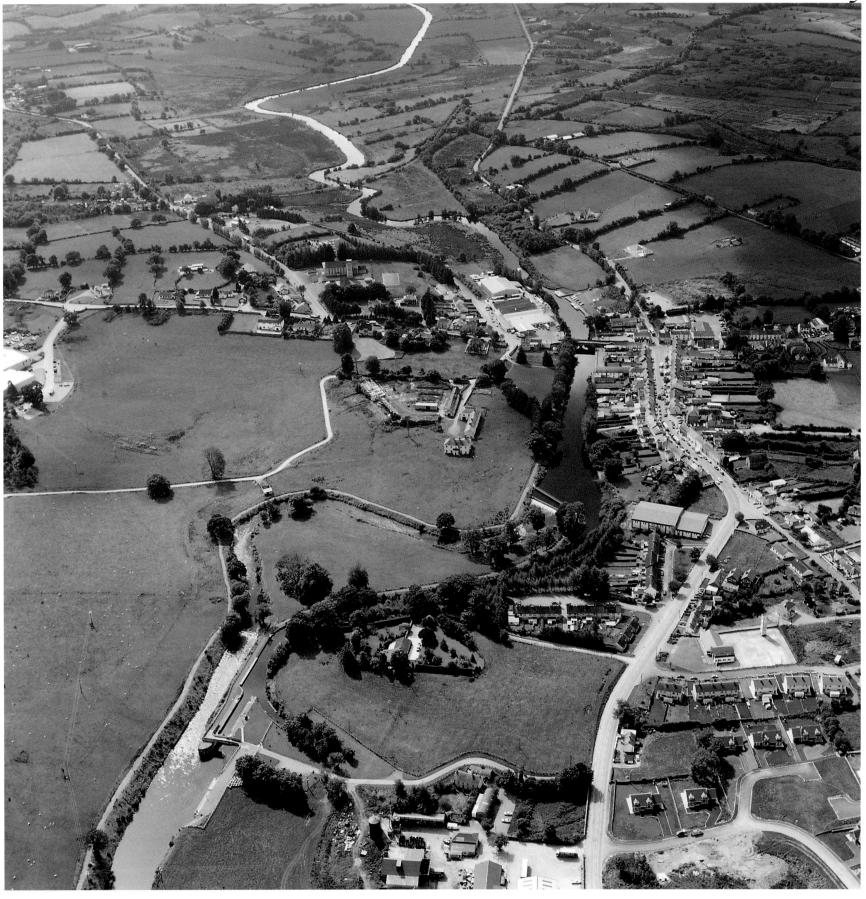

Looking from the north back down on Ballyconnell
with Lock 2 at the bottom of the picture quite far from the weir.

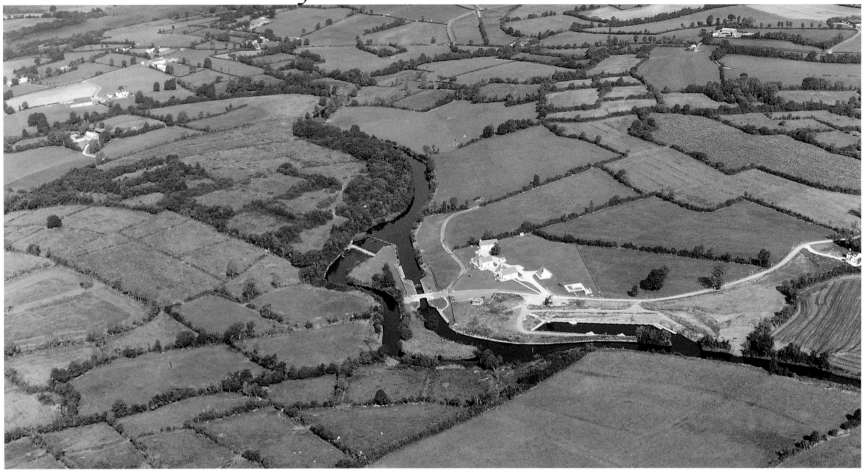

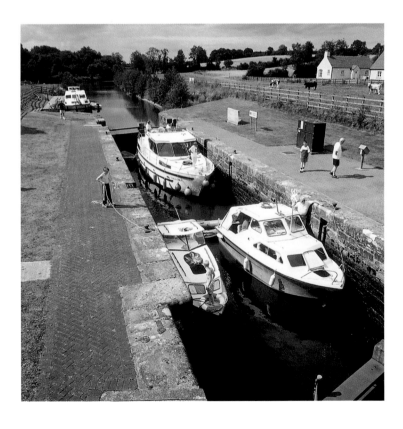

The Woodford River with
County Cavan on one side and
County Fermanagh on the other.
Left: Cruisers taking
their last step down to the Erne
at Corraquill Lock 1.

The Erne Navigation

This is a very beautiful waterway and comprises Upper Lough Erne which is linked through the town of Enniskillen to Lower Lough Erne. The distance from Belturbet at the southern end to Belleek is 85km. This waterway lies in drumlin country where a whole series of glacial islands appear to divide Upper Lough Erne into a number of different lakes.

There are many channels which can be navigated on the Erne Navigation because of numerous islands. Travelling from the Woodford River and the end of the Shannon-Erne Waterway, you can take a westerly channel south to the town of Belturbet in County Cavan.

Leaving the cruiser base of Belturbet by the easterly route and heading north you pass the jetty at Croom Castle, County Fermanagh, before heading around and again north past another jetty at Geaglum.

Inishcorkish Island in the centre of the navigation has a pub and restaurant, to the north of which you have to decide which way to go around Inishmore Island.

Our route takes us to the east past Carrybridge and then to Bellanaleck and the Moorings before arriving at the town of Enniskillen which throughout the ages has been the main crossing place of the Erne. There is a lock between Upper and Lower Lough Erne above Enniskillen. This operates if the water level is reduced by the hydroelectric scheme at Ballyshannon.

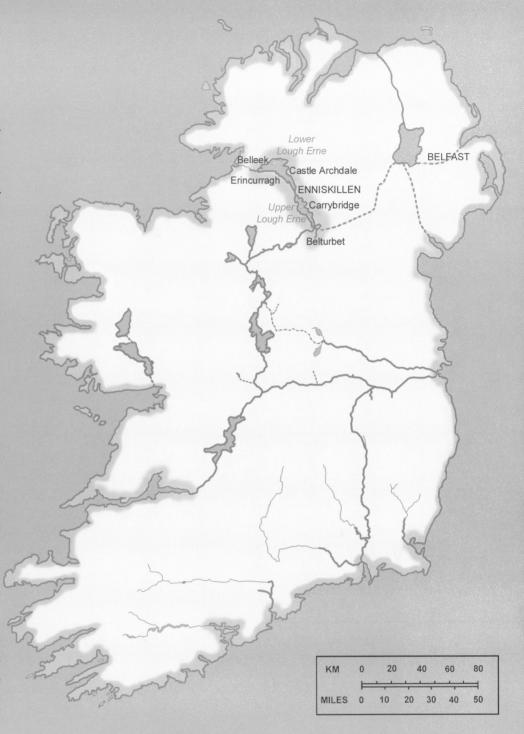

To the north above Enniskillen you enter Lower Lough Erne and come across Devenish Island which has one of the most important monastic sites in Ireland. Five kilometres up the eastern shore is White island where the church ruins have seven carved figures in the north wall.

A number of islands protect the east shoreline and the anchorages at Aghinver, Lakeland and Muckross. On the western shoreline and across from these is Erincurragh.

The Island of Boa, with its interesting Janus figures, stretches along the northern shore of Lower Lough Erne. To the west you enter the 5km waterway which leads to Belleek in County Fermanagh.

Our journey through Ireland will have taken us 480km or 300 miles from St Mullins Lock at the start of the Barrow Navigation.

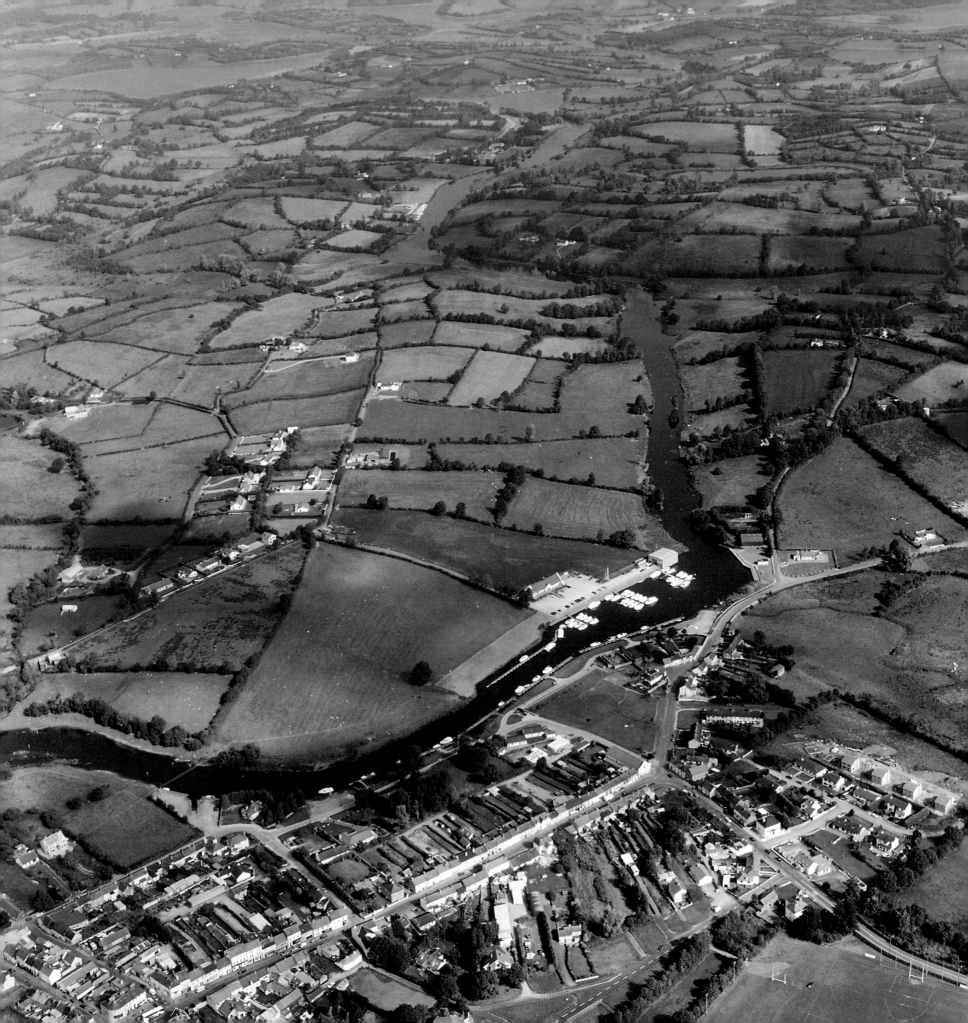

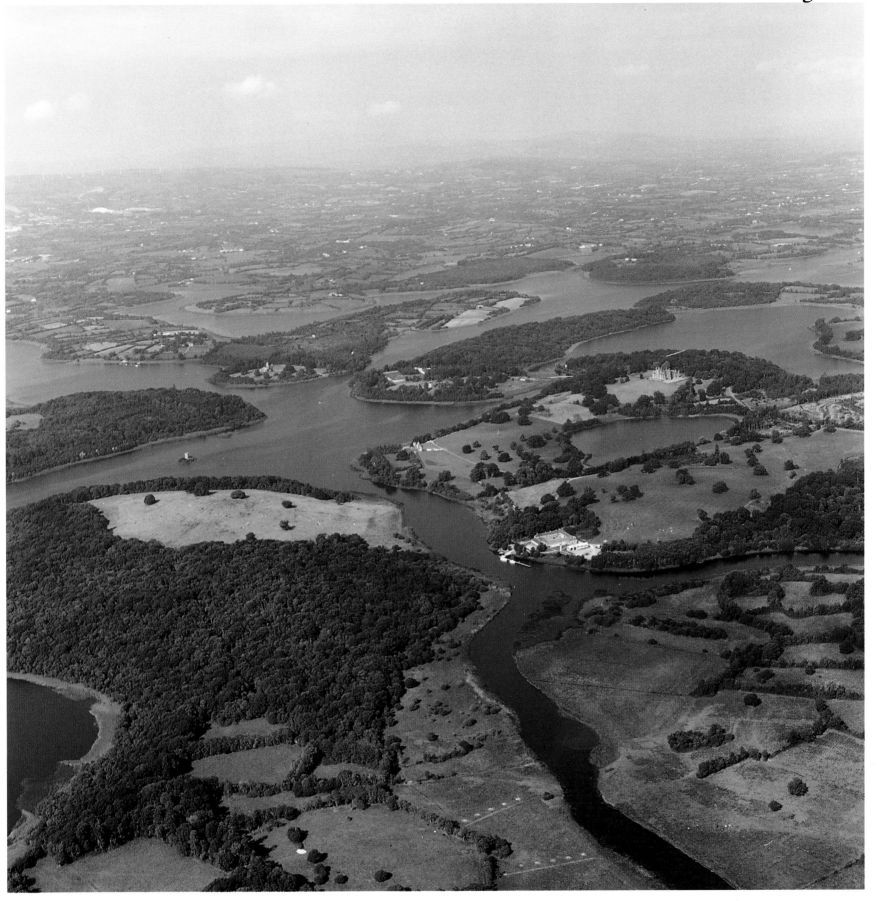

Facing page: The town and cruiser base of Belturbet on the River Erne in County Cavan.
Above: The River Erne approaching drumlin countryside and the jetty close
to Croom Castle in County Fermanagh.

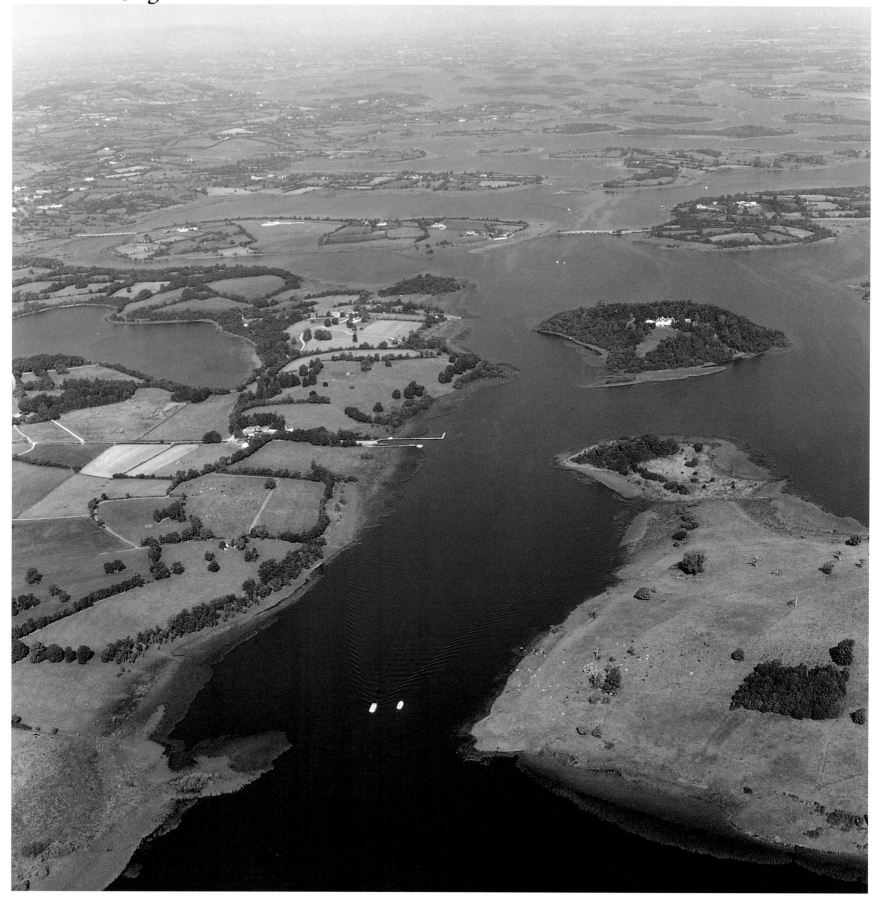

Two cruisers near the small jetty at Geaglum, while other cruisers can be seen near the bridge from Trasna Island. *Facing page:* Looking north over the Share Holiday Centre and the many islands in Upper Lough Erne.

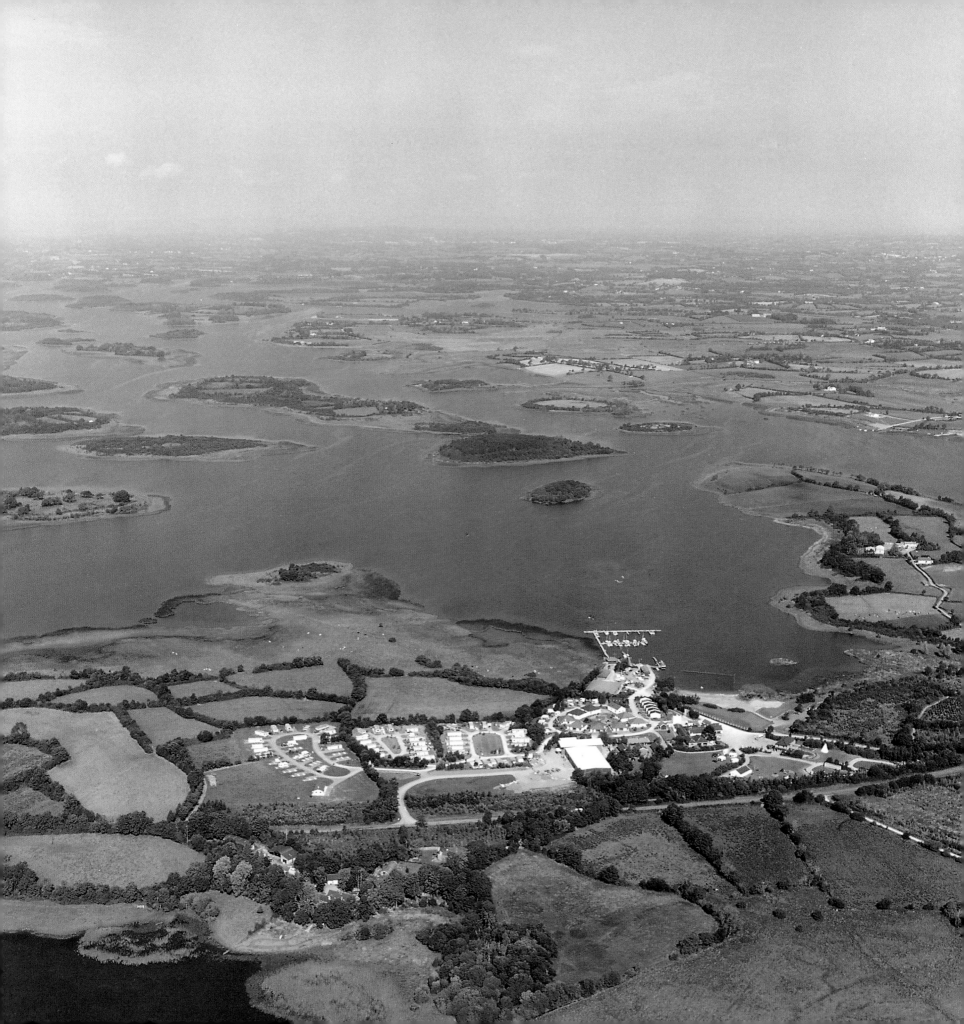

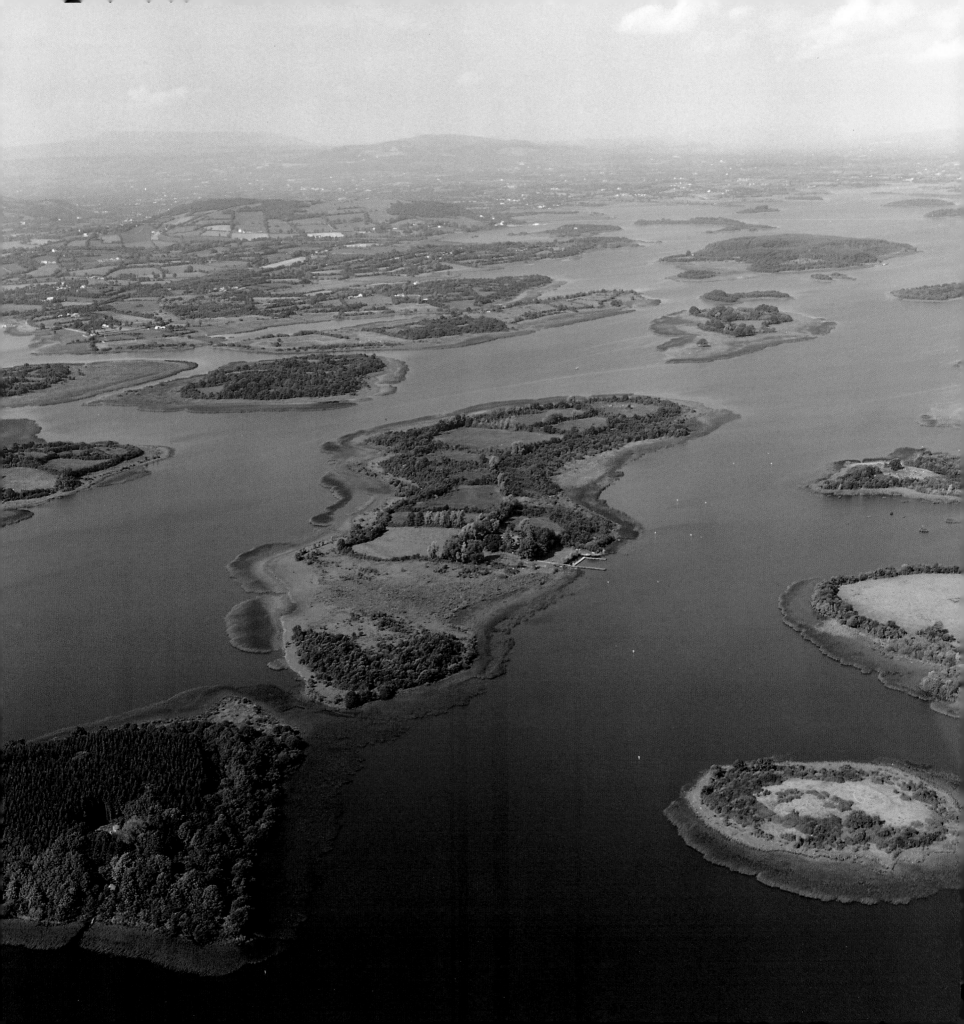

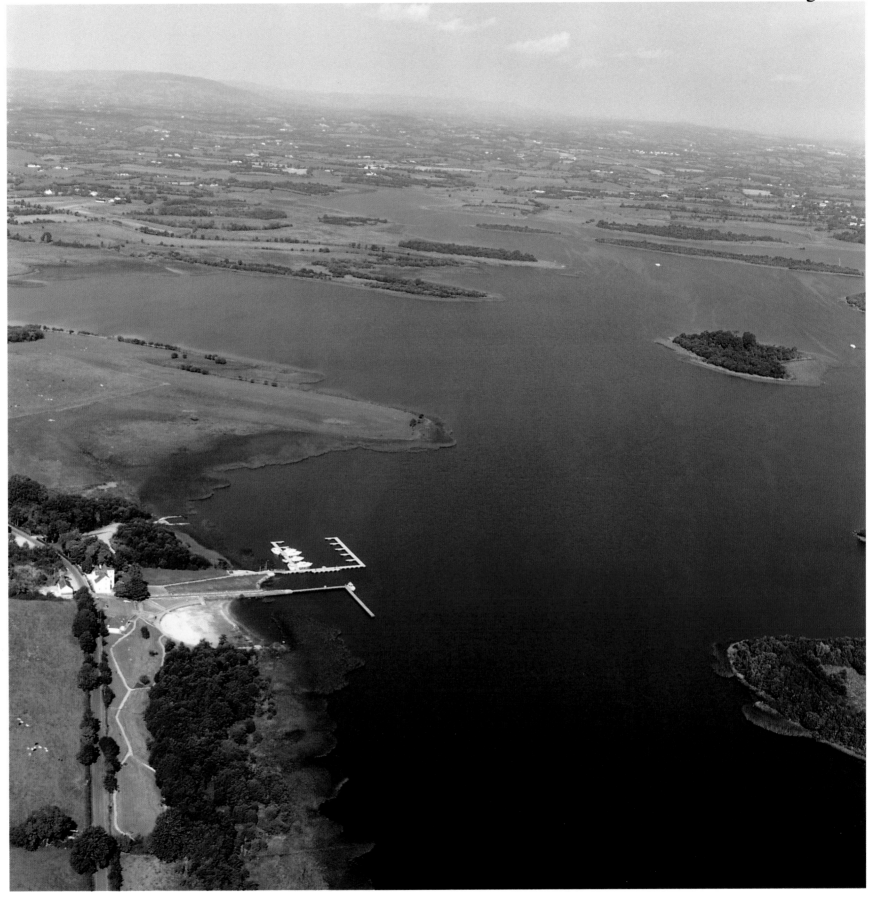

Facing page: The small jetty which leads to the pub and restaurant on Inishcorkish Island.
Above: The marina and cruiser base at Knockninny on the west shore of Upper Lough Erne.

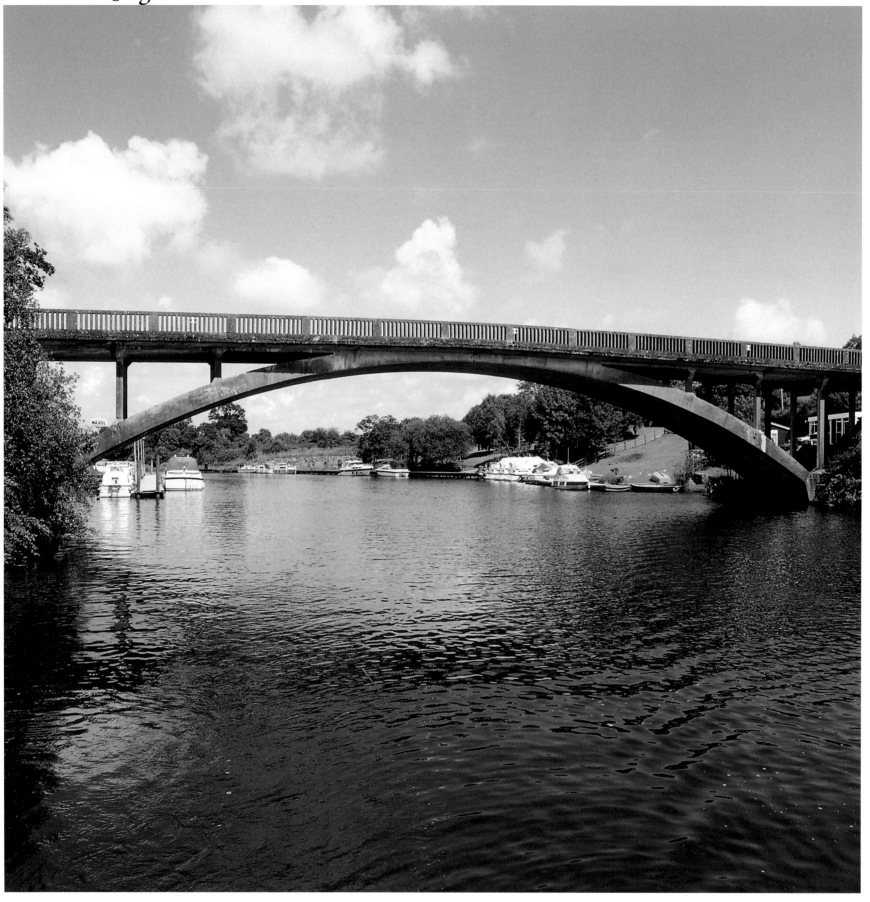

Two views of Carrybridge on the eastern route of the Erne Navigation around Inishmore Island.

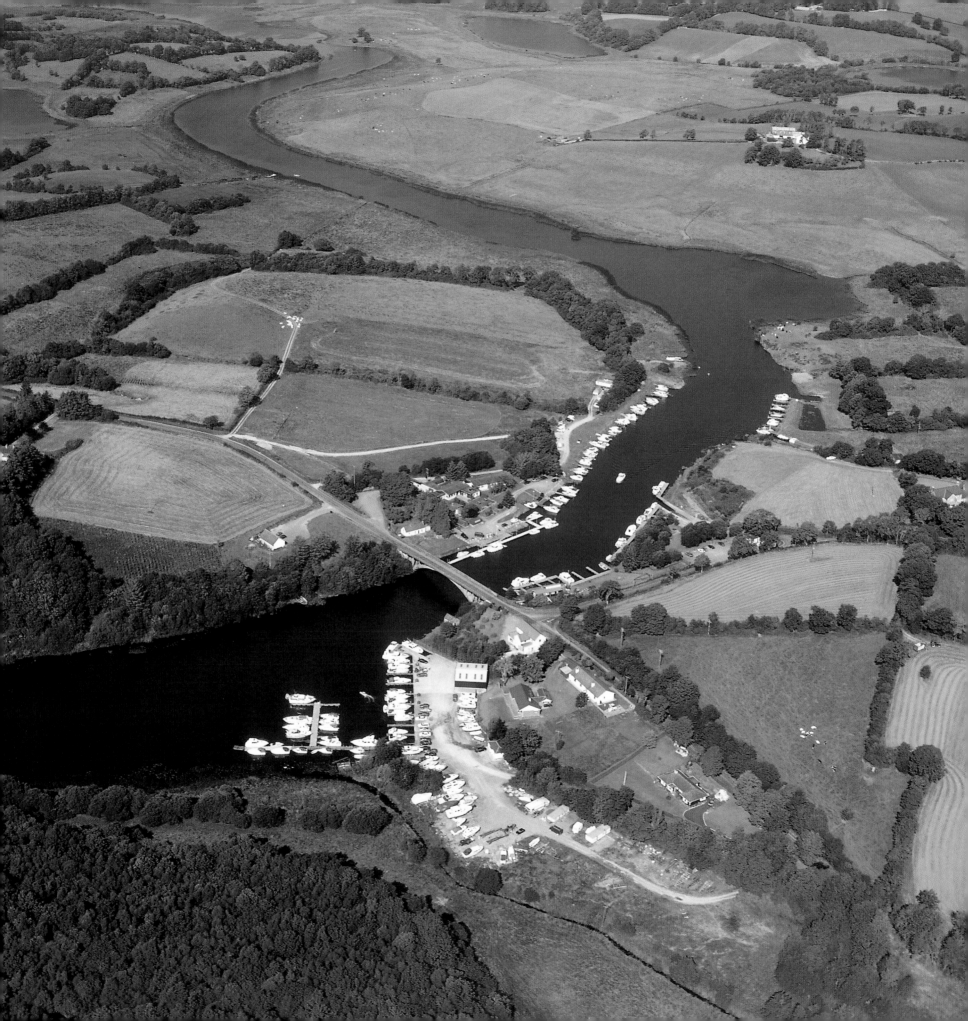

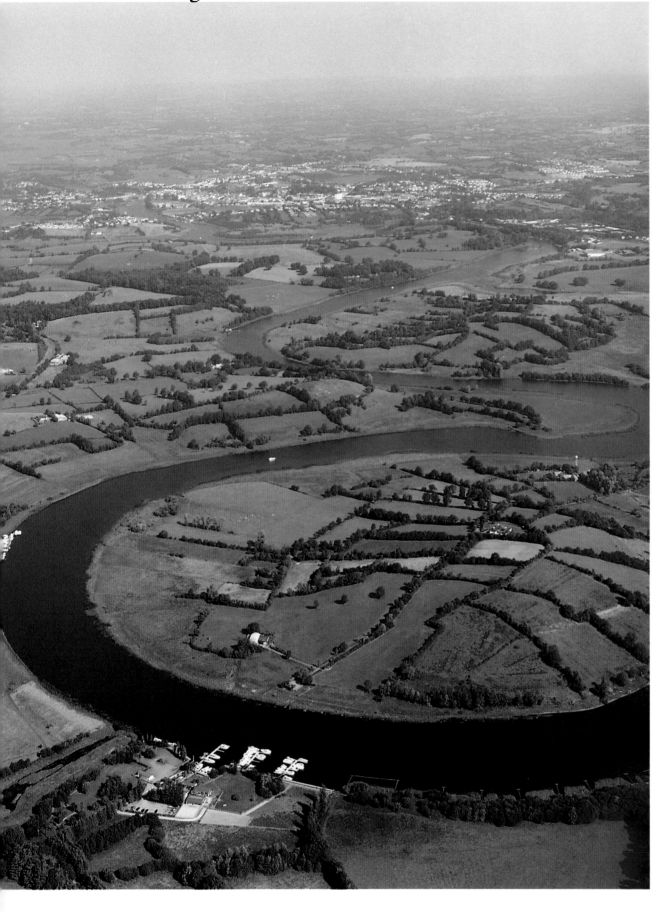

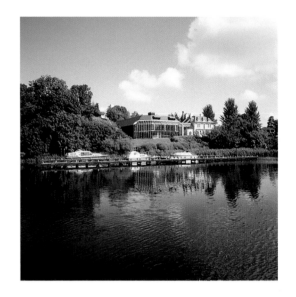

Ardhowen Arts Centre
close to Enniskillen.

Bellanaleck and
The Moorings on a sharp
meander of the Erne with
Enniskillen in the distance.

Facing page: The two
turrets dominating the
Watergate in Enniskillen,
with the new and old road
bridges in the distance.

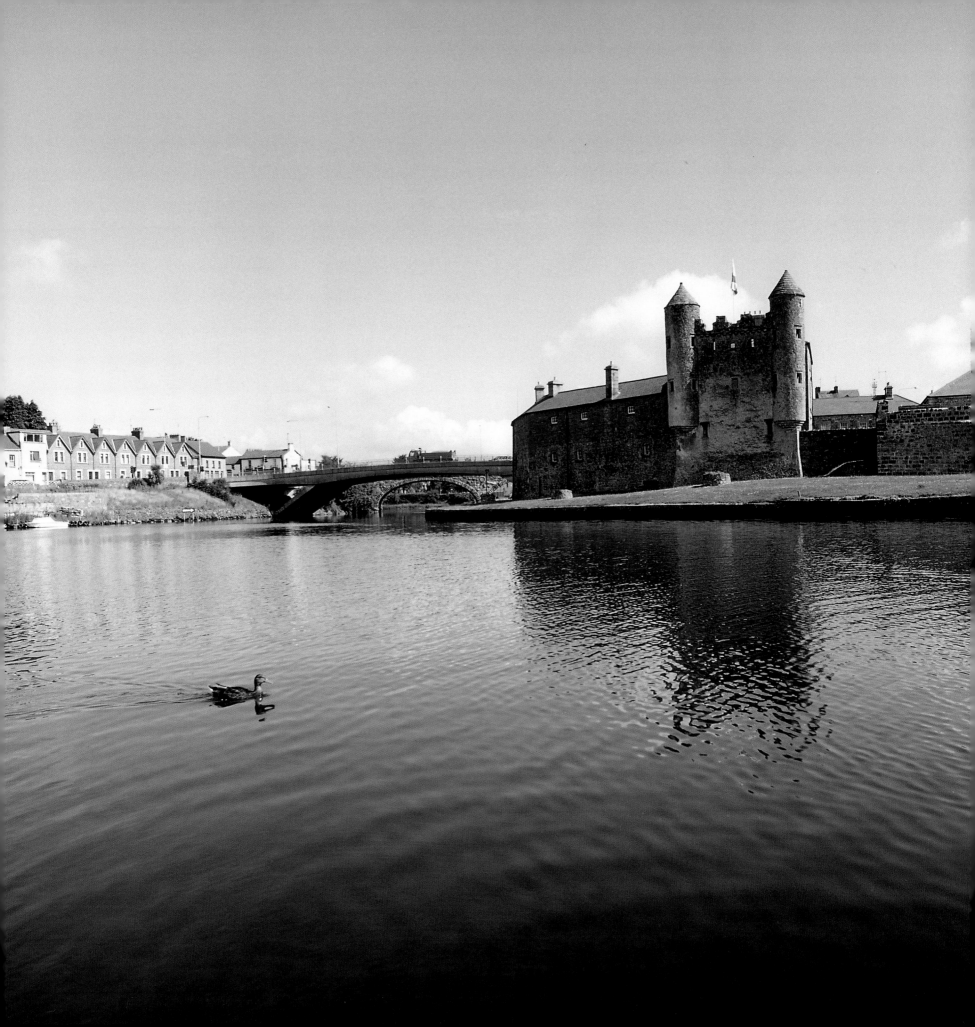

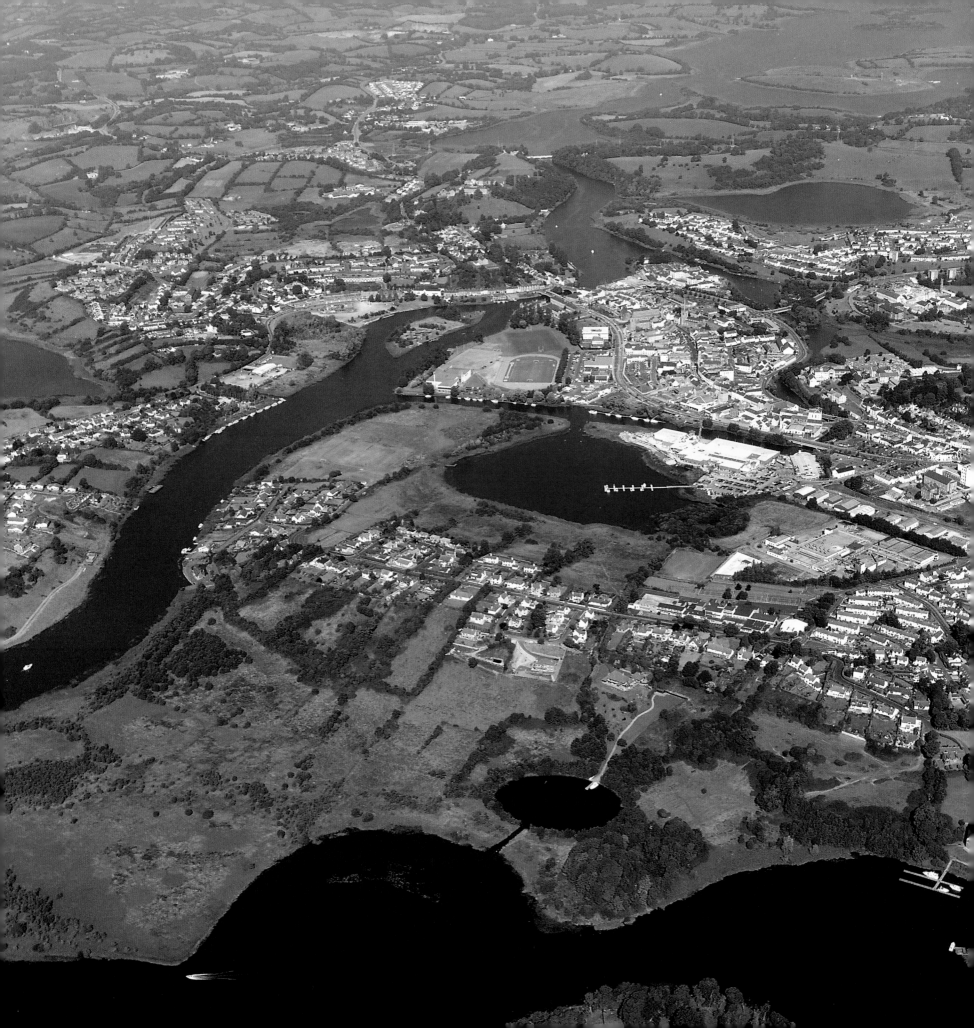

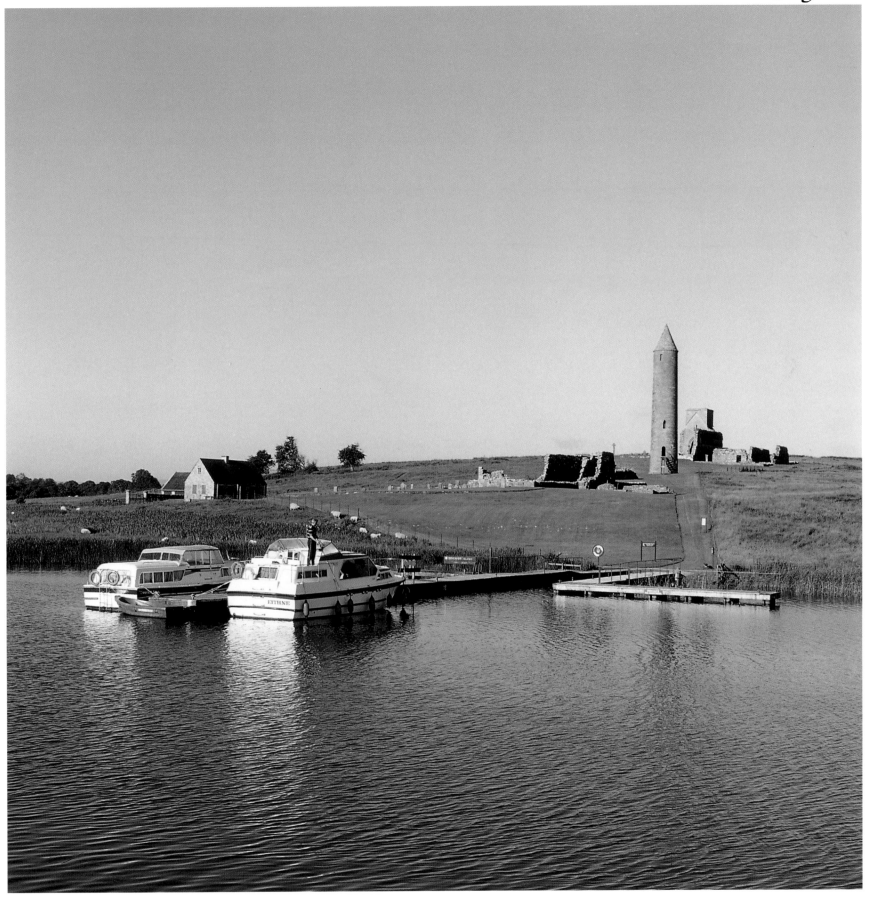

Facing page: The town of Enniskillen in Fermanagh, between Upper and Lower Lough Erne.
Above: Devenish Island, founded by St Molaise in the 6th century, was once one of the most important monastic sites in Ireland. The small museum has a display of finds from the site.

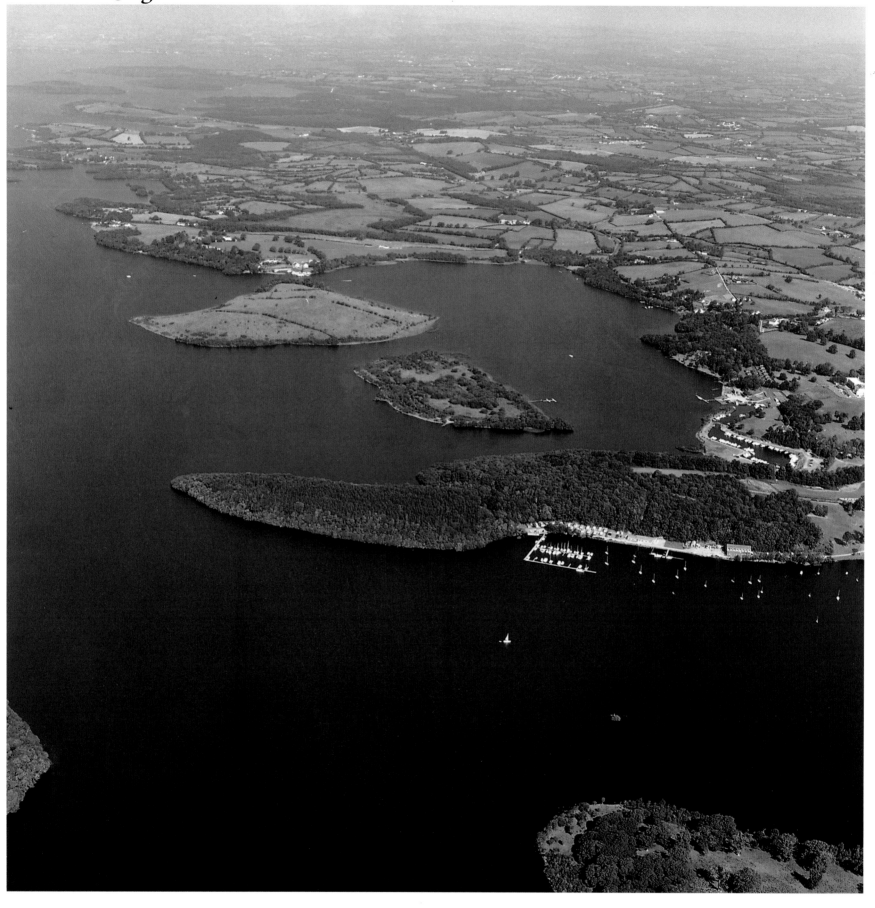

The Erne Yacht Club with Manor House Harbour to its north on the east shore of Lower Lough Erne.
Facing page: Looking over Castle Archdale towards White Island and Aghinver.

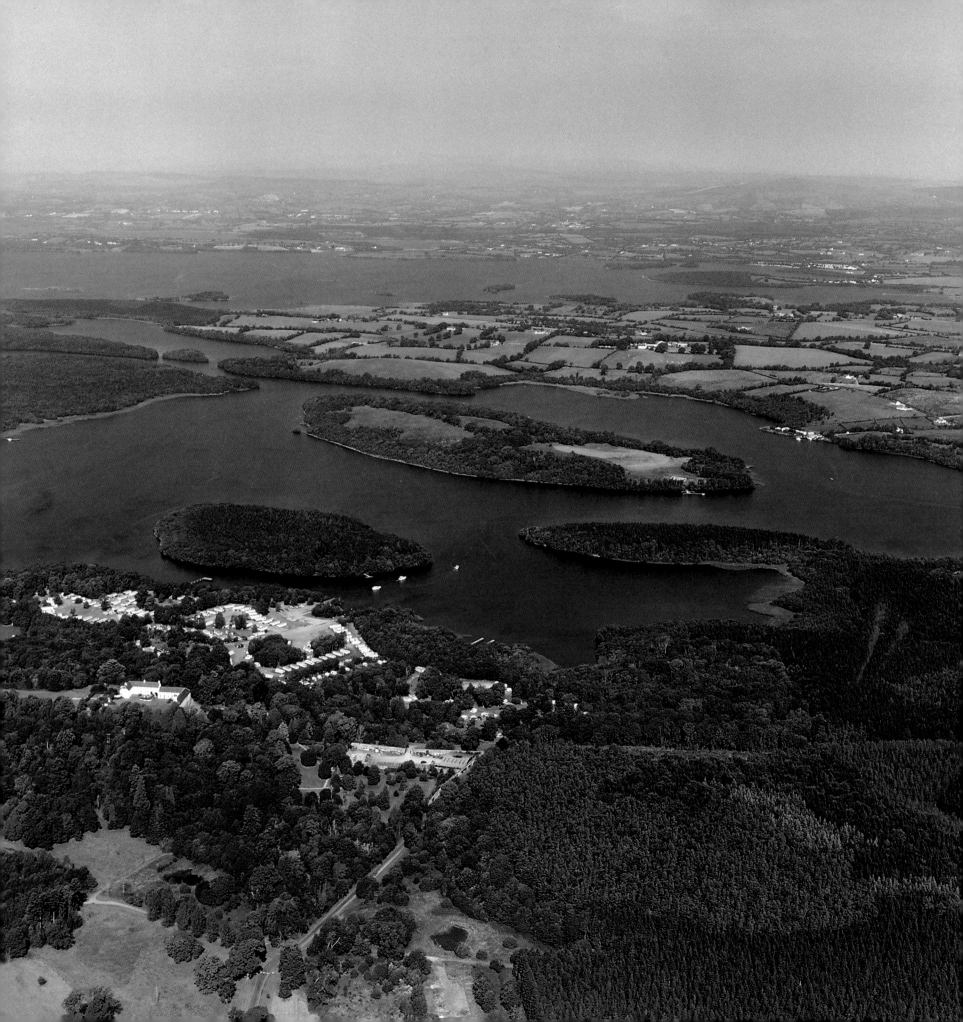

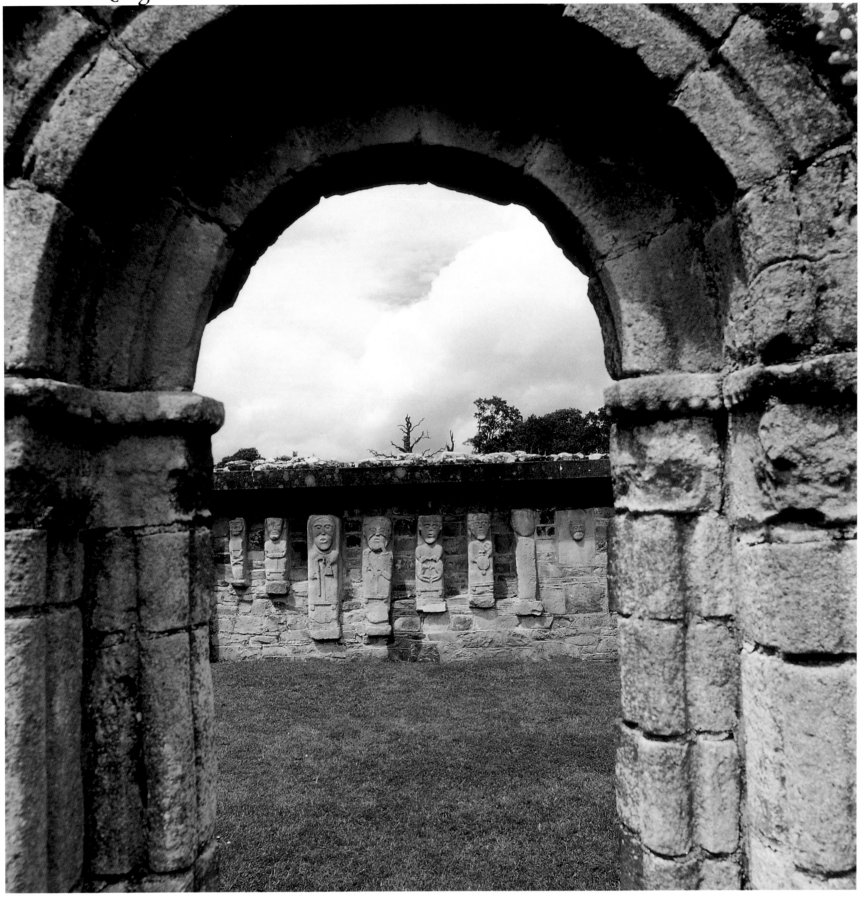

Looking through the Romanesque south door of the church ruins on White Island
towards the seven carved figures in the north wall.

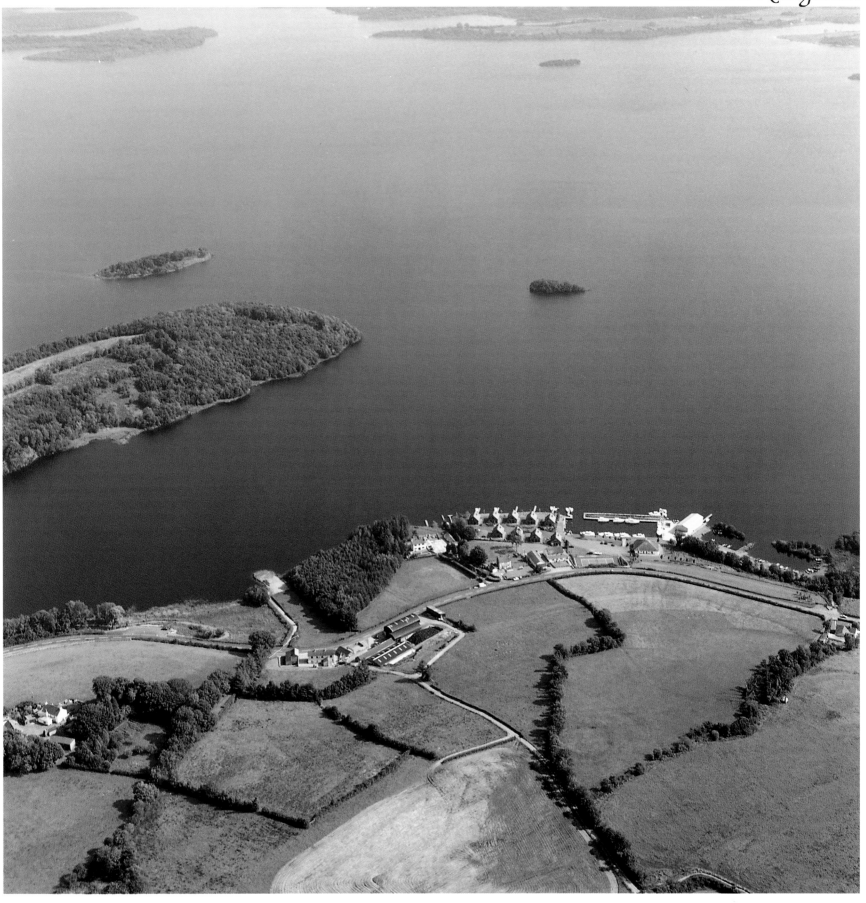

The harbour at Erincurragh on the south-west shore of Lower Lough Erne.

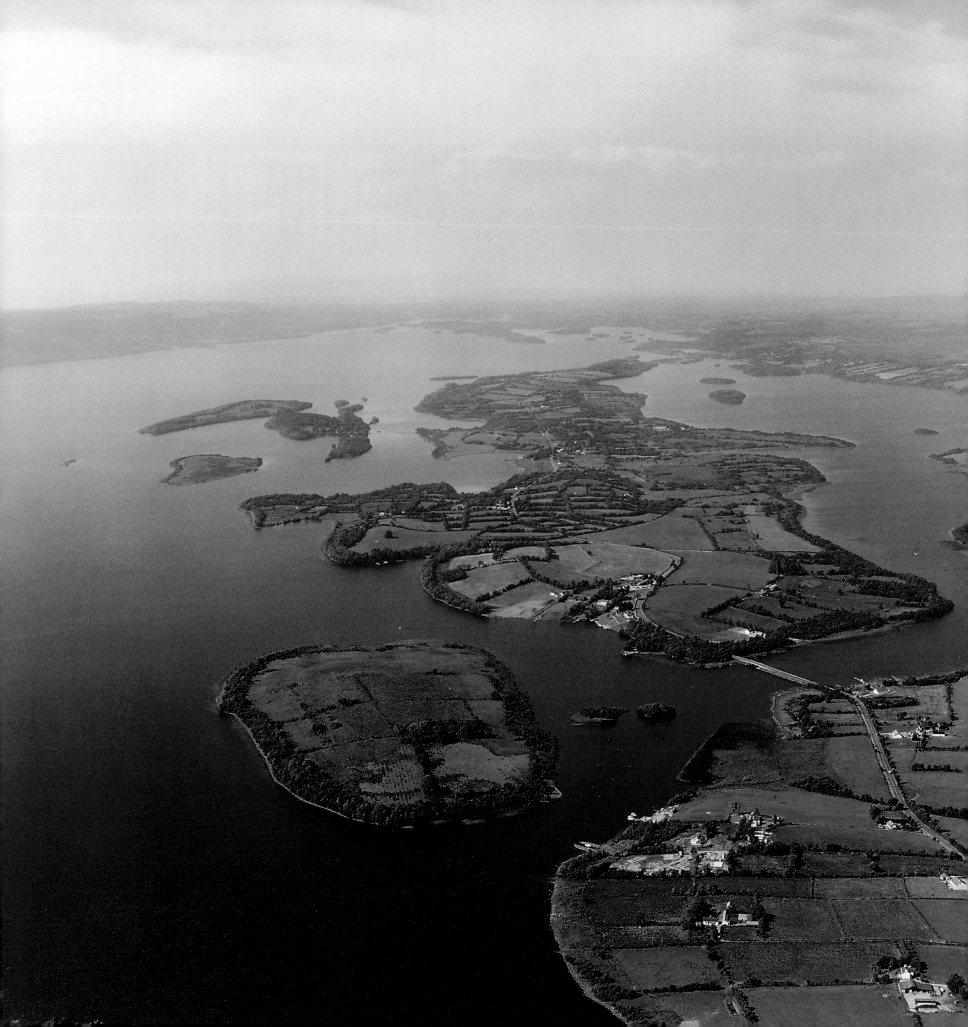

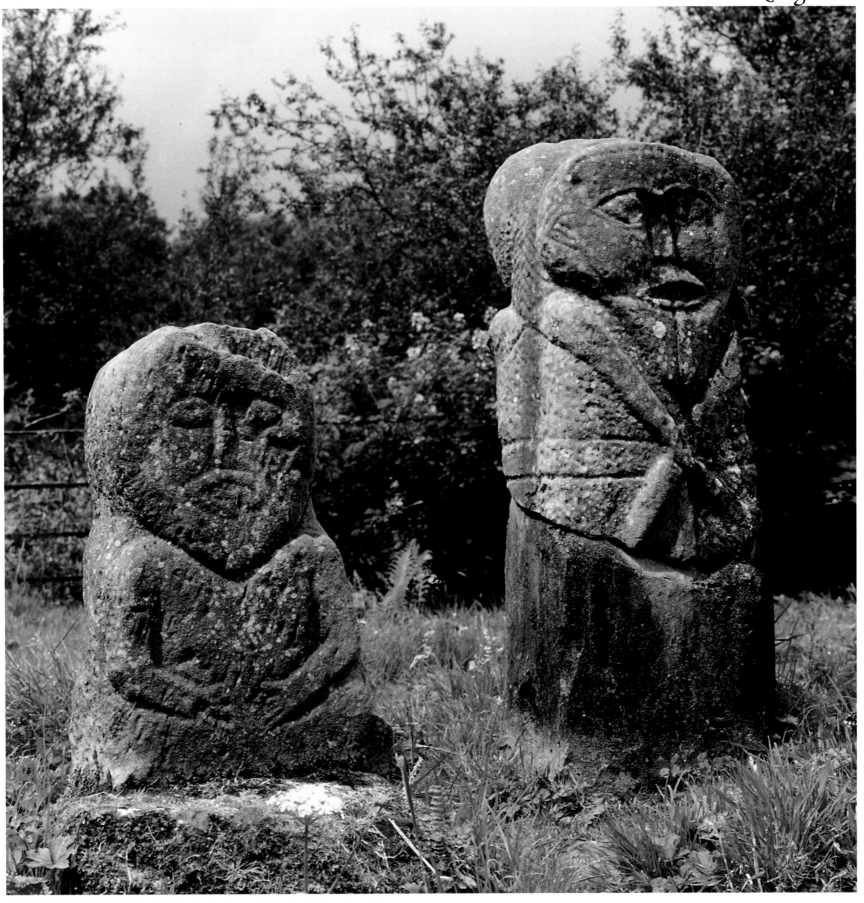

Facing page: Boa Island stretching away to the west and along the northern shoreline of Lower Lough Erne.
Above: One side of the double-headed pre-Christian enigmatic stone Janus figures in
the burial ground of Caldragh, about 3km to the northwest of the chain ferry on Boa Island.

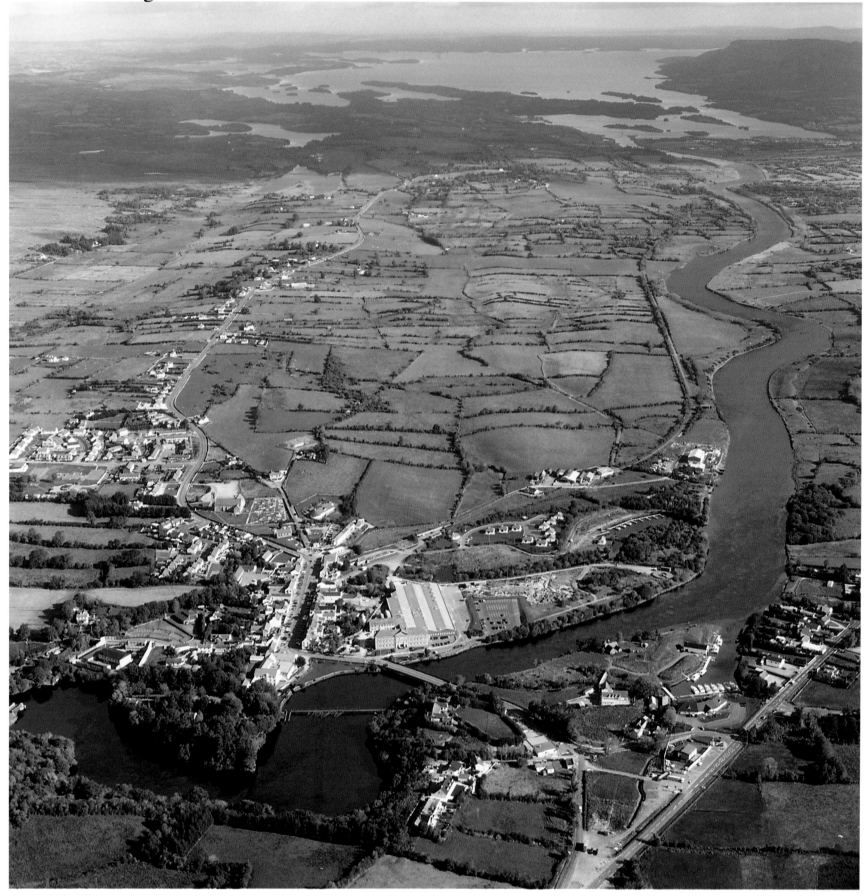

The end of our journey at Beleek in Fermanagh, 480km from St Mullins Lock
on the Barrow Navigation. The River Erne falls 50m over a 5km distance
from here to Ballyshannon in Donegal Bay.

INDEX